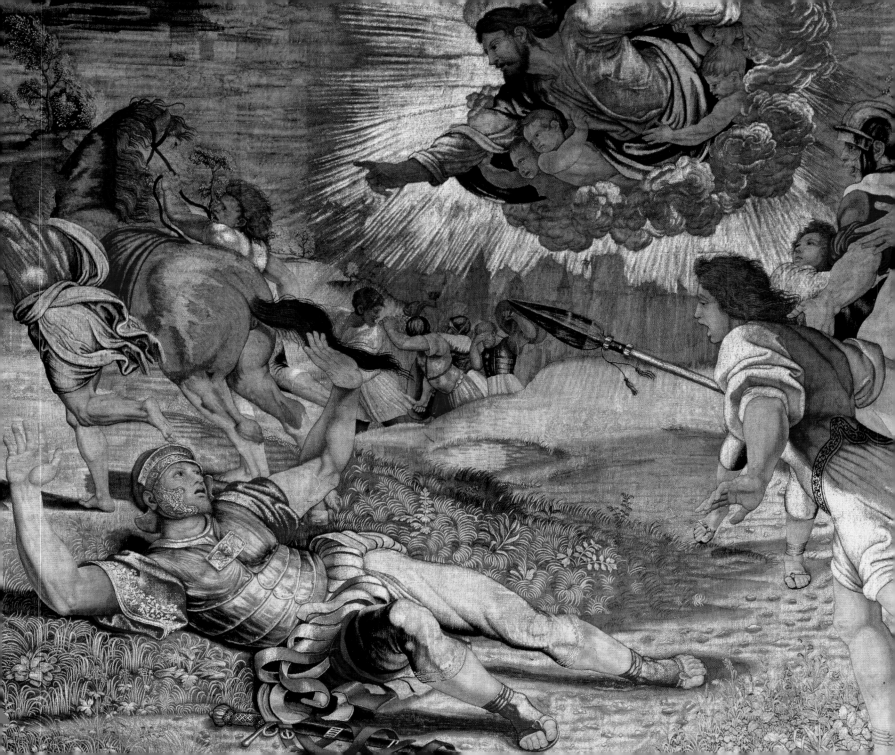

RAPHAEL

CARTOONS AND TAPESTRIES FOR THE SISTINE CHAPEL

EDITED BY
Mark Evans and Clare Browne
with Arnold Nesselrath

WITH CONTRIBUTIONS BY
Mark Haydu and Adalbert Roth

CATALOGUE BY
Mark Evans and Anna Maria De Strobel

V&A Publishing

For John White and in memory of John Shearman

First published by V&A Publishing, 2010

V&A Publishing
Victoria and Albert Museum
South Kensington
London SW7 2RL

© The Board of Trustees of the
Victoria and Albert Museum, 2010

The moral right of the authors has been asserted.

ISBN 978 1 85177 634 4

Library of Congress Control Number
2010930488

10 9 8 7 6 5 4 3 2 1
2014 2013 2012 2011 2010

A catalogue record for this book is
available from the British Library.

Designer: Philip Lewis
Copy-editor: Mandy Greenfield
Initial translations provided by
Sonia Atkinson and Lingo24 Ltd
V&A Photography by V&A Photographic Studio

Front jacket illustration: cat. 1, *Cartoon* (detail)
Back jacket illustration: cat. 1, *Tapestry* (detail)
Back flap illustration: cat. 1.1 (detail)
Frontispiece: cat. 6, *Tapestry* (detail)

Printed in Italy

V&A Publishing
Victoria and Albert Museum
South Kensington
London SW7 2RL
www.vandabooks.com

Contents

Forewords

THE STATE VISIT of Pope Benedict XVI to the United Kingdom is a historic moment. The invitation extended by Her Majesty The Queen brings the Pope as a Head of State and the principal pastor of over one billion members of the Catholic Church. To mark this occasion the Pope sent four exquisite tapestries designed for the Sistine Chapel by Raphael, for display at the Victoria and Albert Museum beside Raphael's preparatory Cartoons from the Royal Collection. They are brought together just as Her Majesty hosts the first ever State Papal Visit. This is a marvellous gift to lovers of art, whatever their faith or conviction, which recognizes the importance of culture in the life of the United Kingdom.

Throughout the centuries the Popes have been patrons of the arts. This often served a political and social function as well as a religious one. Yet, in artists of such skill and inspiration as Raphael, the spiritual realm illuminates the drama of the human. Raphael shows himself as a master of the High Renaissance and its celebration of the human, and as a profound and subtle Christian artist. He understands that the Incarnation of Christ invites us to see the Divinity in what is truly human.

Commissioned when papal authority was being called into question, the tapestries encapsulate the significance of Peter as the head of Christ's Apostles and of Paul as the great Christian missionary. Raphael looked beyond a manifestation of papal authority to an eternal truth, casting light onto the human and historical reality of Christ and his Church.

To grasp this, we need only look at the tapestries depicting Peter. *The Miraculous Draught of Fishes* and *Christ's Charge to Peter* present a man humbly receiving a gift he does not expect. Raphael makes these moments dramatic and personal. Through his mastery of grouping and perspective we sense the universal significance of these personal moments. The distant vistas suggest an event not limited to one historical moment, but touching the viewer in every time and place. Raphael captures the scandal and the grace of the Petrine ministry: at once personal and human, yet without temporal or geographical limits. Peter is called to gather, tend, protect and increase the flock of Christ. It is an apostolic commission received from a commanding Risen Christ and it runs to the end of time.

In *The Healing of the Lame Man* we find an Apostle filled with power and authority. Raphael represents a broken and burdened humanity, drawn to Peter for healing. Positioned between the pillars of the Temple, Peter himself now seems a living pillar of the new Temple, the Church of Christ.

Pope Benedict has said that the '*via pulchritudinis*, the way of beauty, is a privileged and fascinating path on which to approach the Mystery of God'. This exhibition allows us to experience not only the beauty and the art of Raphael, but the faith that inspired and illuminated it. Long after the papal visit it will have encouraged us to look with fresh eyes at ourselves and our world and to understand, in the words of the Apostle Paul, that 'We are God's work of art, created in Christ Jesus to live the good life as from the beginning he had meant us to live it' (Ephesians 2:10).

VINCENT NICHOLS
Archbishop of Westminster

ON 30 JULY 1517 Cardinal Luigi d'Aragona visited the workshop of Pieter van Aelst in Brussels. His secretary Antonio de Beatis wrote: 'Here Pope Leo is having made . . . pieces of tapestry, it is said for the Chapel of Sixtus which is in the Apostolic Palace in Rome, for the most part of silk and gold; the price is 2,000 gold ducats a piece. We were on the spot to see them in progress . . . the cardinal estimated that they would be among the richest in Christendom.' The Raphael Cartoons depict the Acts of St Peter and St Paul. They were commissioned by Pope Leo X as designs for tapestries made to complement Michelangelo's celebrated painted ceiling in the Sistine Chapel. Henry VIII and other European princes later commissioned copies. In 1623 the seven Cartoons that now survive came to England for use in the tapestry manufactory at Mortlake. Since 1865 they have been on loan from the Royal Collection to the V&A, while the tapestries remain in the Vatican Museums.

For almost 500 years the Raphael Cartoons and the Sistine tapestries have lived separate and sometimes highly eventful lives. I am delighted at this unprecedented opportunity to bring four of the tapestries together with the Cartoons.

This exhibition of the tapestries coincides with the historic visit to England and Scotland of Pope Benedict XVI. We are especially grateful to His Eminence the Cardinal Tarcisio Bertone, Secretary of State to His Holiness the Pope, and to the staff of the Vatican Museums, in particular its Director Antonio Paolucci, Arnold Nesselrath and Anna Maria De Strobel. At the Vatican Apostolic Library we are obliged to Rev. Msgr Cesare Pasini and to Adalbert

Roth, and at the Ufficio Celebrazioni Liturgiche to Rev. Msgr Guido Marini. We would also like to thank the Royal Collection Trust, especially its Director, Jonathan Marsden, his predecessor Sir Hugh Roberts and the Hon. Jane Roberts. At the Musée du Louvre, we are grateful to its Director Henri Loyrette and to Carel van Tuyll. We are also grateful to the Trustees of the 9th Duke of Buccleuch's Chattels Fund. At the V&A, this exhibition has been curated by Mark Evans and Clare Browne.

This exhibition is made possible by a collaboration between the V&A and the Vatican Museums and is generously supported by Michael and Dorothy Hintze and the Hintze Family Charitable Foundation, with further support from the Patrons of the Arts in the Vatican Museums.

SIR MARK JONES
Director, Victoria and Albert Museum

RAPHAEL'S TAPESTRIES depicting the Acts of the Apostles Peter and Paul were first displayed in the Sistine Chapel on St Stephen's Day 1519. Contemporary accounts recalled the event with solemn words: 'the papal mass was held in the usual chapel . . . that same day, the Pope ordered that his splendid new tapestries be hung. Judged by all to be superior in beauty to anything else on earth, they aroused the great admiration of all those present.'

'Sunt res quibus non est aliquid in orbe pulchrius . . .': the Latin original of the account, written by the master of ceremonies Paris de Grassis, gives us an even better sense of the wonder and admiration that the tapestries produced. The papal official was right. In 1519 there was nothing in the world more beautiful than the tapestries designed by Raphael and woven by the workshop of Pieter van Aelst in Brussels.

Five centuries have passed since that time, and nothing has changed. Together with the Stanze, the Logge and Michelangelo's Sistine Chapel, the tapestries can be placed at the very peak of works produced during the Renaissance. Every tapestry in the set is unforgettable for its tragedy and pathos, emotion, glory and drama. Flemish weavers were renowned for their technical excellence, but it was Raphael who imbued the great religious stories with infinite beauty. A century later this vision was shared by Annibale Carracci, Domenichino, Pietro da Cortona and Nicolas Poussin. Raphael's tapestries, replicated in sets in many collections across Europe, like the frescoes of the Logge and, even more, those of the Stanza, set an example for centuries and provided an unsurpassed model for artists.

The V&A in London houses the Cartoons for the famous set of tapestries. To mark the occasion of the visit of Pope Benedict XVI to the United Kingdom, we have collaborated closely with our colleagues at this renowned British museum to present the seminal beauty of the Cartoons beside the supreme beauty of the finished tapestries.

At the V&A, four tapestries from the Vatican Museums are being displayed alongside their Cartoons. This extraordinary event will be remembered as a landmark among art exhibitions. It is a worthy tribute to the Holy Father's visit to the United Kingdom.

This unforgettable exhibition would not have been possible without the generous authorization and the benevolent consent of the following: His Eminence Card. Giovanni Lajolo; His Eminence Card. Raffaele Farina; His Excellency Mons. Carlo Maria Viganò; His Excellency Mons. Giorgio Corbellini; His Excellency Mons. James Michael Harvey; His Excellency Mons. Paolo De Nicolò; Monsignor Cesare Pasini; Monsignor Guido Marini and Reverend Father Pavel Benedik.

ANTONIO PAOLUCCI
Director, Vatican Museums

Introduction

MARK EVANS

The Raphael Cartoons are one of the great treasures of the High Renaissance, commissioned in 1515 by the Medici Pope, Leo X. They are full-scale designs depicting the Acts of St Peter and St Paul for tapestries made to cover the lower walls of the Sistine Chapel. The Cartoons were painted by Raphael and his assistants, in gouache on paper. Between 1516 and 1521 their compositions were woven into 10 tapestries of wool, silk and gilt-metal-wrapped thread at the workshop of Pieter van Aelst in Brussels, the main centre for tapestry production in Europe. Like the outstanding French singers and the Franco-Flemish polyphonic music introduced to the Sistine Chapel at the same time, these sumptuous tapestries purposefully emphasized the papal majesty of Leo X. As designs for tapestry, they represent a fundamentally new stylistic departure. In 1623 the seven Cartoons that now survive were purchased for use in the tapestry manufactory at Mortlake, and remained in England. During the eighteenth century Raphael attained the zenith of his reputation, and the Cartoons became some of the most famous paintings in the world. Since 1865 they have been on loan from the Royal Collection to the V&A. The tapestries remain in the Vatican Museums.

Because tapestries were exceedingly costly, and vulnerable to damage from light exposure and dirt, they were usually displayed only on special occasions. Seven of the tapestries woven from Raphael's Cartoons were shown for the first time on St Stephen's Day, 26 December 1519. The set was subsequently displayed on principal feast days. On 31 May 1787 the German poet Johann Wolfgang von Goethe, in Naples to view the eruption of Vesuvius, wrote in his diary: 'I am so firmly set on seeing the Feast of Corpus Christi in Rome, and the tapestries woven after Raphael's designs, that no natural beauty, however magnificent, can lure me away from my preparations for departure.'[1] The loan of four of the tapestries to the United Kingdom in 2010, to mark the visit of Pope Benedict XVI, has continued this tradition of display on special occasions. It has also enabled the Cartoons and the tapestries to be reunited for the first time since they were made, and compared with a group of their preliminary drawings.

The Raphael Cartoons speak a forceful formal language. Closely following the text of the Acts of the Apostles, they represent weighty figures acting out a series of momentous encounters. Raphael seems to have simplified the compositions and magnified the protagonists' gestures so that their message should clearly be read, even when translated into the medium of tapestry, which traditionally emphasized decorative values. Raphael's German contemporary Albrecht Dürer may have seen the Cartoons, as is apparent from his similarly monumental *Four Apostles* of 1526 (see fig. 44, p.51), which bears the cautionary inscription:

> All worldly rulers in these dangerous times should give good heed that they receive not human misguidance for the Word of God, for God will have nothing added to His Word nor taken away from it. Hear therefore these four excellent men, Peter, John, Paul, and Mark, their warning.[2]

As Leo X was especially concerned with the reform of preaching and was certainly mindful of the dangers

of heresy, it is likely that he would have subscribed to this advice, expressed by a moderate Catholic and an admirer of Martin Luther.

On account of their clear dramatic narrative and unimpeachable subject matter, the Cartoons – and woven, painted, engraved and finally photographic copies of them – displayed a seemingly infinite capacity to address the concerns of a succession of audiences, both Catholic and Protestant. In 1772 the first President of the Royal Academy, Sir Joshua Reynolds, wryly observed the 'many disquisitions which I have read on some of the Cartoons . . . where the Criticks have described their own imaginations; or indeed where the excellent master himself . . . left room for every imagination, with equal probability to find a passion of his own'.[3]

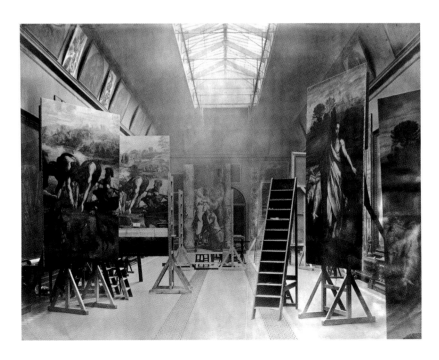

Raphael's pre-eminence was first questioned in 1851 when the influential English critic John Ruskin wrote in defence of the recently founded Pre-Raphaelite Brotherhood:

> they will draw either what they see, or what they suppose might have been the actual facts of the scene they desire to represent . . . all artists did this before Raphael's time, and after Raphael's time did *not* this, but sought to paint fair pictures, rather than represent stern facts; of which the consequence has been that, from Raphael's time to this day, historical art has been in acknowledged decadence.[4]

The sixteenth-century art historian Giorgio Vasari had similarly conceded that the peak of perfection attained by Leonardo, Raphael and Michelangelo was followed by a period of artistic decline.

Ruskin's attitude to Raphael changed over time, from initially unbounded admiration to a mixture of approval of his early work and dislike for his late style. He recalled how already in his youth 'the Cartoons began to take the aspect of mild nightmare and nuisance which they have ever since retained' and vehemently criticized the theme of papal supremacy in 'that infinite monstrosity and hypocrisy – Raphael's cartoon of the Charge to Peter'.[5] Nevertheless, copying the Cartoons (fig. 1) remained a regular part of the curriculum of students at the Royal College of Art until the Second World War.[6] By the time they returned to public display in 1950, Picasso had generally supplanted Raphael as a role model for young artists.

Raphael of Urbino (1483–1520)

MARK EVANS

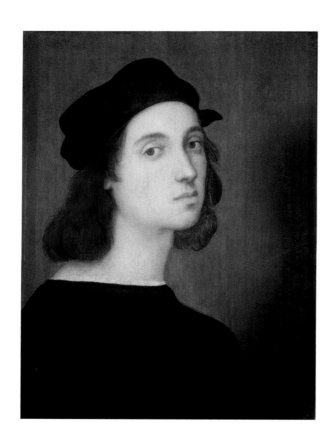

With wonderful indulgence and generosity heaven sometimes showers upon a single person from its rich and inexhaustible treasures all the favours and precious gifts that are usually shared, over the years, among a great many people. This was clearly the case with Raphael Sanzio of Urbino, an artist as talented as he was gracious, who was endowed by nature with the goodness and modesty to be found in all those exceptional men whose gentle humanity is enhanced by an affable and pleasing manner, expressing itself in courteous behaviour at all times and towards all persons. Nature sent Raphael into the world after it had been vanquished by the art of Michelangelo and was ready, through Raphael, to be vanquished by character as well. Indeed, until Raphael most artists had in their temperament a touch of uncouthness and even madness that made them outlandish and eccentric . . . So nature had every reason to display in Raphael, in contrast, the finest qualities of mind accompanied by such grace, industry, looks, modesty and excellence of character as would offset every defect, no matter how serious, and any vice, no matter how ugly. One can claim without fear of contradiction that artists as outstandingly gifted as Raphael are not simply men but, if it be allowed to say so, mortal gods, and that those who leave on earth an honoured name in the annals of fame may also hope to enjoy in heaven a just reward for their work and talent.[7]

FIG. 2
Raphael, *Self-portrait*,
c.1506, tempera on wood;
Florence, Uffizi

This characterization of Raphael from Giorgio Vasari's *Lives of the Painters, Sculptors and Architects* (first edition 1550, second revised edition 1568) remained canonical until the nineteenth century, and is still persuasive today.

Born at Easter 1483, the son of the painter Giovanni Santi (d.1494), Raphael (fig. 2) was felicitously named

after the archangel whose name means 'God has healed'. His father was a court painter of the successful mercenary commander Federico da Montefeltro (1422–82), but is now better known for his rhyming account of the leading artists of the fifteenth century than for his own eclectic paintings.[8] Thanks to the enlightened patronage of Federico, the tiny duchy of Urbino, in the Marches of central Italy, was a principal centre of humanistic culture during the 1460s to 1480s. Its ducal palace provides the setting for that fundamental compendium of Renaissance ideals, the *Book of the Courtier*, by Raphael's friend Baldassare Castiglione (1478–1529). Jacob Burckhardt's *Civilization of the Renaissance in Italy* (1860) defines its enduring image: 'Not only the State, but the court too, was a work of art and organization, and in every way.'[9]

At an early age Raphael attracted the patronage of Elisabetta Gonzaga (1471–1526), Duchess of Urbino and a key protagonist in Castiglione's *Courtier*. Around 1500 he began studying with Perugino (1445/50–1523), a renowned painter with workshops in Florence and his native Perugia, who in 1479–81 joined a consortium of leading Florentine artists to execute the frescoes of *The Life of Moses* and *The Life of Christ* in the Sistine Chapel. It was probably from Perugino that Raphael learned to paint in oils, recently introduced to Italy from the Netherlands, instead of the traditional tempera. His principal early works include the altarpiece of *St Nicholas of Tolentino* (dispersed between Paris, Louvre; Naples, Museo di Capodimonte; and Brescia, Pinacoteca Tosio Martinengo) and the Mond *Crucifixion* (London, National Gallery), painted in 1500–3 for churches in Città di Castello, near Perugia. These have a distinct resemblance to the work of Perugino, with delicately posed figures and elegant, sparse landscapes, while Raphael's *Marriage of the Virgin* (Milan, Brera), dated 1504, creatively revises an earlier composition by his master. His small panel of *St George and the Dragon*

(Washington, National Gallery) includes a background derived from an imported portrait by the Netherlandish painter Hans Memling (1430/40–94).

In 1504 Raphael arrived in Florence, where he became familiar with the heritage of the great past masters such as Giotto and Masaccio, as well as with the more recent works of Leonardo, Michelangelo and Fra Bartolomeo. In this culturally supercharged environment, the delicate fragility of his early work gave way to a more ample grandeur and gravity. This is clearly apparent in the *Entombment* (Rome, Galleria Borghese), painted in 1507 for the Baglioni, the ruling family of Perugia. Although derived from a static composition of the *Lamentation* by Perugino, its muscular figures are linked in a physical chain of activity that mirrors their shared, anguished psychological condition. His pair of portraits of *Angelo and Maddalena Doni* of 1506 (Florence, Palazzo Pitti) established Raphael as one of the most acute portrait painters of his time. Inspired by his Florentine contemporaries, he produced a series of full- and three-quarter-length paintings of the Virgin and Child, which explored and fundamentally transformed the compositional and expressive possibilities of this traditional devotional image.

Pope Julius II (papacy: 1503–13) summoned Raphael to Rome in 1508, initially to decorate the new papal apartments known as the *Stanze* in the Vatican Palace. These he painted in 1508–17 with frescoes of mythological, biblical and historical subjects – most famously the *Disputa*, *Parnassus*, *School of Athens* and *Expulsion of Heliodorus*. Subordinating a complex iconographic programme to a clear and unambiguous system of design, enlivened by sparkling passages of detail, colour harmonies and a range of light effects, this magisterial cycle of monumental narrative paintings remains one of the most influential ever created. In 1513–16 Raphael also produced two novel and

visionary works: the *Sistine Madonna* (Dresden, Gemäldegalerie) for S. Sisto in Piacenza and the *St Cecilia* altarpiece (Bologna, Pinacoteca) for the Bolognese church of S. Giovanni in Monte. To produce these major commissions he assembled a team of talented assistants and pupils, including Giovanni da Udine, Giovanni Francesco Penni, Giulio Romano, Perino del Vaga and Polidoro da Caravaggio. Through these works Raphael was confirmed as one of the principal artists in Italy and an influential figure at the papal court – so much so that its treasurer Cardinal Bibbiena offered him his niece as a wife, and it was later rumoured that Raphael might receive a cardinal's hat.

The election of the Medici Pope Leo X (papacy: 1513–21) confirmed Raphael's position at the Vatican, in preference to his older rival Michelangelo. Following the death of Donato Bramante in 1514, Raphael also succeeded him as architect of St Peter's and began to design profoundly innovative buildings, most notably the burial chapel of the papal banker Agostino Chigi at Santa Maria del Popolo and the Villa Madama for Cardinal Giulio de' Medici. These reveal his extensive knowledge of classical textual sources and ancient remains; as do his paintings. In 1515, with the help of his friend Castiglione, he addressed a passionate appeal to Leo X for the preservation of the remains of ancient Rome, which included an expert account of antique sculpture. Raphael's fluent synthesis of classical subject matter and exquisite design was epitomized by his fresco of *The Triumph of Galatea* painted at Chigi's villa (now Farnesina) around 1512, which, according to a contemporary, 'competes with the beautiful poetry of Poliziano'.[10] At the Vatican, Raphael immortalized the papal court's senior churchmen and its literary figures in a series of penetrating portraits, including those of *Julius II* (London, National Gallery), *Tommaso Inghirami* (Florence, Pitti Palace), *Baldassare Castiglione* (Paris, Louvre) and *Leo X with Cardinals Giulio de' Medici and*

Luigi de' Rossi (Florence, Uffizi). With the aid of his expert workshop, Raphael undertook a series of major commissions within a breathtakingly short period. These included the tapestry cartoons of the *Acts of the Apostles* for the Sistine Chapel (1515–16), as well as the decorations in the bathroom and loggia of Cardinal Bibbiena (1516) and the private loggias of Leo X (1518–19), which pioneered a classicizing style of grotesque decoration derived from excavated Roman remains. For foreign clients, he produced the altarpiece known as the *Spasimo di Sicilia* (1517; Madrid, Prado) and the *Holy Family of Francis I* and *St Michael* (both 1518; Paris, Louvre). He encouraged and facilitated the dissemination of his designs through prints, so that at Antwerp in 1520 the German artist Albrecht Dürer was able to exchange a set of his own engravings for those after Raphael by Marcantonio Raimondi.

At his death, Raphael was working on his largest and most ambitious oil painting, the altarpiece of the *Transfiguration*, commissioned by Cardinal Giulio de' Medici for Narbonne Cathedral (Rome, Pinacoteca Vaticana), and had begun the decoration of the Sala di Constantino in the Pope's private apartments, which was completed by Giulio Romano and Giovanni Francesco Penni. That it was possible to undertake such a huge volume of work while maintaining a high and consistent standard of execution is a testament to Raphael's artistic genius and managerial skills, as much as to the ability and industry of his assistants.

By the time of his death, aged 37, Raphael was one of the most admired painters in Europe, a distinguished architect, the head of a highly skilled team capable of all manner of design tasks, and the creator of what would today be called an internationally recognized visual brand. He had also established an imperishable myth of a genial and courtly genius, blessed with inexhaustible inventiveness and superabundant skill, which set a 'gold standard' for posterity.

Leo X (1475–1521)

MARK HAYDU

> Rome then flourished with outstanding talents and an abundance of everything, which explains why it was that Leo X – a pope of pre-eminent virtue and amplitude – was said to have founded after many centuries an age of gold.[11]

There is something dramatic, high-spirited and utterly beautiful about the artistic and cultural accomplishments of the Renaissance.[12] The grandeur and magnificence of the court of Leo X embodied this golden age as did few others. Raphael's tapestries for the Sistine Chapel took away the breath of the Venetian ambassadors in 1523 and still impress the visitor today. Julius II (1503–13) had been a very controversial successor of Peter: by calling Bramante, Michelangelo and Raphael to Rome, he had created one of the highest concentrations of artistic fervour ever, while on the other hand, he was prepared to defend the papacy in arms. When Leo X Medici ascended to the papal throne he was celebrated as a prince of peace who extinguished the flames of war and as a patron of the arts.

Giovanni de' Medici (fig. 3) was born on 11 December 1475, in the cradle of the Renaissance world, Florence. He died 46 years later and his body was laid to rest in the Gothic church of Santa Maria Sopra Minerva in Rome. His reign marked the apex of the High Renaissance, and he left behind a legacy of diplomacy and artistic accomplishment worthy of his father, Lorenzo the Magnificent. His mother, Clarice Orsini, belonged to an ancient Roman noble family, from which had come a series of high churchmen, including two popes and several cardinals.

As a young man from an eminent family, he was prepared for great things from his earliest years. The poet Angelo Poliziano inculcated in him a love for the humanities that would last his entire life and mark in large part his future ecclesiastical career. His classical education included poetry, literature and music as well as theology, philosophy and the ancients. He loved the Latin poems of the humanists, the tragedies of the Greeks and the Livian comedies of Bibbiena and Ariosto, and was fascinated by the discoveries of the present, reading assiduously the accounts arriving from the New World. This love for the arts and culture

FIG. 3
Attributed to Antonio de'Benintendi, Bust of Cardinal Giovanni de' Medici (later Leo X), c.1512, painted terracotta; V&A: A.29-1982

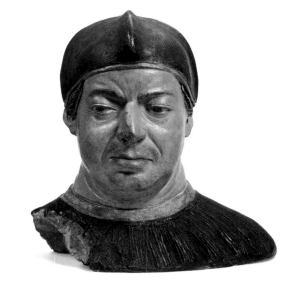

was by no means contrary to his love for God and the Church. Such a humanistic interest was itself religious. The gilded threads intertwining the classical past and the Christian world of Rome in religious and artistic harmony led him to patronize with such brilliant and devoted enthusiasm all forms of artistic expression.

Leo X had a warm demeanour that won the affection and support of many. Because of his widely recognized virtue, he was elected Pope with very little opposition. Just a week after his election, he broke with protocol and humbly walked on foot in the Palm Sunday procession, abandoning the portable throne on which popes were traditionally carried. Despite his fascination with intellectual and cultural pursuits, his priorities were clear and he never missed fulfilling his religious duties. He was often seen praying in his chapel, kept weekly fasts of bread and water and heard mass daily. A final endearing quality of Leo X was his extreme generosity. The papal ledgers record that his charitable contributions aided displaced families, discharged soldiers and the education of children, and provided food for the destitute. His monthly donations reputedly totalled the enormous sum of 8,000 ducats. But to few endeavours did he give with equal enjoyment and generosity as to the arts.

As a cardinal, Leo X had already rebuilt the beautiful Palazzo Madama, which he had purchased in 1505, and had restored the church of Santa Maria in Domnica. As Pope, he continued the architectural and urban development of the Eternal City that Julius II had begun, first of all with the rebuilding of the new basilica of St Peter's. On 2 November 1516, Leo reinstated the financial incentives given by Sixtus IV (1471–84) to private home owners to renovate their domiciles. The works begun by Julius II on the Campo Marzo, Piazza del Popolo and the area between the Vatican and the Castel Sant'Angelo were continued with vigour. The

area from Piazza Navona to the Campo dei Fiore took on new life as Rome sloughed off the coarse image it had had 60 years earlier under Eugene IV (1431–47).

The papal priority of art patronage was not confined to architecture and urban planning. Of principal importance were artists, and none more so than Raphael. The painter from Urbino was already at work on the *Stanza of Heliodorus* in the Apostolic Palace, commissioned by Julius II. But Leo, pleased with his work, invited Raphael to accept another major undertaking: the design of the tapestries for the Sistine Chapel. The historian Ludwig von Pastor commented: 'Besides these two responsibilities, each of which themselves would be enough to claim all the strength of an artist, he continued receiving other numerous commissions, great and small, whether from the Pope or from others who admired the art that surrounded the Pope.'[13] By the time the fresco of *The Fire in the Borgo* in the third *Stanza* was begun, Raphael was already immersed in the study of the ancient architecture of

Leo X and music

ADALBERT ROTH

Rome to confront his most recent charge from Leo X – that of head architect of the new basilica of St Peter's, to which the planning for the Villa Madama on Monte Mario was soon added. Raphael also found time to design the tapestries that would decorate the lower register of the Sistine Chapel. Their impact was splendid. The papal master of ceremonies, Paris de Grassis (fig. 4), stated: 'Everyone was astounded at the sight of those magnificent tapestries, which by unanimous acclaim, belong to those works of art whose beauty have no rival in all the Universe.'[14]

The historical judgement of Leo X often depends on his handling of Martin Luther. Since it now appears that the Augustinian monk did not actually attach his 95 theses to the door of the Schlosskirche in Wittenberg on 31 October 1517, but distributed them as was academic usage, Leo's whole reaction must be reconsidered, because he could not react if there was no act. The actual schism took place only after Leo's pontificate. The Pope's great advisor in political matters and in his negotiations with the superpowers of the time was Cardinal Bernardo Dovizi da Bibbiena.

Leo met daily with Raphael and Fra Giocondo to discuss the building of the basilica of the new St Peter's and other artistic matters. His hugely productive pontificate witnessed a growth in artistic patronage that was unprecedented in its sheer breadth and scope. Music, architecture, theatre and the visual arts all flourished in consequence of his generosity. Raphael, Michelangelo and Bramante are all associated with his reign in Rome. His legacy still glitters on the walls of our museums today.

During the coronation of Leo X a contemporary expressed the hope that, with the new Pope, the goddess Athena would accede to the papal throne, after the reign of Venus under Alexander VI and that of Mars under Julius II.[15] The fame of the young Florentine cardinal as a great patron of the arts resounded throughout Europe, as befitted a member of the Medici family. The Maecenas on the papal throne did not disappoint at least this expectation. Among the numerous artists who flocked to the Eternal City in search of papal patronage were many musicians – singers in particular. The new Pope's predilection for music, especially sacred music, was proverbial. Among his predecessors and his successors in early modern times his musical competence was unparalleled. Leo had a good theoretical knowledge of music and was an active musician, an accomplished singer and even a composer. From the late Middle Ages until the present day, he was the only trained musician and the only major patron of music to occupy the chair of St Peter.

Leo X received his musical training in his youth in Florence as part of a comprehensive humanistic education in the house of his father, Lorenzo the Magnificent. He was educated by professional humanists of the calibre of Angelo Poliziano, Pico della Mirandola, Marsilio Ficino and Demetrio Calcondila. The musical training of young Giovanni was entrusted to the leading Flemish composer Heinrich Isaac between 1485 and 1489.

After the expulsion of the Medici from Florence, between 1494 and 1500, with his cousin Giulio, Giovanni travelled throughout Germany, the Netherlands and

France. This certainly widened his musical horizons, but his most decisive musical experiences were probably gained as a young cardinal in Rome, which he visited repeatedly between 1492 and 1494. From 1500 he lived permanently in the Eternal City, where his residence, later known as Palazzo Madama, became a rich and vibrant centre of cultural activities.

As an eminent figure at the Roman Curia, he was obliged to attend the solemn divine services, mostly masses and some vespers, presided over by the Pope, the so-called *capellae papales*. They were celebrated mainly in the Sistine Chapel, on about 50 occasions during the Church year. At the *capella papalis* he heard one of the outstanding choirs of his time, the singers of the College of the Papal Chapel, performing polyphonic liturgical music. During this period Josquin des Préz, the famous composer, was a papal singer and composed music for the Papal Chapel. With such a background, it is perhaps unsurprising that Leo X transformed musical life at the papal court. The establishment of musicians, singers and instrumentalists maintained for his private entertainment was of unprecedented scale. These were his famous *musici segreti*, paid from his privy purse, and with whom he regularly made music, as he had done as a cardinal.

But Leo's main interest was focused on the music known today as Franco-Flemish vocal polyphony, which found its most sublime expression in cyclic polyphonic compositions of the Ordinary of the Mass and other liturgical chants. This type of music was regularly performed during the *capellae papales* by the singers of the College of the Papal Chapel, then one of the most distinguished musical institutions in Europe. Its purpose was first and foremost liturgical: the correct performance of religious services at the papal court. While music – plainchant and polyphony – was an essential element of the service, its extensive requirements involved not only singing chaplains, but also numerous officials charged with the other liturgical or ceremonial aspects of the service, or its administration: the chapel master, sacristan, chaplains, masters of ceremonies and clerics. This group was considerably reinforced during the first decades of the sixteenth century.

Leo X took a serious and persistent personal interest in the College of the Papal Chapel, especially musical issues. Numerous witnesses report how he was moved to tears when listening to his singers performing during a *capella papalis*. Half a year after his coronation he made a signal reform, designating Elzéar Genet (also known as Carpentras), a former papal singer and composer from the south of France, as the new chapel master, a position normally occupied by a bishop with merely administrative responsibilities. The first official appointment of a musician as chapel master, this proved a unique episode in the history of the Papal Chapel. The repertory of polyphonic liturgical music was also considerably enriched and became predominantly French in character. As the leading musical nation at that time, France supplied most of the singers active in and around the Curia. The Pope's personal influence on their practice, and the renewal of the polyphonic repertory performed during the *capellae papales*, is both manifest and documented.

The *capellae papales* represented the main theatre for the display not only of the spectacular tapestries designed by Raphael, but above all of 'papal majesty' (*maiestas papalis*), a term that first appears in the writings of the papal masters of ceremonies during the pontificate of Leo X. This was not accidental, because under the coordination of the masters of ceremonies the display of majesty became the main instrument of self-representation for the first Medici Pope. Polyphonic music was confirmed as a fundamental ingredient of papal self-representation, and acquired

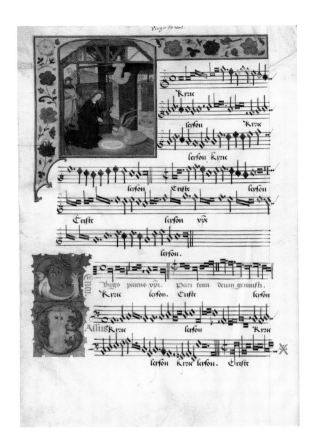

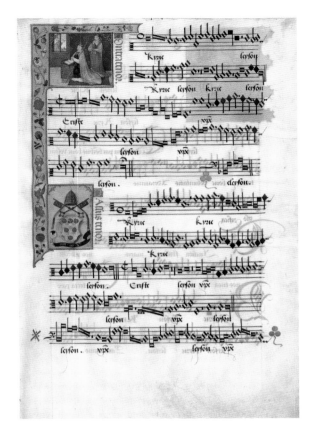

additional importance as the acoustical dimension and expression of majesty. Both polyphony and tapestry were regarded as luxuries whose use was curtailed during Holy Week, while the beneficial acoustic qualities of tapestry were well known at Leo's court.[16]

The pontificate of Leo X represents a remarkable moment in the history of European music. As a result of his expert musical patronage, the College of the Papal Chapel became the leading musical centre in Italy and, probably, the principal court chapel in Europe. During the reign of Leo X not only the arts and sciences, but also fine polyphonic music entered

a Golden Age at the Roman Curia, a unique and splendid moment in the history of the College of the Papal Chapel, which would never recur.

The presence of such a distinguished musical connoisseur on the throne of St Peter attracted particular musical gifts. The Archduchess Margaret of Austria (1480–1530), Governor of the Habsburg Netherlands, gave Leo a set of three manuscript choir books containing polyphonic liturgical music, probably to celebrate his elevation to the papacy. These were produced at Malines in the workshop of Petrus Alamire (c.1470–1536), a Dutch music copyist and

The commission and the Cartoons

MARK EVANS

calligrapher of German origin with close relations to Margaret's court, which had its main residence in that city. They are lavishly decorated by Flemish miniaturists and copied by skilled calligraphers on parchment, which was preferred to paper for prestigious gifts of state. The first two volumes seem to exalt the donor's musical taste, since they comprise liturgical works by her principal court composer, Pierre de la Rue. The third manuscript (no.160, Fondo Capella Sistina, Bibliotheca Apostolica Vaticana, fig. 5) pays ostentatious homage to the personal musical taste of its papal recipient, including a polyphonic composition by his old teacher Heinrich Isaac and an anonymous polyphonic cycle of the Ordinary of the Mass composed for the feast of St John the Baptist, the patron saint of Giovanni de' Medici and of his home town of Florence. No less than the tapestries of the *Acts of the Apostles*, designed by Raphael but woven by Pieter van Aelst in Brussels, such choir books were a potent embodiment of papal majesty.

Four decades after the Pope's death the theologian and historian Wilhelm Eisengrein noted laconically in his *Chronicle of Speyer* (1564): 'Leo X loved musicians most of all'.

The *Acts of the Apostles* tapestries were Leo X's principal contribution to the enrichment of the Sistine Chapel, together with the provision of a silver-gilt pulpit, candlesticks, vestments and choir books. At the same time the Pope reorganized and considerably enhanced its establishment of performers and composers. This liberality moved the Venetian ambassador to remark in 1517: 'the pope is an excellent musician, and when he sings with someone, he gives him 100 ducats and more'.[17] This sum provides some context to the payment of 1,000 ducats, which the Venetian diarist Marcantonio Michiel later stated that Raphael was paid for designing the Cartoons. The commission was made sometime before 15 June 1515, the date of the earliest surviving record of payment to the artist of 300 ducats; another, of 134 ducats made on 20 December 1516, probably closed the account.[18]

As an engraving by Agostino Veneziano after *The Conversion of the Proconsul* (fig. 7) is dated 1516, Raphael seems to have speedily made his preparatory designs available to engravers. The full-scale Cartoons had probably arrived at the Brussels workshop of the weaver Pieter van Aelst by mid-1516, as the tapestry of *Christ's Charge to Peter* (cat. 2, tapestry) was complete by 30–31 July 1517, when it was admired by Cardinal Luigi d'Aragona and his secretary Antonio de Beatis, who claimed that the tapestries cost 2,000 ducats each and that 16 were being made.[19] On 26 December 1519 seven of them were displayed at the Sistine Chapel, prompting Michiel's comment on Raphael's fee and his estimate of the cost of weaving at 1,500 ducats

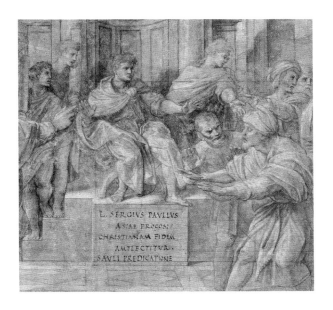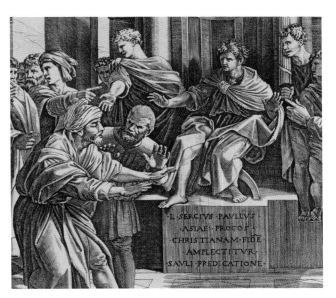

FIG. 6 (far left)
Raphael, *The Conversion of the Proconsul* (detail of cat. 7.1)

FIG. 7 (left)
Agostino Veneziano after Raphael, *The Conversion of the Proconsul* (detail of cat. 7.2)

apiece. All 10 had arrived by the time of Leo's death on 1 December 1521. By then the Cartoon of *The Conversion of Saul* was already in the collection of Cardinal Domenico Grimani at Venice, but the seven that still survive seem to have remained in Brussels until 1573 or later.

Given that such full-size cartoons are preparatory designs rather than independent works of art, and are more fragile than oil paintings, few remain from the Renaissance. The rare survival of the *Acts of the Apostles* Cartoons reflects their utility as tapestry designs, their high quality and finish and the international fame of their designer. Grimani's early acquisition of *The Conversion of Saul* suggests that it was valued by this discriminating collector as an independent work. The cartoon also survives for the lower part of Raphael's fresco of *The School of Athens*, made around 1508 for the *Stanza della Segnatura* in the Vatican.[20] This measures 275 × 795 cm and its support is a mosaic

of 195 'half-sheets' of paper, each measuring around 40 × 28 cm. These were obtained by cutting in half a quantity of standard-sized sheets, known as *foglio reale bolognese*, and pasting them together with substantial overlaps, a procedure that would have given this exceptionally large paper support additional strength. A similar method was followed in making the supports for the *Acts of the Apostles* Cartoons, which comprise around 170–200 sheets each and measure between 319 × 399 cm and 347 × 532 cm. *The School of Athens* cartoon is a monochrome work, drawn in black chalk and charcoal: there was no need to colour it laboriously, because Raphael participated directly in the fresco made from it. However, it was essential to faithfully represent the colour scheme of the *Acts of the Apostles* for the guidance of the Flemish weavers, working far from their designer in Rome.

The surviving preparatory studies for the Cartoons demonstrate how Raphael explored alternative

compositions, as in the double-sided sheet of *The Miraculous Draught of Fishes* in Vienna (Albertina, inv. SR 226r), and made careful drawings of posed models, like the red chalk for *Christ's Charge to Peter* (cat. 2.1) and the silverpoint for *The Sacrifice at Lystra* (cat. 8.1), both in Paris (Louvre, inv. 3854 and inv. RF 38813). He and his assistants would then draw up highly finished *modelli* of the final compositions, such as that for *The Conversion of the Proconsul* (fig. 6, previous page) at Windsor (Royal Collection, RL 12750), which could be approved before the design was transferred to the full-scale Cartoon, or even lent to print-makers for reproduction as engravings.

In view of the considerable size of the Cartoons, it is unlikely that work was carried out simultaneously on more than one or two of them. Their supports would have been fixed to a wall, where Raphael and his assistants could work with the aid of ladders or scaffolding, much as Benjamin Haydon and his assistants did when copying them 300 years later (fig. 55, p.61). There is no sign of squaring up, to transfer the preparatory designs, but there is some charcoal underdrawing, reinforced with black paint applied with a brush, and on the whole the drawing is fluent and spontaneous. Raphael utilized a modest range of colours: lead white, azurite blue, malachite green, vermilion and red lead, lead tin yellow, yellow, red and brown earth colours and carbon black. He also used some red lake pigments made from vegetable or insect dyes, which

have faded. The colours were used pure, or with a variable quantity of lead white, and mixed with animal glue and water to make a distemper or gouache, which was applied quite thickly. Much of the painting comprises a single layer applied directly to the paper, with modelling supplied by dark underdrawing and hatching on top.

It was probably when the finished Cartoons reached Pieter van Aelst's tapestry workshop in Brussels that they were pricked for transfer, doubtless to make a duplicate set of cartoons. This entailed pricking along the contours with a needle, to leave an outline on a secondary support, which was then filled in. The Cartoons were then cut vertically into sections about a metre wide for use by the weavers. They were still in pieces at the time of their acquisition for the Mortlake tapestry works in 1623. It may have been then that the edges of the sections were strengthened by the application to their reverses of strips of fine canvas. Further duplicate cartoons were made at Mortlake for the later weavings. In the late 1690s the Cartoons were reassembled and glued to canvas backings for display at Hampton Court, and latterly other royal palaces, where they remained until their arrival at South Kensington in 1865. Campaigns of conservation carried out in 1964–5 and 1992 demonstrate that, considering their age, their fragility and the centuries of robust use, these masterpieces remain in a surprisingly good state of preservation.

The Sistine Chapel

ARNOLD NESSELRATH

As in 2010, when Raphael's tapestries accompanied the visit of Pope Benedict XVI to the United Kingdom, the display of these masterpieces at the Sistine Chapel has for centuries announced great pontifical events. They were created to embellish major liturgical services celebrated by Christ's vicar on earth, marking the great feast days of the Catholic Church. Through them Pope Leo X (1513–21) added to the decorations of the spiritual core of the Vatican Palace commissioned previously by his predecessors Sixtus IV and Julius II.[21]

The Sistine Chapel was, and still is, the *cappella magna*, the Great Palace Chapel of the papal residence at the Vatican (fig. 8). Here took place the major liturgical ceremonies that were not celebrated in St Peter's basilica, and here cardinals and popes lay in state before burial. The Chapel is located among the halls for the great general receptions or consistories of the popes, where they met rulers and ambassadors as well as cardinals. In the Sala Regia, which leads directly to the main entrance to the Chapel, were held the Royal Consistories, and to this day the Pope still receives the diplomatic corps there. Public Consistories took place in the Sala Ducale, which in the sixteenth century was still divided into an *Aula secunda* and an *Aula tertia*, or second and third halls. Since the Middle Ages the *cappella parva*, the Small Palace Chapel, has been located directly opposite the Great Palace Chapel. As the latter was never intended to house a tabernacle, the former served as the chapel of the Holy Sacrament, with all the related liturgical functions. Moreover, during papal Conclaves, votes were cast in the Small

Chapel and the newly elected Pope was venerated there for the first time. On these occasions, temporary cells for the cardinals were installed in the Great Chapel, so that it could serve as a dormitory for them and their entourage. In 1537 the Small Chapel was demolished and replaced by the present so-called Cappella Paolina at the far end of the Sala Regia, and only since 1670 has the voting actually taken place in the Sistine Chapel, to accommodate the increased number of cardinals who were by then participating in the Conclaves.

Measuring 40.93 m in length and 13.41 m in width, the Sistine Chapel occupies the same ground plan as its medieval predecessor, which was not vaulted, but had a wooden ceiling. That chapel may have been built as early as the time of Pope Innocent III (1198–1216), who sought temporary refuge at the Vatican when the official papal residence at the Lateran proved insecure during a period of political unrest in Rome. After the definitive return of the papacy from its long exile in Avignon, the popes moved to the Vatican Palace next to the tomb of the Apostle Peter, which they began to reorganize as a new permanent residence at the beginning of the fifteenth century. Soon after the Jubilee of 1475, Sixtus IV (1471–84) began the work of consolidating the Great Palace Chapel. Due to its geologically unstable site, major works were required to secure the walls of the previous building, which are still contained within the present structure. The main changes brought about by Sixtus' architects were to increase the height of the walls from the windows upwards and the introduction of a vault, so that the interior reaches

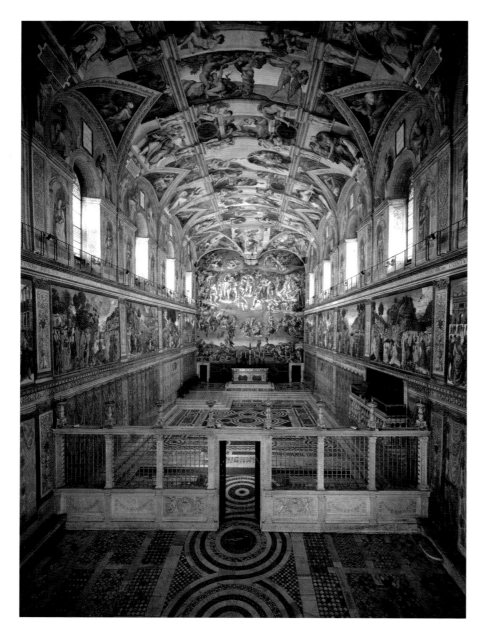

a total height of 20.7 m, permitting a much taller and more imposing space than was previously possible.

While insufficient evidence is available to identify the architect of the new building or the sculptors of its subtly carved marble fittings – including the screen dividing the presbytery from the area for the laity, the pulpit for the singers intersecting with the screen, and the impressive monolithic coat of arms over the entrance – precise documentation exists for the frescoes. On 27 October 1481 the Florentine painters Botticelli, Domenico Ghirlandaio, Perugino and Cosimo Rosselli (fig. 9) signed a contract with the papal superintendent Giovannino de'Dolci for the first 10 murals. In less than seven months, by April 1482, the four painters and their collaborators (including Biagio di Antonio, Luca Signorelli and Bartolomeo della Gatta) had finished all 16 frescoes on the four walls, while Pier Matteo d'Amelia had painted the huge vault a sky-blue field spangled with gilded stars. The altarpiece, also executed in fresco by Perugino, depicted the *Assumption of the Virgin Mary*, to whom the Chapel is dedicated. The choice of artists from the great artistic centre of Florence – a city only recently at war with the papal state – signalled the recent peace agreement that had ended a period of political turmoil and warfare among Italian princes, including the Pope.

The fifteenth-century decorations of the Sistine Chapel comprise several cycles, all of which start on the altar wall and run around the lateral walls to conclude on the entrance wall. The main programme combines the themes of Salvation and Resurrection. In the tradition of such iconography, two cycles – *The Life of Moses* (fig. 10), starting to the left of the west wall above the altar, and *The Life of Christ* (see fig. 9) starting to its right – confronted biblical scenes from the Old and the New Testaments; from the time of the Law (*sub lege*) and the time of Grace (*sub gratia*). The final frescoes of both cycles collapsed in a tragic

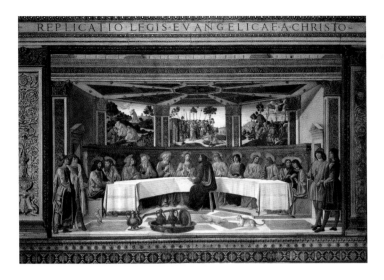

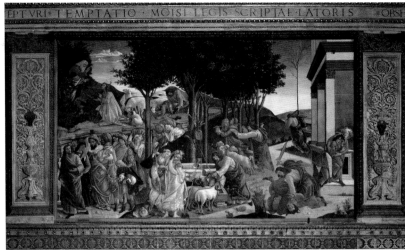

FIG. 8 (opposite)
The Sistine Chapel looking towards the altar and *The Last Judgement*

FIG. 9 (above left)
Cosimo Rosselli, *The Last Supper*, 1481–2, fresco; Vatican City, The Sistine Chapel

FIG. 10 (above right)
Sandro Botticelli, *Scenes from the life of Moses*, 1481–2, fresco; Vatican City, The Sistine Chapel

structural failure at the Christmas mass in 1522 and were only replaced around 1560. However, their subjects – *The Archangel Michael defending the Body of Moses*, paired with the corresponding scene of *The Resurrection of Christ* – were crucial to the overall decorative scheme, as they amplify and affirm the subject matter of the *Assumption of the Virgin Mary* over the main altar. Above the cycles of *The Life of Moses* and *The Life of Christ*, in the upper register punctuated by the clerestory windows, appears a gallery of full-length images of Christ and the first 31 popes representing the early Christian Church. The appearance within the *Christ* cycle of portraits of its painters, and of other contemporaries of Sixtus IV, brought the history of Salvation up to the present day.

The interior divides into registers, composed of a system of pilasters and entablatures into which the frescoes were inserted, ending at the top with the series of painted niches occupied by figures of popes, and at the bottom with a row of fictive tapestries. These architectural divisions provided a module that determined each later addition. While Michelangelo seemingly erected his painted architecture upon the fifteenth-century elevations of the walls, Raphael was obliged to fit his real tapestries between the painted pilasters of the bottom register.

After the Great Palace Chapel acquired an entirely new guise, its structural problems by no means lessened. Sixtus' nephew, Pope Julius II (1503–13), was obliged to close it from May to October 1504 for further major consolidation work. Most likely during this period, and due to the growing number of cardinals, the presbytery was enlarged and the screen that originally stood in the middle of the room was moved to its present position. The date for this alteration – of crucial significance for the reconstruction of the hanging order of Raphael's tapestries – was formerly unknown. However, the sweeping board under the bench that runs around the Chapel, at first sight a minor detail that was discovered during the restoration in 1999, provides conclusive evidence of this. It is decorated with acorns and oak leafs, the heraldic devices of the della Rovere family, and continues uninterrupted precisely at the point where the screen

originally stood and formerly covered the area against the bench. Thus this frieze cannot date from the pontificate of Sixtus IV, the first della Rovere Pope, but must have been made during the reign of Julius II (fig. 11). The painted ornaments also continue the sculptural motifs on the outer side of the screen in the left corner so correctly as to suggest that this is not an accidental juncture, but a planned extension of a single programme of decoration. The written sources seem to confirm this dating for the moving of the screen, because during the Conclave of 1522, when Hadrian VI (1522–3) was elected, twice as many cardinals had their cells inside the screen as outside. This corresponds with the description given by the German lawyer

Johannes Fichard (1512–81), who visited Rome in 1536 and described the marble screen as being located one-third of the way down the Chapel. Since in its new location the screen no longer intersected with the singers' pulpit, the *cantoria*, it had to be enlarged. The style of the additional capital and candelabrum may be based upon a design by Michelangelo. This new evidence indicates that Raphael had to take into account the current setting and the present position of the screen when he designed his tapestry Cartoons.

The enormous cracks in the vault caused by settlement seem to have damaged Pier Matteo d'Amelia's painted sky to such an extent that Julius II decided to have the vault repainted after the additional structural consolidation of the building. He followed his uncle Sixtus IV by not simply refreshing the old décor, but extending the figurative decoration upwards to cover the ceiling itself, thus transforming the spatial sense of the interior. When Michelangelo began to organize and articulate this enormous surface through his fictive architecture, the position of the screen may well have influenced his decision to divide its pictorial space into three groups of three main scenes: three show *God Creating the World* (fig. 12), three the *Creation of Man* and three the *Story of Noah* and the establishment of the Old Covenant. These scenes are surrounded by alternating biblical prophets and mythological sibyls, and by the ancestors of Christ on the spandrels and the lunettes. Our knowledge of Michelangelo's Sistine Ceiling is strongly conditioned by the painter's own testimony. His claim that Julius had wanted him to paint the entire Chapel and replace the Quattrocento (fifteenth-century) frescoes is provably untrue. And his claim that it was he who convinced the Pope to accept scenes from Genesis instead of the 12 Apostles seems to reflect discussion among the papal advisors about possible iconographic programmes for the new ceiling, rather than his own

FIG. 11
The Sistine Chapel *cantoria*

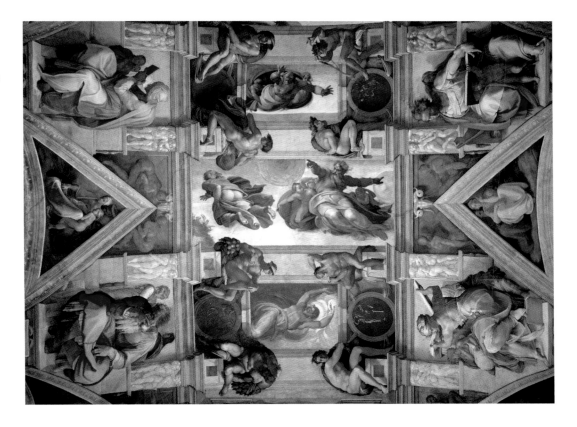

FIG. 12
Michelangelo, *God Creating the World*, *c*.1508; Vatican City, The Sistine Chapel

choice. In fact, the two themes that could most aptly be added to the decorative programme of the Sistine cycles to extend its overarching illustration of the history of Salvation were the Creation of the World and the Acts of the Apostles. After Michelangelo had realized the first on the vaults of the Chapel, it is perhaps unsurprising that the other was chosen next, by Pope Leo X, as the theme for Raphael's tapestries.

With his commission of the tapestries, Leo X transferred papal patronage from the physical fabric of the Sistine Chapel to the more ephemeral decoration of this sacred space at the spiritual core of the Apostolic Palace. The damage caused by the partial collapse of the entrance wall at Christmas 1522, when frescoes by Ghirlandaio and Signorelli were lost, fostered new ideas for adding to the existing decoration of the Chapel in ways that would expand its general theme. This was achieved most spectacularly in 1532 by Pope Clement VII (1523–34), when he commissioned from Michelangelo the ultimate vision of human destiny, the fresco of *The Resurrection of the Flesh*, in a prominent location over the altar, thereby transforming the Chapel of Sixtus IV. When the artist was commanded in 1541 by Pope Paul III (1534–49) to move on to the decoration of the Small Palace Chapel, known as the Pauline Chapel, and was prevented from repainting the entrance wall of the Sistine Chapel, its painted programme was destined to remain for ever incomplete.

The Sistine Chapel tapestries and their setting

ANNA MARIA DE STROBEL AND
ARNOLD NESSELRATH

Thirty years after the creation of Raphael's tapestries, Vasari's lavish praise of them[22] hints at the emotion these beautiful works would have aroused in those fortunate enough to see them on the walls of the Sistine Chapel during the papal mass of 26 December 1519.[23] Leo X sought to associate his name with the Sistine Chapel through the commission, continuing the ambitious programme of redecoration begun by Sixtus IV (1471–84) and Julius II (1503–13) – but Leo's opportunity to make his mark on the Chapel was restricted to the lower register of the walls, previously painted with fictive hangings under Sixtus IV. He needed a decorative scheme that would exalt its patron through its magnificence, while accommodating ceremonial requirements. This probably directed his attention towards the prestigious genre of tapestry.

Leo wanted to create a work that was authoritative enough to compete with the fifteenth-century frescoes on the upper register of the walls and with Michelangelo's painted ceiling, completed under his predecessors. His choice of artist to contribute to the decoration of the Chapel was unsurprising. The pope opted for one of the most acclaimed artists of the age, already present at the papal court and his own favourite painter: Raphael. A master of such renown required a workshop able to transform his Cartoons into tapestries, without modifying their meaning and charm. Pieter I van Edinghen, known as van Aelst, was one of the best-known entrepreneurs in the tapestry industry and the head of a leading tapestry workshop. Born around 1450 in Waterloo, near Aalst (eastern Flanders), he was one of the key figures who had

made Brussels the most renowned centre for tapestry production in Flanders. Appreciated as early as 1497 at the court of Philip the Handsome (1478–1506), ruler of the Netherlands, Van Aelst accompanied him to Spain in 1502, following his marriage to Joanna of Castile (1479–1555), and received the title of *valet de chambre et tapissier du roy* (a salaried member of the royal household). In 1511 he became court *tapissier* to Philip's successor, Margaret of Austria (1480–1530), the aunt of the future Charles V. As Van Aelst had worked in partnership with Florentine merchants and may have supplied tapestries in 1502 for the wedding of Lucrezia Borgia, daughter of Pope Alexander VI,[24] Leo's decision to entrust Raphael's Cartoons to his workshop seems to have been an informed one.

The only exact record we have of the arrival of the Cartoons in Brussels and the weaving of the tapestries can be found in Antonio de Beatis' account of the travels of Cardinal Luigi d'Aragona in Flanders. The entry for 30 July 1517 reads:

> Here (Brussels) Pope Leo is having made XVI pieces of tapestry, it is said for the Chapel of Sixtus which is in the Apostolic Palace in Rome, for the most part of silk and gold; the price is two thousand gold ducats a piece. We were on the spot to see them in progress, and one piece of the story of the *Donation of the Keys*, which is very fine, we saw complete; and from it the cardinal estimated that they would be among the richest in Christendom.[25]

The number 16, cited by Beatis, has generated much discussion on the intended size of the set. Only

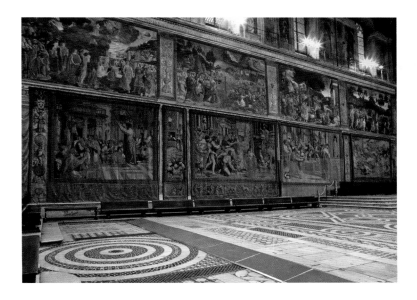
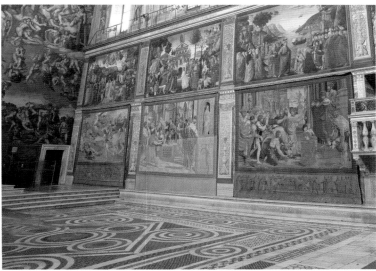

FIG. 13
The Sistine Chapel showing
the reconstructed display of
the tapestries in 1983 (above
left) contrasted with that of
2010 (above right)

10 tapestries based on Raphael's Cartoons arrived in
Rome between late 1519 and 1521. Seven had arrived
by 26 December 1519, when Marcantonio Michiel saw
them on display in the Sistine Chapel and described
their subjects. *The Death of Ananias*, *Paul in Prison* and
Paul Preaching at Athens were not present at that time.

The question of the intended location of the tapes-
tries within the Sistine Chapel is closely linked to
the size of the set. The most popular theory to date
supports the idea that just 10 tapestries were designed
and created on the basis of Raphael's Cartoons,
suggesting that the larger number, cited by Beatis,
includes the borders, which were woven separately.[26]
Another hypothesis is that the commission included
a second group of six 'cloths' depicting different
subjects, which were not designed by Raphael.[27] An
alternative proposal is that Raphael was commissioned
to design 16 tapestries, to cover the whole lower
register of the Chapel, but that the work was not

completed.[28] While it may be objected that there are no
drawings or cartoons by Raphael that demonstrate plans
to extend the set beyond the 10 known works, prepara-
tory designs are also lacking for three of the tapestries
and for all the borders and friezes that were woven.

On the assumption that only 10 tapestries were
commissioned from Raphael, an attempt was made to
reconstruct their arrangement at the Sistine Chapel in
1983 (fig. 13). The results were not entirely convincing.
The location of *The Stoning of Stephen* on the altar wall
of the Chapel, followed by the *Pauline Cycle* on the
south wall, left *Paul Preaching at Athens* in a location
on the other side of the marble *transenna*, in the area
reserved for the laity. The isolation of a single tapestry
was unconvincing in aesthetic terms, as it created an
unusual and unpleasing asymmetry. Moreover, the
positioning of all the other tapestries within the area
reserved for the clergy meant that the tallest ones,
which significantly exceeded the height of the fictive

painted hangings (lower in this area) by about 40 cm, had to be hung in such a way that their bottom edges rested on the stone seat. This anomaly cannot be accounted for by attributing it to the relaxing of the weave's tightness, because the difference is too great and because it only applies to some tapestries, while others, such as *The Conversion of Saul*, are smaller in size and fit perfectly into the spaces. This demonstrates that the tapestries must have been designed with variable dimensions intended to match those of the panels of fictive drapery, which are higher in the area of the *transenna* near the entrance door and lower by the altar.

We only have two very brief accounts of payments made for the execution of the Cartoons (15 June 1515; 20 December 1516). They provide no information on the contractual stipulations, the number of works, methods of payment or the delivery of the Cartoons to Brussels. We therefore cannot exclude the possibility that the set was not finished. This theory may be supported by several considerations that could have interrupted the production of the Cartoons: the death of Raphael (1520) just a few months after the delivery of the first seven tapestries; the precarious state of the papal finances, which could have slowed down the completion of subsequent orders; and finally, on 1 December 1521, the death of Leo X, whose extensive debts were so great that some of the tapestries that had been delivered were pawned.

A number of proposals can be made on the basis of this possibility, and in the light of findings made during the most recent restoration of the Chapel. The repositioning of the marble *transenna*, which preceded the tapestries' arrival, leads us to reconsider the location of *Paul in Prison*, whose unusual dimensions suggest that it must have been designed for a precise location. The space between the singing gallery and the current position of the *transenna* provides a perfect match for the dimensions of the tapestry.

This correspondence offers a convincing reason for positioning the *Pauline Cycle* under the earlier frescoes of *The Life of Christ* on the north wall of the Chapel, and the *Petrine Cycle* beneath *The Life of Moses* on the south wall, overturning the generally accepted reconstruction, re-created in 1983. This revision, re-created in 2010 (fig. 13), situates the two Apostles, customarily taken to represent the Jewish and Gentile branches of the Church, in positions that are traditionally hallowed, with Peter associated with the Old Testament and Paul with the New. Such a location would also tie in with the liturgical prescriptions of the master of ceremonies, Paris de Grassis, written around 1515 (fig. 14, see also fig. 4, p.14).

The scenes in the tapestry borders must certainly have played a fundamental role in the placing of

FIG. 14
Anonymous copyist of Paris de Grassis, Diary of the Master of Ceremonies of Pope Leo X, 1550–1600; Vatican City, Ufficio delle Celebrazioni Liturgiche del Sommo Pontefice, INV. A.C.P.

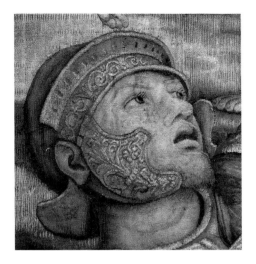

FIG. 15 (far left)
Cat. 6, *tapestry* (detail)

FIG. 16 (left)
Raphael, *The Battle of Ostia*,
c.1515, fresco; Vatican City,
Apostolic Palace

each tapestry in the Chapel. The *Petrine Cycle* depicts events from the life of Leo X and the *Pauline Cycle*, with one exception, scenes from the Acts of the Apostles. Although the identification of the events illustrated seems now to have been resolved, it does not provide sufficient information to establish the definitive locations of the individual tapestries. The decision to locate scenes from the Acts of the Apostles in the only register of the Chapel still lacking figurative decoration may have resulted from discussions amongst theologians in the papal court initiated by debate on the subject matter for Michelangelo's ceiling paintings.

The cycle of tapestries, as we see it today, provides few pointers for an exhaustive analysis of its references to, and relationship with, the other decorative cycles in the Sistine Chapel. We can observe that *The Miraculous Draught of Fishes* and *Christ's Charge to Peter* are respectively sequential to the frescoes of the *Calling of the Apostles* by Ghirlandaio and *The Donation of the Keys* by Perugino. However, some fundamental episodes from the life of the Princes of the Apostles are missing from the tapestries: Peter's deliverance from prison and the martyrdoms of both saints.

The period when Raphael painted the Cartoons was one of the busiest of his career as a painter, architect and student of the antique. The participation of his large workshop is correspondingly clear in the Sistine project, as in his other productions during these years. While the hand of the great artist is evident throughout the original preparatory drawings, contributions were clearly also made by his closest assistants. They include Giovanni da Udine, who worked assiduously alongside Raphael in all his pictorial work of this period. To him we can attribute the studies for animals and plants, and other details, such as the helmet worn by Saul in the *Conversion* (fig. 15), which is similar to one in the left foreground of the almost contemporary fresco of *The Battle of Ostia* in the *Stanze* (fig. 16). Raphael used selected models, including Dürer's woodcuts as well as his own works, so that his workshop could execute the cartoons in the most effective way. For example, the overall composition of *The Death of Ananias* (fig. 17)

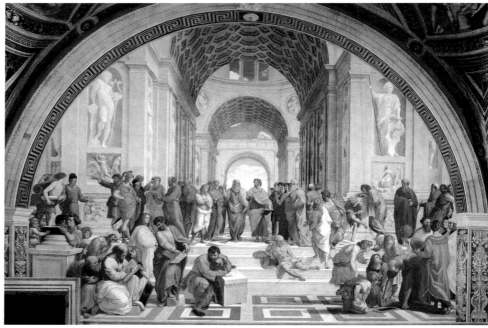

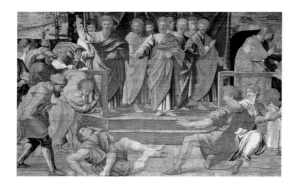

makes clear reference to his painting *The School of Athens* (fig. 18). Individual figures (fig. 19) also have close counterparts in the frescoes in the *Stanze* (fig. 20). References to the *Stanze* are also strong in *Paul in Prison*, where the light reflected on the bars (fig. 21) tangibly recalls the chromatic variations seen in the *Deliverance of St Peter* in the *Stanza di Eliodoro* (fig. 22). The various effects, from nocturnal lighting to reflections on the wall (fig. 23), which Raphael achieved in the fresco by means of glazing – and in the Cartoon through more traditional techniques – were interpreted with equal skill by the weavers, using a very different material.

On account of their beauty and rich materials, the *Acts of the Apostles* tapestries experienced numerous trials and tribulations over the ensuing years, which

influenced their state of preservation. This troubled history began on 17 December 1521 shortly after the death of Leo X. Seven of the tapestries, and other precious objects, were pawned to Giovanni Becher (or Belsser) for the sum of 5,000 ducats and were struck from the Inventory of the *Floreria* (the papal store-room).[29] The money was needed to pay for the Pope's funeral and the costs of the coming Conclave. The tapestries were redeemed by Hadrian VI (1522–3) and returned to the Sistine Chapel on 31 August 1522 on the occasion of his coronation. The imperial soldiers who occupied the Vatican Palace during the Sack of Rome in 1527 also singled out the precious tapestries, and other valuables. As a result, at least three were taken beyond the papal territories: *The Conversion of Saul*, *Paul Preaching at Athens* and *The Conversion of the Proconsul*. The whereabouts of the other seven are unclear until 1536, when they reappear in the first-known Inventory of the *Floreria* compiled after the Sack.[30] A letter of 13 December 1530 from Pietro Paolo Marsi in Rome mentions that a certain Giovan

Francesco da Mantova wanted to offer Clement VII (1523–34) some tapestries found in Lyons. However, it does not identify the tapestries in question, and the Pope sought clarification, mentioning that he was interested only in acquiring the tapestries by Raphael.[31] An appraisal by the embroiderers Angelo da Cremona and Ioanne Lengles de Calais of the tapestries of *The Life of Christ*, commissioned by Clement VII from the same workshop and completed in 1531, suggests that some of the *Acts of the Apostles* never left the papal collections. After viewing 'the aforementioned cloths and tapestries laid out for comparison in the Chapel of the Pope in the Palace in Rome on the last day of March 1531', it concluded that the new tapestries were richer than Pope Leo's stories of St Peter and St Paul.[32]

The other three tapestries experienced protracted adventures, eventually returning to the papal collections between 1544 and 1554. In 1528 Marcantonio Michiel saw *The Conversion of Saul* and *Paul Preaching at Athens* in Venice, in the home of Zuanantonio

Venier,[33] who had purchased them from Contarino Cacciadiavoli. Venier sold them to Cesare Fregoso for 2,500 scudos. Subsequently they were taken to France.[34] The Constable of France, Anne de Montmorency, had the two tapestries restored, and in 1554 returned them to Julius III (1550–55), as is recorded in the Inventory of the *Floreria* of 1555.[35] One-quarter of *The Conversion of the Proconsul*, perhaps already in Naples by 1532, was recovered in the Kingdom of Naples and given to Paul III (1534–49) in 1544. Sometime before 1592 this fragment was reunited with another quarter of the tapestry.

The tapestries experienced a similar fate during the French occupation of Rome in 1798. They were looted once again, this time with those of *The Life of Christ*, auctioned with furniture from the Vatican Palaces and purchased cheaply by a second-hand dealer. Traced in 1808, they and the other tapestries were bought back by the Papal Government for a total sum of 23,500 scudos. Following restoration at the papal tapestry workshop of San Michele in 1814, they were divided between the apartment of the Librarian Cardinal and the new rooms adjacent to the Gallery of Maps. In 1932 they were transferred to their current location in room VIII of the new Vatican Picture Gallery.

Re-creating the multiple shades of Raphael's colours in tapestry was no easy task for Pieter van Aelst and his workshop (see next chapter). They were faced with the challenge of replacing brushstrokes with passages of wefts through the warp, to bring complexions to life, add precision to the architecture and create lighting effects. Despite the toll of time, those of us with the good fortune to admire these beautiful tapestries almost five centuries after their creation can confirm that the challenge was triumphantly met.

Weaving the Sistine Chapel tapestries

ANNA MARIA DE STROBEL

The task of translating Raphael's Cartoons into tapestry must have been an arduous one, because the weavers had to relinquish their customary freedom to interpret and were confronted with designs in a very unfamiliar style. Raphael was also faced with the problem of designing for a very different art-form. There was no opportunity for direct communication between the artist and the weavers to resolve any technical difficulties that might arise. Alert to these obstacles, Raphael created images more suitable for translation into tapestry than his compositions for the *Stanze* of the papal apartments. The architecture in the Cartoons appears to have been simplified, and their compositions are often dominated by groups relating to individual figures, whose gestures are accentuated, highlighting movements and features to facilitate their reproduction in woven form.

Technical difficulties ranged from the challenge of dividing the Cartoons into appropriate strips, as required for working on a low-warp loom, to the need to increase the spacing at times and give greater depth to the colours. Raphael did not always take into account that to keep the work flow constant, with several artisans weaving side by side, cartoons had to be cut into strips with clearly defined working zones, such as whole heads or hands, details of the landscape or buildings, so that weavers specializing in different types of work (for instance, figures or landscapes) could work simultaneously without getting in one another's way, which would slow down the process.

We can be sure that the *Acts of the Apostles* were woven on low-warp looms because the Cartoons are mirror-images of the tapestries. The weaver worked on the back of the tapestry, with the warps horizontal in front of him and the strip of cartoon positioned beneath the warps. Secured by two rollers spaced a regular distance apart, the warps formed the core of the woven fabric and were subsequently entirely covered by the wefts, which were used to create the image. The weaving was carried out by passing weft threads back and forth, aided by treadles on the low-warp loom. The use of treadles speeded up work compared to the high-warp loom, as the hands were left free to pass the weft threads – wound around shuttles – through the warps. The weaver moved the warps slightly apart to check the cartoon. Having it close to hand facilitated precise and fast workmanship. The main features of the design were also marked on the warp in black chalk or ink.

The first seven tapestries in the series were made over the relatively short period of about three years. Therefore several looms must have been used and a considerable number of weavers involved, under the supervision of Pieter van Aelst. Some looms must have been almost 5 m wide, since a number of the tapestries are just under 5 m high.

Although their cartoons are missing, it is clear that the Greek-key pattern and the frieze were envisaged as an integral part of each piece. This is shown by *The Death of Ananias*, in which they are woven together with the central scene. The warp in Raphael's tapestries is made from wool, and the warp count, ranging from 6.8 to 7.6 per cm, was that commonly used during the Renaissance for the finest tapestries. It enabled a more

detailed and sophisticated design and colour than a lower count, providing greater opportunity for expression and ensuring that the tapestry was strong, compact and soft. In the *Acts of the Apostles* the quality of the material, the tension of the warp and the regularity of the weft compression display a thorough knowledge of the techniques involved, facilitating the preservation of the works, despite constant use over many years.

The weft was executed in wool, silk and gilt-metal-wrapped thread. Wool comprises the largest part of the tapestry due to its great strength, while silk is mainly used for areas of light, cold colours and to create an iridescent effect in the fabrics (fig. 24). Metal thread, produced by wrapping gilt-metal strip around a yellow silk core, adds brightness and highlights illuminated passages, accentuating drapery folds and embellishing

the hems and sleeves of robes with rich decorative elements (fig. 24). To further simulate the raised-embroidery effect, the weavers used *crapautage*, a technique that consisted of running the metal thread over and under several warps (generally two in these tapestries), sometimes using a thicker thread as well (fig. 24, top right).

In the *Acts of the Apostles* the metal thread is sometimes combined with wool or silk thread to accentuate the chromatic variation of certain areas, without producing the excessively luminous effects of gilt-metal used alone. The procedure is applied by combining two threads of the same or different fibres, in different colours, to increase the range of tonal shading compared to that obtained using the hatching technique only. The latter is an ancient technique used for chromatic transitions from one shade to another, and for chiaroscuro and relief effects. It involves the alternate juxtaposing of lines parallel (fig. 24) to the weft in two or more colours, or a sequence of contrasting blocks of colour. The choice of the length and thickness of the hatch is generally left to the weavers and their ability to interpret the cartoon. To achieve subtle shading and colour changes in skin tones, the weavers used finer threads than those utilized in adjacent areas, thereby accentuating the legibility of the figures' profiles (fig. 26).

As part of the Vatican Museums Tapestry and Textile Laboratory's ongoing project to conserve all of the *Acts of the Apostles* tapestries, which began in 1983 on the fifth centenary of Raphael's birth, detailed investigations have been carried out into the fibres, their deterioration, the manufacture of the metal thread and the dyes that were used.

It was discovered that the workshop of Pieter van Aelst used various types of metal thread without distinction during the weaving of the tapestries. Adjoining areas were found to contain different kinds

FIG. 24 (below left)
Cat. 5, *tapestry* (detail)

FIG. 25 (opposite,
top row left to right)
Cat. 5, *tapestry* (details)

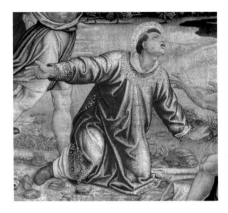
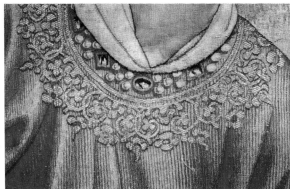

FIG. 26 (right)
Cat. 3, *tapestry* (details)

FIG. 27 (below left)
Tapestry detail showing the
deterioration of different
kinds of metal thread

FIG. 28 (below right)
Gilt-metal wrapped around
a silk core

of gilt-metal-wrapped threads (fig. 27), some of which
have survived almost intact, while others have
deteriorated. This is due to the composition of the
alloys, which contain variable percentages of copper
to silver, and due to the different thickness and 'hold'
of the pure gold-leaf gilding (fig. 28). The gold leaf
was sometimes applied only to the outer side, but in
other cases was applied to both sides. The gilt-metal-
wrapped thread was evidently purchased from more
than one supplier, using different procedures that were
not obviously apparent, and whose appearance aged at
different rates.

Yarn dyeing was a delicate and important operation, which made one workshop stand out from another, for each had its own secret methods for creating high-quality, fast colours. In the case of the Raphael tapestries, as in many other cycles, not all the dyes have withstood light exposure in the same way. Some have faded completely, as in the case of the purplish-reds, while others have become somewhat muted, particularly shades created by mixing several elements. The back of the tapestry, which faces the wall and is usually protected by a lining, is less subject to colour changes and, consequently, preserves the original colours better. It can therefore be misleading to rely solely on observation of the colours on the front.

Investigations into the ingredients of the dyes used in Raphael's tapestries has highlighted the constant use of orchil for the purplish-red shades (fig. 29). This dye was already known for its lack of colour-fastness in ancient times, and has faded over time to beige on the front of the tapestries, significantly altering the overall colour scheme (fig. 30). The reds, which have remained very bright, were made using madder, which was much appreciated for its resistance; the most-prized quality madder was produced in Flanders. The

FIG. 29
Cat. 8, *tapestry* (detail, below left) with reverse (below centre) and reverse in infrared light (below right)

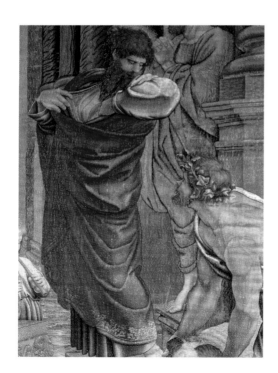

FIG. 30
Examples of the deterioration
of orchil

The popes and their tapestries: the history of the papal collection

ANNA MARIA DE STROBEL

From the fourteenth century, ruling families in Europe began to demonstrate the wealth and magnificence of their courts through the new and luxurious medium of tapestry, large-scale figurative textiles woven in wool and silk, and often highlighted with threads of precious metal.[36]

Tapestries met the practical need of being readily portable whatever their size, which could be immense. They could be moved from palace to palace and court to court as rulers travelled around their domains, changing the appearance of a room (even if it had frescoes), or hung on the outside of a building, conveying the prestige of the house or church by affirming its importance and wealth. Their narrative subjects ranged widely, from religious and mythological scenes to secular episodes of hunting and court life.

yellow was obtained from dyer's broom, which contains the dye genistein, while the greens were obtained from mignonette, which contains apigenin. The blue was derived from indigo, from Asia, which belongs to the class of dyes known as 'vat dyes', because of the receptacles in which the dyeing took place; it was sometimes combined with other dyes to obtain warmer shades (fig. 31).

FIG. 31
Examples of thread dyed with madder, dyers broom, apigenin and indigo

Understandably these precious and beautiful textiles, commissioned with some rivalry by the most important patrons, were very attractive to the popes. The inventories of the *Floreria* (who were responsible for the papal wardrobe and other furnishings) show that possession of them became increasingly important after the early 1400s. Most of these textiles are no longer in the papal collections. Their continuous use over the centuries inevitably led to deterioration in their condition, until they were given as gifts, often to the *Floriere* (the custodian of the *Floriera*), or disposed of, to be replaced by new ones more to the taste of the reigning pope.

The first-known documents testifying to the arrival of great tapestries in the papal collections go back to the time of Martin V (1417–31). Philip the Good (1396–1467), Duke of Burgundy, was one of the richest princes in Europe and ruled the highly important economic centres of Flanders and Brabant. He bought a series of six tapestries depicting the life of Mary, from Giovanni Arnolfini, a merchant from Lucca resident in the Low Countries, to send to Martin as a gift. The Pope's successor, Eugene IV (1431–47), also received a tapestry from Philip in 1441, depicting 'three moral stories of the pope, emperor and nobility'.

Nicholas V (1447–55) was the first Pope to buy tapestries directly, not only in Flanders, but also some of the earliest produced in Italy. He had contacts with well-known tapestry weavers, such as Jacquet d'Arras, who worked in Siena and from whom he ordered a series of the *Life of St Peter*, and the Parisian Regnault de Maincourt, who was also commissioned to work in Rome with a group of five other weavers. This seems to be the first attempt to set up a factory in Rome that could meet the needs of the papal court. These tapestry weavers worked on a large depiction of the *Creation of the World*, narrated in six parts, which must have been continued under Nicholas' successor, because inventories mention that the coats of arms of both Nicholas V and Callixtus III (1455–8) appeared on it. It was considered a hanging of great value, due to the quantity of the silver, gold and silk used in the weaving.

Two other fifteenth-century popes were also passionate about tapestry: Pius II (1458–64) and Paul II (1464–71). Pius II was particularly interested in the *cappella magna*, which Pope Sixtus IV della Rovere renamed the Sistine Chapel after its restoration. Twelve *bancali* (pews) were ordered, and he commissioned Jacquet d'Arras to produce some *spalliere* (decorations set into the panelling of a room) for the

Chapel. As a result of Paul II's love of tapestries, the papal collection was enlarged to some 132 pieces, with a value of almost 1,750 gold ducats. This probably included many textiles that he had commissioned.

In the first half of the sixteenth century the papal tapestry collections began to overtake in wealth and refinement those of other European princes, primarily thanks to the Medici popes Leo X and Clement VII. Leo's taste for tapestry is apparent from his commission from Raphael of the Cartoons for the *Acts of the Apostles*, which were woven in Pieter van Aelst's tapestry workshop, then one of the most highly regarded in Brussels. These cartoons transmitted knowledge of High Renaissance style to the capital of Brabant, Brussels, where weaving was a dominant industry. Vasari records that the resulting work was 'so miraculously accomplished that it evokes astonishment'.

The successful relationship between Raphael's workshop and Van Aelst continued through the years of Leo X's papacy (1513–21), with the execution of 12 tapestries in silk and gold, depicting *Children's Games (Giochi di putti)*, a set of bed hangings (canopy: *The Trinity with God the Father*, side panels: the *Nativity* and the *Visitation*) and a series of eight pieces of the 'Grotesques' (*The Birth and Triumph of Venus*, *The Might of Hercules*, *Fortune*, *Seven Muses*, *Seven Virtues*, *Triumph of Mars*, *Triumph of Bacchus*, *Liberal Arts*), all listed in the papal inventories until at least 1770.

Clement VII (1523–34) maintained the close relationship with Pieter van Aelst, and commissioned from him a set of 12 tapestries of *The Life of Christ* (fig. 34), known as the *Scuola Nuova (New School)* tapestries, woven between 1524 and 1531. Their cartoons were designed by Raphael's pupils, some of whom had contributed to the *Acts of the Apostles*. The series was conceived as two groups of six works, the first dedicated to the Childhood of Christ, and the second to events after the Crucifixion. The two cycles were

FIG. 32 (opposite)
Fiamminga manufactory,
Allegory of Religion, c.1527,
tapestry; Vatican Museums

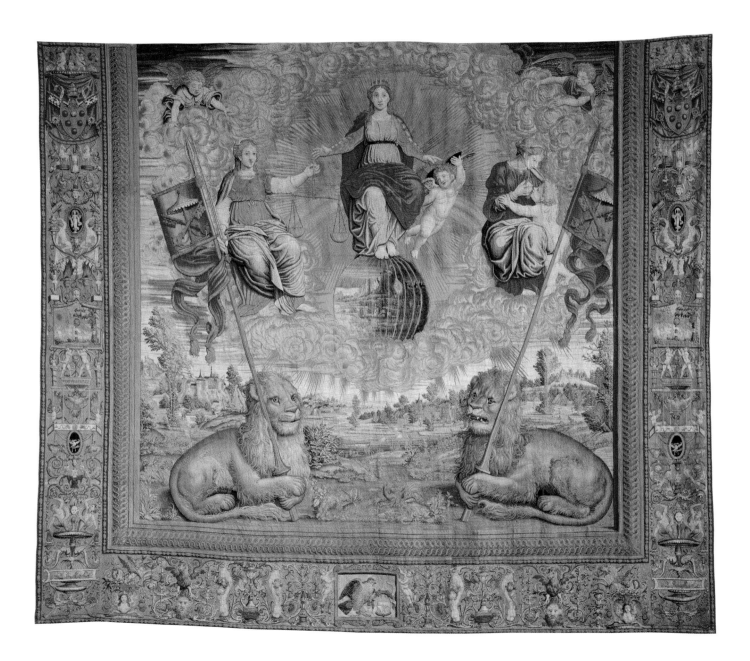

FIG. 33
Flemish workshop after
Leonardo da Vinci, *The Last
Supper*, before 1514, tapestry;
Vatican Museums

designed to be interchangeable; each tapestry in the first cycle is the same size as the corresponding one in the second. They were made for the Consistories and it is probable that they were displayed over Christmas (the *Childhood of Christ*) or Easter (the *Crucifixion*), as documented in the inventories from the mid-sixteenth century. The tapestries are now displayed in the Tapestry Gallery of the Vatican Museums.

The last major papal tapestry commission before the Sack of Rome in 1527 was the ornamental canopy for the papal throne commissioned by Clement VII. It depicts an *Allegory of Religion* (also known as *Faith, Justice and Charity*, fig. 32).

In addition to commissions, the papal collections were augmented in the first half of the sixteenth century by several major gifts. An especially important example, on display in the Vatican Museums, is *The Last Supper*, a full-size copy of the fresco of this subject by Leonardo da Vinci in the convent of Santa Maria delle Grazie in Milan (fig. 33). It was woven in Flanders, probably before 1514, for Francis I of France (1494–1547), who gave it to Clement VII in 1533 on the occasion of the marriage of Francis' son Henry to Clement's niece, Caterina de' Medici. As a gift for the Medici Pope, to celebrate a Franco-Florentine alliance, Francis selected a tapestry copying a celebrated work by a renowned Florentine artist who had ended his days in 1516–19 at Amboise in the service of the French monarch. To it was added a velvet border (now lost) with the donor's initials embroidered in gold and silver.

FIG. 34 (below left)
Workshop of Pieter van Aelst,
The Resurrection, 1524–31,
tapestry; Vatican Museums

FIG. 35 (below right)
Barberini manufactory,
The Nativity, c.1635, tapestry;
Vatican Museums

Numerous further acquisitions in the first half of the sixteenth century included the purchase by Julius III (1550–55) of a series of 10 Flemish tapestries with the *Story of Julius Caesar* (one of which is still in the Vatican Museums). Another tapestry, *The Crowning of the Virgin*, was given by Erard de la Marck, Prince-Bishop of Liège, to Paul III (1534–49), probably as a sign of recognition for being appointed *legate a latere* of the diocese of Liège in 1537. In the second half of the 1500s, however, the rate of acquisition decreased, and those already in the *Floreria* were reused when appropriate. Tapestries were still commissioned occasionally, such as a series of *Grotesques* for Gregory XIII (1572–85), but this was exceptional.

This trend was reversed in 1627, when Cardinal Francesco Barberini, nephew of Pope Urban VIII (1623–44), founded a tapestry workshop in Rome. This 'family' business became, therefore, the principal supplier for the Pope and his court – greatly reducing the number of orders and acquisitions from foreign merchants and workshops. In this way the popes' wishes were fulfilled as of the fifteenth century: a Roman tapestry to meet their needs.

In 1635 Urban VIII commanded his nephew to order a series of altarpieces for display during the most important events in the liturgical calendar. It began with the *Nativity* (fig. 35) and the six hangings of its canopy, to which the *Resurrection* and *Feed my*

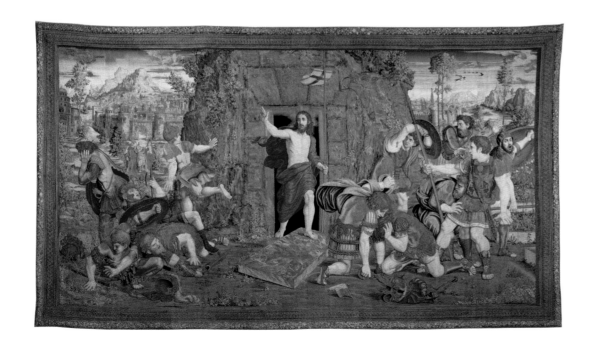

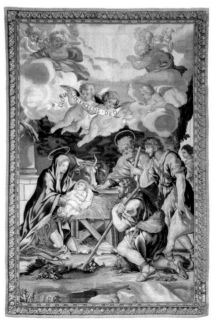

Sheep were added between 1642 and 1643. The series was completed in 1658, after the death of the Pope, with the *Annunciation* tapestry, which Cardinal Francesco gave to Alessandro VII Chigi (1655–67). The drawings and some cartoons for this were made by one of the greatest painters of the time, Pietro da Cortona (1596–1669), who worked for the Barberini family. He designed some of its finest tapestries, and set an example to painters from his circle, who designed other cartoons for the factory. Just as had happened in the time of Raphael, over a century before, a celebrated artist and his pupils set a new standard for the papal tapestry commissions.

The Barberini manufactory continued to be active for most of the seventeenth century, producing many valuable works, including another cycle requested by the Pope: *Giochi di putti* (1637–42), revised in a baroque style with the specific aim of celebrating the family name, which Leo X had commissioned to be woven by Pieter van Aelst around 1520 and which is now, sadly, lost.

The 10 large scenes of the last and one of the most important works of the Barberini workshops, the *Life of Pope Urban VIII*, finally entered the Vatican Museums between 1937 and 1966. Ordered by Cardinal Barberini in honour of his uncle, who died in 1644, this cycle was made between 1663 and 1679. The manufactory closed after the death of the cardinal in 1679. It is recorded in a manuscript from the Secret Vatican Archive (Archivio Segreto Vaticano)[37] that the factory was closed when Cardinal Francesco died, 'selling the looms for firewood, and all there was to burn along with the other fine and smaller things from the Wardrobe; and the poor tapestry-weavers found themselves without ornate work and begging'. In closing, its author, Arcangelo Spagna, hoped that the city of Rome 'would replace such a noble investment'.

In 1710 Pope Clement XI (1700–21) established the San Michele tapestry manufactory, under the manage-

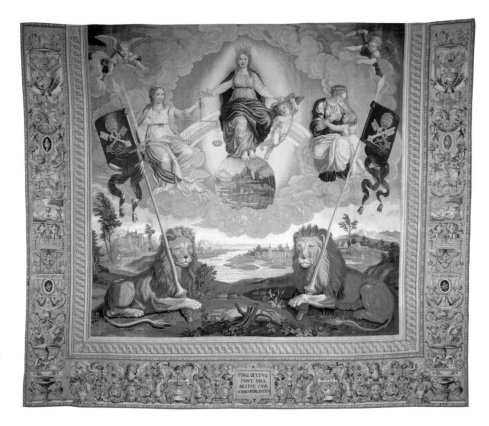

ment of a Parisian tapestry weaver, Jean Simonet, which would supply the court until 1870, when the capture of Rome transferred the city to the recently unified Italian state. Clement XIII (1758–69) and Pio VI (1775–99) ordered the San Michele workshop to enrich the altar in the Cappella Paolina of the Quirinale, the most popular papal palace from the seventeenth century until 1870 and now the official residence of the President of the Italian Republic.

Other important projects of the San Michele manu-factory included the copying and restoration of earlier

tapestries. That the sixteenth-century tapestries of the *Last Supper* and *Allegory of Religion* still survive to be admired in the Vatican Museums is due to the fact that from the 1780s they were seldom used – being replaced by copies made at San Michele (fig.36). In 1725 Benedict XIII (1724–30) decreed that the director of the San Michele factory should act as custodian of all tapestries belonging to the Sacred Apostolic Palaces. The most important restorations undertaken were the three tapestries from the *Acts of the Apostles*: *The Miraculous Draught of Fishes, The Stoning of Stephen* and *The Healing of the Lame Man.*

Raphael's tapestries still remain at the centre of the papal tapestry collection and, until they entered the Vatican Museums, were accorded priority. Just one example is the opening of the Porta Santa in the portico of St Peter's, as described in this account from 1749:

> the Papal Throne was erected to the right of the Porta Santa . . . decorated with silver brocade and gold lace, the remaining 'Portico' was richly adorned with crimson damask equally adorned with gold lace, combined with Raphael's tapestries, the greatest of which covered almost the whole of the 'Bronze Door' of the above mentioned Basilica.[38]

In the later nineteenth century it became clear that these precious works needed to be conserved, and the tradition of tapestry production maintained to meet the needs of the Vatican. Accordingly a papal tapestry works, first proposed in 1870, was eventually established in 1916. This later merged with the Restoration Laboratory, created in 1927, and was entrusted to nuns of the Franciscan Missionaries of Mary, who enlarged it to become the Tapestries and Textiles Restoration Laboratory of the Vatican Museums, in which mostly lay personnel work. The restoration of the *Acts of the Apostles* has been under way here for a number of years.

Alongside this conservation work on existing tapestries, additions to the papal collections were also made in the nineteenth and twentieth centuries, mostly in the form of gifts. These include two particularly significant donations: four tapestries, woven at Gobelins between 1753 and 1759 with the *New Testament*, were given by Napoleon to Pius VII (1800–23) in 1805, along with four others now in the Palazzo del Quirinale. Two other great tapestries made in the late fifteenth century, depicting the *Credo* and *Christ's Passion*, were given by Maria Christina Habsburg-Lorraine, Queen Regent of Spain, to Leo XIII (1878–1903) in 1893, on the occasion of his Episcopal Jubilee.

The influence of the Cartoons on sixteenth-century tapestry design

CLARE BROWNE

Raphael's designs for the *Acts of the Apostles* were to become the most frequently woven of all tapestry series, copied repeatedly over three centuries with varying degrees of accuracy, in Flemish, English and French manufactories; nearly 50 sets have been identified. Four of these sets, woven in the early decades following Leo's original commission, exemplify the appropriation of its message of papal authority and High Renaissance style by patrons with differing motivations for such a display of magnificence and propaganda.

During Pieter van Aelst's lifetime no other versions of Raphael's designs were produced, and the original Cartoons or working copies probably remained in his workshop. But in about 1533 the weaving of a set was undertaken for Francis I (1494–1547) of France in the Brussels workshops of Willem Dermoyen and Daniel and Antoon Bombergen.[39] Francis had great admiration for High Renaissance Italian art, and this commission enabled him to represent Raphael's work within his court further and more substantially, through the highly prestigious medium of tapestry. Three pieces had been completed before 1534, and the 1542 inventory of Francis' tapestries lists a set of nine (without *Paul in Prison*, whose narrow size had been so specific to its Sistine Chapel location). The new set replicated the old in all other respects except for its wide lower borders, where in place of episodes from the life of Leo X, Francis' tapestries were ornamented with allegorical scenes reflecting aspects of his kingship, including good government. The set of nine tapestries remained in the French royal collection, displayed on great state occasions including the coronation of Louis XIV in 1654 when they decorated the façade of Reims Cathedral.[40] They were among the pieces lost in 1797, when the royal collection was burned in order to reclaim the precious metals with which the tapestries were woven.

Henry VIII (1491–1547) also purchased a set of Raphael's *Acts*, with two pieces recorded in a list of the furnishings of Westminster Palace in April 1542, and a further seven obtained in June the same year, all probably through the same Antwerp-based Italian merchant, Gualteroti.[41] Among the most expensive of Henry's documented acquisitions, they were one of a number of extremely costly tapestry sets that he acquired towards the end of his reign, and in most cases the subjects seem to have been chosen to support his self-image. By hanging his palace walls with tapestries made to Raphael's designs originally commissioned by Pope Leo X, but now decorated with borders that were no longer overt in their reference to him, Henry was appropriating the papal iconography of the subject for his own purposes.[42]

Henry's set of *Acts* was recorded in the inventory taken after his death in 1547, and was hung in Westminster Abbey for Elizabeth I's coronation in 1558.[43] It remained in the royal collection until 1650, after the

execution of Charles I. The set went to Spain, where by 1662 it was in the collection of the Duke of Alba, and was eventually acquired by the Berlin Museum in 1844. The tapestries are assumed to have been destroyed there in 1945.

At some point after Henry's set was completed, cartoons for the *Acts* were in the possession of the Brussels merchant-weaver Jan van Tieghem, whose mark appears on two sets woven in the late 1540s or early 1550s. The mark FNVG also appears on them, possibly that of Frans Ghieteels, Van Tieghem's brother-in-law, together with another unidentified mark. One set is now in the Patrimonio Nacional in Madrid, with the earliest identified reference to it in the inventory taken after Philip II of Spain's death in 1598.[44] Philip (1527–98) was an active patron of Brussels tapestry-weaving workshops in the 1550s and 1560s, so the set might have been purchased by him, but it could also have been acquired by Charles V, before 1555. The other set, now in the Palazzo Ducale in Mantua, was woven for Cardinal Ercole Gonzaga (1505–63).[45] During the 1550s Ercole had hoped for election to the papacy, and the subject of the tapestries would appear to have symbolized his ecclesiastical aspirations. The set was first mentioned in a testament of 1557, in which the tapestries were destined for the cathedral in Mantua, a bequest later revised in favour of Santa Barbara, the church of the Palazzo Ducale.

Ercole's coat of arms appears in the upper corners of each piece of the Mantua set (fig. 37), but they are not integral to the design, having been woven separately and inserted later. The Madrid set has undecorated shields in the corresponding corners, but is otherwise identical to it. This suggests that Van Tieghem was able to produce sets of the *Acts* suitable for different patrons using the same cartoons, and indeed various similarities between the four extant sixteenth-century sets suggest that they could all have been woven using the same set of working cartoons.[46] These might have been made in 1516–17 and later adapted, and the pricking of Raphael's Cartoons before they were cut into strips could support this theory. It is also possible that they were first prepared for Francis' set. This might help to explain that when Cardinal Granvelle was told by his agent in Brussels in 1573 that the original Cartoons were too damaged to use for the weaving of a new set of *Acts* tapestries and that a set of copies had been substituted for such commissions (figs 38 and 39), this reference was to a first and second set of working cartoons, not to the originals by Raphael.[47]

The influence of Raphael's Cartoons at the most prestigious level of tapestry production went well beyond the popularity of woven copies, and their success is recognized to have fundamentally affected the subsequent development of tapestry design. Earlier in the sixteenth century the production of tapestries in Brussels had reached a level of technical excellence unequalled elsewhere, but the workshops were continuing to produce the types of design that had been successful over the preceding centuries, with multiple, crowded narratives, using surface pattern for effect. In their experience, this was the most successful visual exploitation of the strengths and weaknesses of the tapestry medium.

In his designs for the Sistine Chapel tapestries, Raphael replaced these complex, crowded scenes typical of Netherlandish design with a specific dramatic moment for each panel, depicted in realistic perspective, and with minimal superfluous detail. His innovation also extended to the tapestries' borders, introducing an iconography of historical and allegorical scenes related to the main field, and to the work's patron, instead of the customary decorative swags. During the 1520s further papal tapestry commissions were sent to Brussels using designs by artists associated with Raphael,

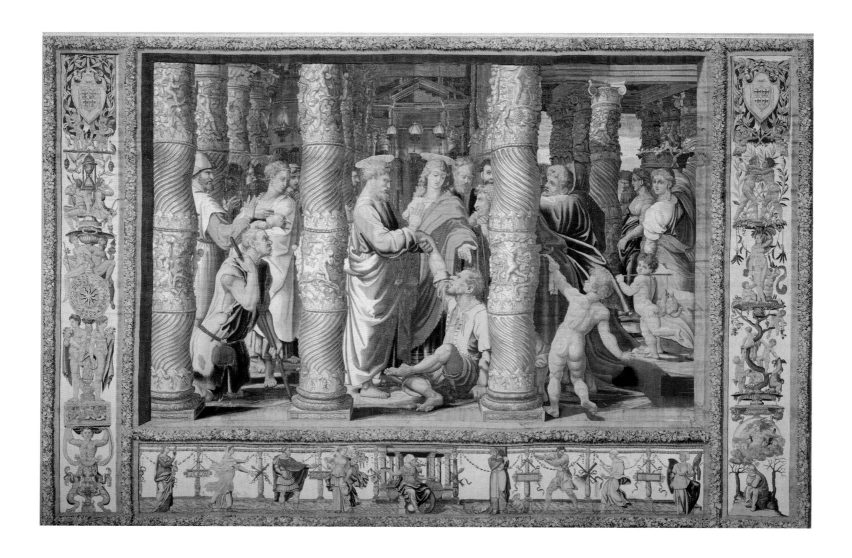

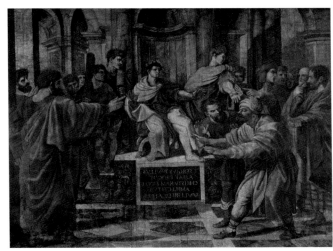

including Giulio Romano, Giovanni da Udine, Giovanni Francesco Penni and Tommaso da Vincidor. The visual effects of space and volume that these Italian designs required were no easier to achieve on the loom than in the past, but as Brussels weavers responded to them with technically outstanding work, and they were widely acclaimed, leading Netherlandish artists began to reflect such artistry and innovation in their own tapestry designs.[48]

One of the first of these was the Brussels master and court painter to Margaret of Austria, Bernaert van Orley. Van Orley devised a new approach to the composition of large-scale tapestry designs, combining the central dramatic moment characteristic of Italian tapestry cartoons with subsidiary elements taken from Netherlandish tapestry tradition, including narrative background scenes with picturesque and human detail, and attention to nature and the landscape. This approach was a response to the aesthetic properties and technical challenges of tapestry, helped by workshop practice that Van Orley also learned from Raphael's example, in which he assigned the working-up of his designs into full-scale cartoons to artists who specialized in depicting landscapes, animals and decorative borders. This would also have helped the timing of the completion of sequences of large tapestry cartoons.

Van Orley's artistic and administrative innovations were taken up and developed by his followers, including Pieter Coecke van Aelst, whose designs for tapestries showing the Story of St Paul, for example, which were acquired by Francis I in 1533, show clear influence from Raphael's *Acts*, refigured with Van Orley's compositional approach.[49] Michiel Coxcie, who became the leading Brussels tapestry designer after Van Orley's death, had lived in Rome during the 1530s, and his admiration for Michelangelo, Raphael and Giulio Romano was reflected in his approach, a highly successful adaptation of Van Orley's innovations with strong foreground action and subsidiary and detailed background narrative. These three designers had the scope to develop their styles in a period that saw unprecedented demand for high-quality tapestry, with huge sums of money spent on the commissioning of some of the finest pieces that had ever been produced.

The impact of the Cartoons

MARK EVANS

When Raffaello had finished all the cartoons of the
tapestries for the Papal Chapel, which were afterwards
woven in silk and gold, with stories of S. Paul,
S. Peter, and S. Stephen, Marc' Antonio engraved the
Preaching of S. Paul, the Stoning of S. Stephen, and
the Blind Man receiving his Sight; which plates, what
with the invention of Raffaello, the grace of the design,
and the diligent engraving of Marc' Antonio, were so
beautiful, that there was nothing better to be seen.[50]

Giorgio Vasari's *Lives of the Painters, Sculptors and
Architects* includes an extensive account of the first
half-century of print-making, and mentions several
of the early prints relating to the Acts of the Apostles.
At least three of these were produced under Raphael's
supervision from his preparatory designs. Vasari
seems to have misidentified Agostino Veneziano's
engraving after *The Conversion of the Proconsul*
(Bartsch XIV, 48.43) as 'the Blind Man receiving his
Sight', and attributed it to Marcantonio Raimondi
(cat. 7.2). This print is dated 1516, which is probably
the same year that the Cartoons arrived in Brussels.
Agostino's copy of *The Death of Ananias* (Bartsch
XIV, 47.42) may date from the same period (cat. 4.1).
Marcantonio's engraving after *Paul Preaching at
Athens* (Bartsch XIV, 50.44) has been dated around
1517–20 (fig. 40, see cat. 10), but no impressions are
known of his print after *The Stoning of Stephen*, which
is mentioned by Vasari. Whereas Agostino's engrav-
ings are both reversed in relation to the Cartoons,
Marcantonio's is in the same direction.

Ugo da Carpi's chiaroscuro woodcut of 1518 after
The Death of Ananias (Bartsch XII, 46.27) (cat. 4.2) was
copied from Agostino's engraving, made two years
earlier. It was probably authorized by Raphael, as it
bears his name and a lengthy copyright granted by
Leo X. That Raphael facilitated Ugo's woodcuts is
suggested by the direct tracing from the surviving
modello at the Royal Collection in Windsor of the
latter's chiaroscuro print of *The Miraculous Draught
of Fishes* (Bartsch XII, 37.13) (cat. 1.2). This undated
work is probably contemporary with Ugo's copy
of *The Death of Ananias*. The circulation of these
prints broadcast knowledge of Raphael's designs. For
example, Agostino's engraving after *The Conversion
of the Proconsul* was known to Andrea del Sarto in
Florence by 1517.[51]

Parmigianino's full-size ink-and-wash drawing
(Frankfurt, Städel) after Marcantonio's engraving of

FIG. 40
Marcantonio Raimondi after
Raphael, *Paul Preaching at
Athens*, c.1517–20, engraving,
second state; V&A, Dyce 1013

Raphael's *Paul Preaching at Athens* was probably made in Rome around 1524–7. His print after *The Healing of the Lame Man* (Bartsch XII, 78.27 and XVI, 9.7) (fig. 41) is reversed in relation to the Cartoon, but may be based on a counterproof of a lost autograph sketch. This experimental print combines an etched impression with overprinting from a tonal woodblock. It could have been executed in Bologna in 1527–9, but was more probably made earlier in Rome, perhaps in partnership with Ugo da Carpi, who was a specialist block-cutter.

The Sack of Rome by the imperial army in 1527 scattered Raphael's followers and brought to an end an inventive series of prints inspired by the Acts of the Apostles, and fuelled by access to their preparatory drawings. An engraving after *The Miraculous Draught of Fishes* by the Antwerp artist Cornelis Massys was made around 1537–9 and probably copied from the Cartoon in Brussels.[52] Although the engraving of *Christ's Charge to Peter* by Diana Scultori and that of the same subject attributed to Nicolas Beatrizet (Bartsch XV, 434.5 and 17.6) are in the same direction as the Cartoon, they date from the second half of the sixteenth century.

The Cartoon of *The Conversion of Saul* was in the Grimani collection in Venice by 1521 and was studied around this time by Titian.[53] Nevertheless, it appears that the monumental and didactic style of the Cartoons was not widely imitated in Italy. Two of them were copied at a much-reduced scale by Giulio Clovio around 1537–8 for Cardinal Marino Grimani. These are the miniature of *The Conversion of Saul*, after the Cartoon owned by the cardinal, in a manuscript *Commentary on the Epistle of St Paul to the Romans*

(London, Sir John Soane's Museum) (fig. 42), and a smaller copy of *The Conversion of the Proconsul* on a detached leaf (Paris, Louvre) (fig. 43).[54] As the latter is also in the same direction as the original, it may derive from an autograph study.

The earliest evidence of the impact of the Sistine Cartoons in the Netherlands is provided by a triptych by the court painter and tapestry designer Bernaert van Orley. His *Job Altarpiece*, dated 1521 (Brussels, Musée des Beaux-Arts), includes on an outer shutter a repre-

sentation of Dives in Hell, derived from Raphael's figure of the dying Ananias. It is also likely that Albrecht Dürer based the heads of St Mark and St Luke in his *Four Apostles*, dated 1526 (fig. 44), upon two of the Apostles in *Christ's Charge to Peter* (fig. 45), which he could have seen during his visits to Brussels in 1520 and 1521, when he socialized with Van Orley and exchanged works with Raphael's former assistant, Tommaso da Vincidor.[55] Vincidor had arrived in the Netherlands in 1520 to oversee the preparation of

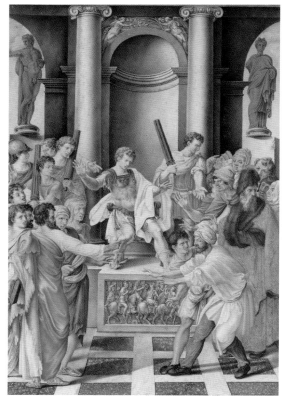

FIG. 42 (far left)
Giulio Clovio after Raphael, *The Conversion of Saul*, 1537–8, in a manuscript *Commentary on the Epistle of St Paul to the Romans*, miniature on vellum; London, Sir John Soane's Museum, MS. 11, fol. 8v

FIG. 43 (left)
Giulio Clovio after Raphael, *The Conversion of the Proconsul*, 1537–8, miniature on vellum; Paris, Département des Arts Graphiques, Musée du Louvre, inv. RF 3977

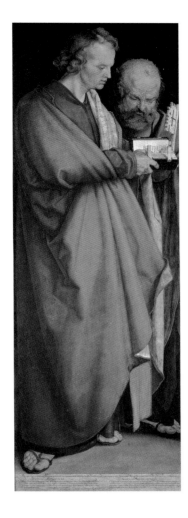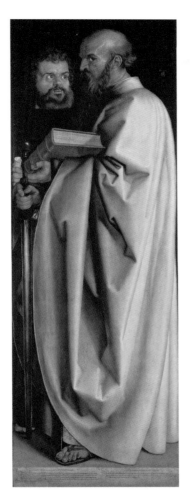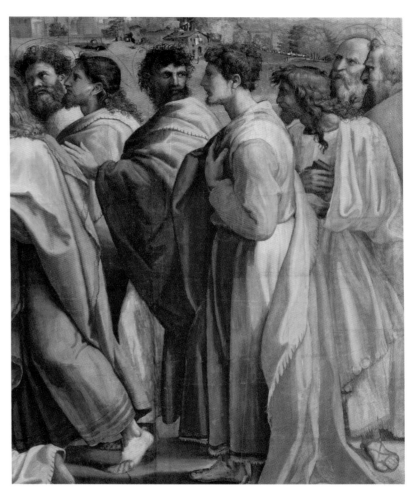

FIG. 44
Albrecht Dürer, *The Four Apostles*, dated 1526, oil on panel; Munich, Bayerische Staatsgemäldesammlungen

FIG. 45
Cat. 2, *cartoon* (detail)

full-scale cartoons, based upon designs by Raphael and members of his workshop, for additional series of tapestries for Leo X: the so-called *Children's Games* (*Giochi di putti*) and an elaborate set of bed hangings, neither of which survives. He also probably assisted with the series of *The Life of Christ*, known as the *Scuola Nuova* tapestries, designed by Giovanni Francesco Penni and others, and woven by Pieter van Aelst, probably commissioned by Leo X, but not completed until a decade after his death in 1521.[56]

Netherlandish artists became acclimatized to Raphael's style by the presence of the Cartoons, tapestries woven from them and other designs by his workshop, and by the circulation of prints after his work. One painting by the Liège artist Lambert Suavius (*c.*1510–74/6) borrows figures from both the Acts of the Apostles and the *Scuola Nuova* cartoons.[57] Similarly, Jan van Orley, Jan Gossaert, Jean Bellegambe, Jan de Hemessen, Lucas van Leyden, Jan van Scorel and Maerten van Heemskerck all appropriated individual poses from the Acts of the Apostles. Taking this practice further, the so-called Master of the Dinteville Allegory redeployed a clutch of figures from *The Conversion of the Proconsul* in his large painting of *Moses and Aaron before Pharaoh*, dated 1537 (New York, Metropolitan Museum). This tendency to borrow piecemeal may reflect the fragmented state of the Cartoons, because when cut into vertical strips, the

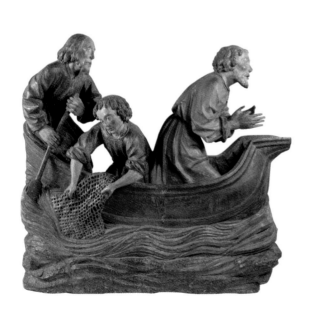

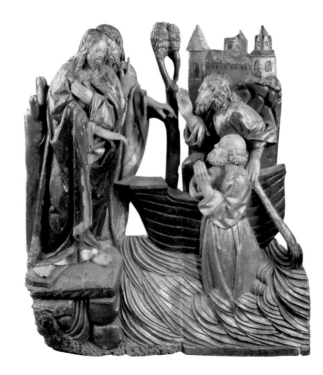

FIG. 46 (far left) Wilhelm von Arborch, *The Miraculous Draught of Fishes*, polychromed limewood; Aachen, Suermondt-Ludwig Museum, inv. SK 281

FIG. 47 (left) Anonymous north-German sculptor, *Navicella*, polychromed wood; present whereabouts unknown

striking poses of individual figures would have been more apparent than the overall narrative rhythm of their compositions.[58]

German wood sculptors also paid attention to the Acts of the Apostles. A carving from a dismembered altarpiece of *The Miraculous Draught of Fishes* (Aachen, Suermondt-Ludwig Museum), attributed to the Cologne sculptor Wilhelm von Arborch (*c*.1506–33), incorporates figures of Peter and a steersman whose poses resemble two consecutive stages in a single motion (fig. 46), like those of Peter and Andrew in Raphael's corresponding Cartoon.[59] A north-German carving of similar date, representing the miracle related in Matthew 14:22–33, when Peter began to sink after Christ walked on the waves (fig. 47), paraphrases several motifs from *Christ's Charge to Peter*.[60] This is apparent in the bearded helmsman, who gestures with a raised palm, as does Raphael's St Andrew; in the confidential exchange between Christ and the figure behind him – like those between the hindmost Apostles in the Cartoon; and in the background landscape with trees and towers.

The Dutch artist Lucas van Leyden reveals a particular understanding of Raphael's expressive figural rhetoric and compositional harmony, as is apparent in his *Christ Healing the Blind Man* of 1531 (St Petersburg, Hermitage).[61] A later, anonymous painting of *Paul and Barnabas at Lystra* (Budapest, Museum of Fine Arts), sometimes attributed to the Antwerp painter Jan Mandijn (1500–59), takes its subject matter from the Acts of the Apostles, borrowing compositional groups and architectural devices, as well as individual figures, from *The Death of Ananias*, *The Conversion of the Proconsul*, *The Sacrifice at Lystra* and *Paul Preaching at Athens*.[62] Full-scale duplicates of the Cartoons were made in the Netherlands during the sixteenth century, as is indicated by a letter to Cardinal Granvelle of 1573. Surviving examples of such duplicates probably include the three fragments of a copy of *Christ's Charge to Peter* (Chantilly, Musée Condé), which may have been made as early as 1516–33, as well as the intact copies after *The Healing of the Lame Man* and *The Conversion of the Proconsul* (Dublin, National Gallery of Ireland, NGI 171, 172) (figs 38 and 39, p.47).

Netherlandish artists became acclimatized to Raphael's style through the production of such copies, as well as by the presence of the actual Cartoons, tapestries woven from them and other designs by his workshop, and by the circulation of prints after his work. The short-lived successor of Leo X, the Dutch Pope Hadrian VI (1522–3), employed the Utrecht painter Jan van Scorel, who was reputedly put in charge of the Vatican Belvedere. Scorel's student Maerten van Heemskerck spent the years 1532–6 in Rome, where he sketched classical remains, studied recent works by Raphael and Michelangelo and met Vasari. By 1550 most fashionable Netherlandish artists had adopted a consciously Italianate style.

The Cartoons at the Mortlake tapestry manufactory

CLARE BROWNE

In 1623 seven of Raphael's Cartoons were purchased in Italy on behalf of Charles, Prince of Wales (1600–49), and brought to England. Sir Francis Crane wrote to James I (1566–1625) that he had been charged by Charles 'to send to Genua for certayne drawings of Raphaell of Urbin, which were desseignes for tapistries made for Pope Leo the Xth, and for which there is 300l. to be payed, besides their charge of bringing home.'[63] Their vendor is not known, but the seven Cartoons can possibly be identified with the '*sette ò otto pezzi grandi di Raffaello d'Urbino*' ('seven or eight large pieces by Raphael of Urbino') that belonged to Andrea Imperiale of Genoa in 1615, according to a contemporary account.[64]

Sir Francis Crane was the owner of the tapestry manufactory set up at Mortlake, on the south bank of the River Thames near London, in 1619.[65] The workshops were established and supported with royal grants through James I's patronage, and reflected his personal interest in the enterprise, and that of his son, Charles, Prince of Wales. Although the royal wardrobe already contained a very great number of tapestries accumulated by previous monarchs and available for his use, James had accepted Crane's proposal to establish a new English industry, an equivalent to the highly successful royal workshops in Paris set up by Henry IV (1553–1610) at the beginning of the seventeenth century. With the help of James I's diplomatic agent in Brussels, William Trumbull, Crane recruited a number of weavers from the Netherlands, described as 'the principal masters of this art . . . coming daily over from Brussels and elsewhere'. Flemish weavers from Paris

may also have been brought over to England at the same time, accompanying Philip de Maeght, who was employed as director of the weavers and workshops at Mortlake. De Maeght had previously been in charge of the Paris royal workshop, weaving tapestries with gold thread.

This rapid accumulation of skilled hands enabled Crane's enterprise at Mortlake to be ambitious from the start, and it made feasible Prince Charles' plan to undertake a new weaving of Raphael's *Acts of the Apostles*, securing the original Cartoons for the greatest fidelity to the artist's intentions. At the same time Charles invited the German artist Francis Clein to come to England, possibly motivated by a desire to save the original Cartoons from direct use in the workshops, by having them copied by Clein, a successful painter at the court of Christian IV of Denmark. Charles also attempted to gain access to the remaining two Cartoons missing from the set of seven that he had purchased in Genoa.[66] *The Conversion of Saul* and *The Stoning of Stephen* were believed to belong to the Grand Duke of Tuscany, and Francis Crane tried, on Charles' behalf, to arrange and pay for copies of them to be made. No record of such a completed transaction exists, and presumably it did not take place, as these two subjects were not woven at Mortlake.

Francis Clein settled and became resident designer for the Mortlake manufactory. The first two of Raphael's Cartoons that he copied were *The Death of Ananias* and *The Conversion of the Proconsul* (fig. 48). The original Cartoon for *The Conversion of the Proconsul* was missing the architectural feature of a female

FIG. 48 (opposite) Mortlake manufactory, *The Conversion of the Proconsul*, c.1631–6, tapestry; Paris, Mobilier National, GMTT 16/3

54

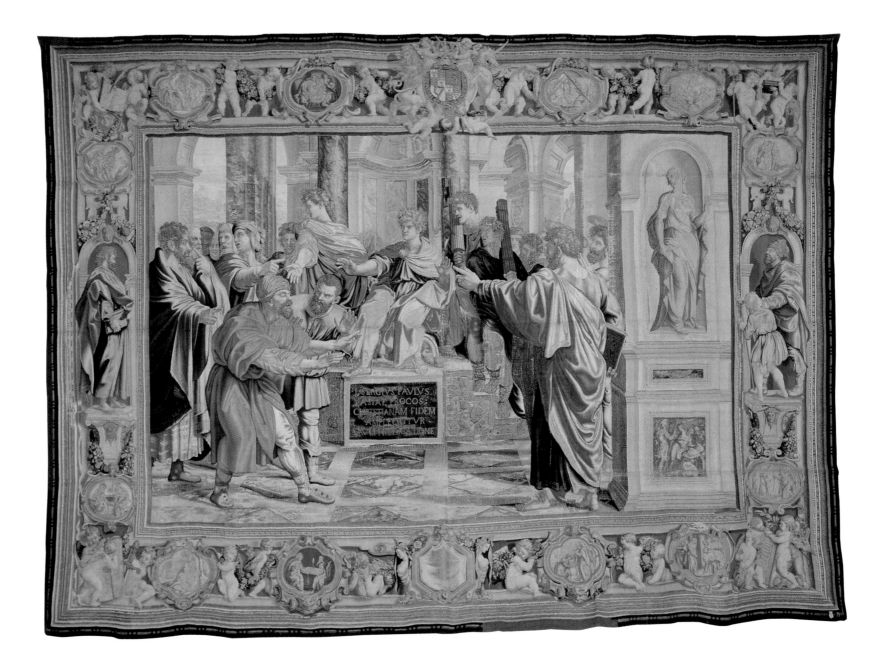

L·SERGIVS·PAVLVS·
ASIAE·PROCOS·
CHRISTIANAM·FIDEM
AMPLECTITVR
SAVLI·PRAEDICATIONE

statue in a niche, which had been incorporated into Pieter van Aelst's and other sixteenth-century tapestry versions. So Clein augmented his copy with a new interpretation of this element of the design. His bill for the two copies includes 'The greate border about it with his Ma[jes]ties Arms', and although this is the only surviving reference to a payment for a border for the set, he designed separate borders for each subject. They were exceptional designs, distinctive from each other, but visually linked by incorporating the royal arms above the main field and a cartouche for inscriptions below. Clein was also commissioned to design an additional subject, the *Death of Sapphira*, perhaps after the failure to obtain copies of the missing Raphael originals in 1627. This subject forms part of the story of the death of Ananias. A warrant of 1628 making available to Crane *Ananias* or any other of the *Acts* that he wanted from Henry VIII's sixteenth-century set kept at the Tower of London suggests that Clein might have wanted to refer to it for his composition, which features some of the same poses, or to check the fidelity of his interpretation against that of the Brussels weavers. Although the original Cartoons may have been temporarily reassembled for him to copy from, they had presumably come to England still in the strips into which they were cut in the previous century. Clein was commended by a contemporary for his 'almost incredible diligence' in the demanding task of reproducing them accurately.

The first set of *Acts* woven at Mortlake was made for Charles himself, now King, but only two or possibly three pieces of this set seem to have been completed during Sir Francis Crane's lifetime. The delay in production may reflect the length of time that Clein would have needed to devise and get approval for his complex border designs. Crane died in 1636, and the manufactory was acquired from his brother Richard by King Charles, becoming The King's Works under the governorship of Sir James Palmer. A further five pieces with Charles' arms were woven, and the pieces still extant from this set show that it was the most faithful of all the copies of Raphael's original Cartoons, and amongst the finest tapestries ever made in England. The set had probably left England before Charles' execution in 1649, as it was not among his goods in the posthumous inventory. Passing through the collections of the French Minister of Finance Abel Servien, and of Cardinal Mazarin, seven of the tapestries (without the *Death of Sapphira*) were acquired by Louis XIV (1648-1715) after Mazarin's death in 1661. Six pieces now survive (Paris, Mobilier National) – *St Paul Preaching* having been lost during the Second World War.

Other sets of Raphael's *Acts* were woven at Mortlake during its years as a royal manufactory in the 1630s and early 1640s, but financial support from the Exchequer ceased in 1641, and during the civil war it was cut off from any royal connection. Raphael's original Cartoons, however, having had copies made for workshop use by Clein, were recorded among the list of pictures at Whitehall, after Charles' execution in 1649. They were reserved from sale when many of the King's other artworks were dispersed during the Commonwealth period.

The 'afterlife' of the Cartoons, 1600–1865

MARK EVANS

Two great seventeenth-century painters were indebted especially to the Acts of the Apostles: Pieter Paul Rubens and Nicolas Poussin.[67]

Rubens may have sketched the Cartoon of *Paul Preaching at Athens* in 1600–08 at Genoa and seen the later weavings of the tapestries at Mantua. Around this time he also copied Parmigianino's etching of *The Healing of the Lame Man*. There may be truth in a claim made in 1720 that the Cartoons had been purchased for the Mortlake tapestry manufactory in 1623 on his recommendation. Rubens' inventory of 1640 indicates that he owned no fewer that six 'Peeces of the Workes of ye Apostles after Raphael', apparently his own

painted copies, now lost.[68] These provided a store of expressive poses for his own compositions. He was especially fascinated by the twisted columns in *The Healing of the Lame Man*, a recurrent motif in his works from 1601. Rubens' oil sketch of *The Miraculous Draught of Fishes* of 1618–19 (London, National Gallery) (fig. 49), reflects his familiarity with Raphael's Cartoon.

Poussin arrived in Rome in 1624 and became familiar with the Sistine Chapel tapestries. An ink study in the Hermitage after *The Healing of the Lame Man* is apparently his only known direct copy after Raphael, who was a formative influence on his figural style. In 1641 Louis XIV (1638–1715) commissioned

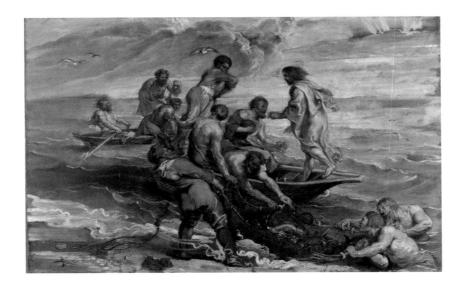

FIG. 49
Pieter Paul Rubens, *The Miraculous Draught of Fishes*, 1618–19, pencil, pen and oil on paper stuck on canvas; London, National Gallery, NG 680

Poussin to design tapestries of Old Testament subjects as pendants to the king's own weavings of the *Acts of the Apostles*, made for Francis I (1494-1547). Nothing came of this, but Poussin's knowledge of the tapestries is already apparent in his first series of *The Seven Sacraments*, painted in 1638-42 for Cardinal Cassiano dal Pozzo (five of which are in the Rutland collection, now on loan to the National Gallery). Their influence is even more apparent in his solemn compositions of the 1640s and 1650s, including the second series of *The Seven Sacraments*, painted for Paul Fréart de Chantelou in 1644-8 (Sutherland collection, on loan to the National Gallery of Scotland) (fig. 50).

After the dispersal of the collection of Charles I (1600-49), the Cartoons remained in store, still in strips, at the Banqueting House in Whitehall, and on the Restoration were returned to the Crown. There they remained, despite being pawned by Charles II for £3,000 in 1680, and an attempt by Louis XIV to acquire them for the Gobelins tapestry factory. William III (1650-1702) ordered the Cartoons to be reassembled and framed, and in 1699 they were put on exhibition for the first time in a gallery designed for them by Sir Christopher Wren at Hampton Court Palace (fig. 51).

During the later seventeenth century Raphael became central to the classicizing curriculum formulated by the French Academies in Paris and Rome. This is apparent from the *Scale of Painters* published in 1708 by the critic Roger de Piles, which graded 57 leading painters, with marks ranging from 0 to 20 each for composition, drawing, colour and expression. Joint winners by a considerable margin were Raphael and

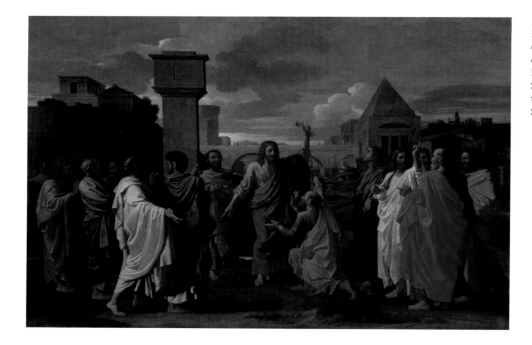

FIG. 50
Nicolas Poussin, *Ordination*, 1647, oil on canvas; Collection of His Grace the Duke of Sutherland, on loan to the National Gallery of Scotland, Edinburgh

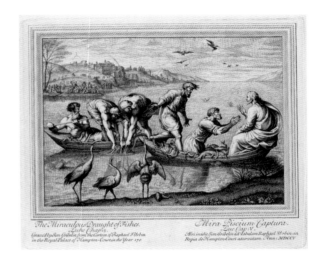

FIG. 51 (left)
Simon Gribelin, frontispiece to the engravings of the Raphael Cartoons, 1720, engraving; V&A: Dyce 2504

FIG. 52 (right)
Simon Gribelin after Raphael, *The Miraculous Draught of Fishes*, 1707, engraving, later impression; V&A: Dyce 2505

FIG. 53 (below)
Sir Nicolas Dorigny after Raphael, *The Sacrifice at Lystra*, 1719, etching and engraving, later impression; V&A: Dyce 20288

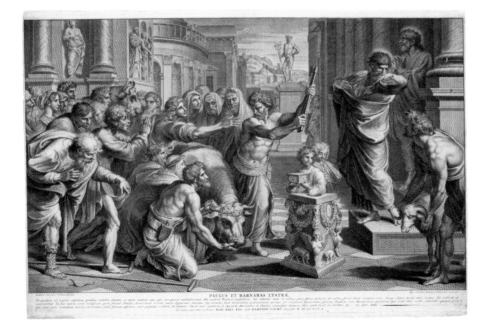

Rubens with 65, while Poussin was let down by a low score of 6 for colour and received 53, as did Correggio; and the lowest mark, of 23, went to Raphael's assistant, Giovanni Francesco Penni. On display, and with the reputation of their designer inexorably rising, the Cartoons attracted more interest than ever before.

In 1707 the French Huguenot silver engraver Simon Gribelin published the first complete set of prints after the Cartoons (fig. 52).[69] Their modest format of 18.3 × 21.5 cm set limitations on Raphael's monumental rhetoric, but served for reproduction at a diminutive scale, as in the fine gold watch-case by C. Clay, hallmarked 1724, engraved with the principal figures from *The Healing of the Lame Man*.[70] In 1711–19 Nicolas Dorigny, who had engraved Raphael's Roman works, was brought to England to produce copies at the more ample format of 52 × 62.2–74.9 cm, which he offered for sale at a subscription price of four guineas (£4. 4s. 0d.) a set (fig. 53). Dorigny was rewarded by George I (1660–1727) with a knighthood –

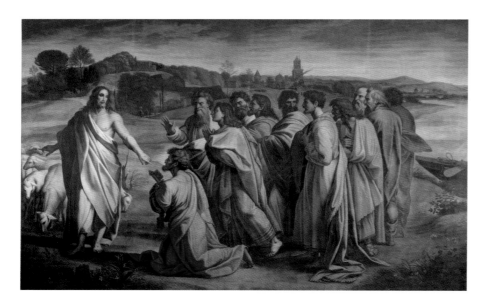

FIG. 54
Sir James Thornhill after
Raphael, *Christ's Charge to
Peter*, *c*.1729–31, oil on canvas;
London, The Royal Academy,
inv. 03/1221

a previously unheard-of honour for a print-maker. The Cartoons were lauded in patriotic terms by Jonathan Richardson in 1725:

> . . . we have the best history pictures that are anywhere now in being, for we have the cartoons of Raphael at Hampton Court, which are generally allowed even by foreigners, and those of our own nation who are the most bigotted to Italy, or France, to be the best of that master, as he is incontestably the best of all those whose works remain in the world.[71]

From 1729 the King's Serjeant Painter, Sir James Thornhill, made numerous tracings and studies of details after the Cartoons, many of which survive in the library of St Paul's Cathedral and at the V&A.[72] With their aid, he painted a set of full-size oil copies of the Cartoons, purchased in 1735 by the Duke of

Bedford and presented to the Royal Academy in 1800 (fig. 54). Thornhill also made smaller sets of oil copies, one-quarter and one-sixteenth the size of the originals. In 1722 a consortium of French engravers produced 90 copies of heads from the Cartoons after Dorigny's drawings. The London publisher John Boydell reissued these, with additional prints after Thornhill's studies, in 1759 as *The School of Raphael*, a highly successful illustrated book, which influenced the representation of emotions by British artists until the early nineteenth century.[73] In 1772 Sir Joshua Reynolds cited the Cartoons and the Vatican frescoes of Michelangelo and Raphael as 'The principal works of modern art . . . on which the fame of the greatest masters depend', and in 1777 they were hymned by the radical politician John Wilkes 'as the pride of our island, as an invaluable national treasure, as a common blessing'.[74]

Despite this canonical status, public access to the Cartoons was restricted by their move to Buckingham House in 1763 and their transfer to Windsor in 1787–8. The ink-and-wash copies made by the young John Constable in 1795, which reputedly earned him the approval of the connoisseur and art collector Sir George Beaumont, were after Dorigny's engravings, not the originals.[75] These returned to Hampton Court in 1804, and in 1816–19 were lent, one or two at a time, to the British Institution. A caricature of 1818 shows *The Conversion of the Proconsul* being copied at full scale, on three separate canvases, by the eccentric artist and teacher B.R. Haydon and his pupils (fig. 55).[76]

From 1838 Hampton Court was opened free to the public, with guided tours of the Cartoons. The following year appeared the first modern catalogue of

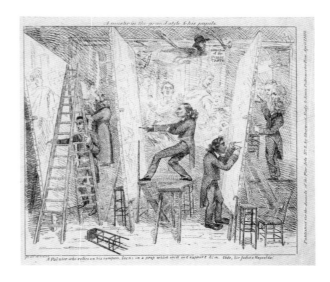

Raphael's work, by J.D. Passavant. Queen Victoria's consort, Prince Albert of Saxe-Coburg, and his artistic advisor Ludwig Gruner (1801–82) shared the taste for Raphael that was common to German artistic circles in Rome and the courts at Berlin, Munich and Dresden. In 1853 Albert's librarian, Ernst Becker, initiated a campaign to assemble a print or photograph of every known work by Raphael, one of the first strictly art-historical projects of its kind, completed by his successor Carl Ruland in 1876.[77] From 1857 Richard Redgrave combined his post of Inspector-General at the recently founded South Kensington Museum (now the V&A) with that of Surveyor of The Queen's Pictures. The following year the museum's photographic studio undertook its most ambitious early project: a comprehensive record of the Cartoons. This entailed lowering them one at a time through a window to scaffolding in a courtyard, where they

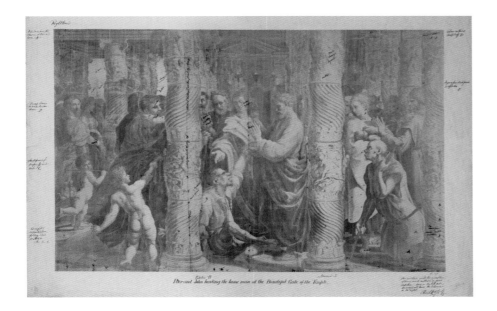

were photographed in natural light by a photographic apparatus more than 3.5 m long, running on a small tramway, on glass plates almost 1 m square.[78] The results were applauded in *The Athenaeum*:

> These photographs are all but as valuable as the originals . . . come fire or sword . . . the Cartoons are now safe and sown all over the world for ever. Great works of Art are now, when once photographed, imperishable . . . [79]

The Museum offered the photographs (fig. 56) for sale in a range of five different sizes, up to a maximum of 76 × 122 cm at £4. 19s. 7d. a set.[80]

Following the foundation of the National Gallery in 1824 and a minor fire at Hampton Court in 1841, voices were raised over the security of the Cartoons and the desirability of moving them to a more accessible location. Redgrave deplored the damage they had suffered from repeated rolling for transport, the pinning of tracing paper to them for copying, and the dust generated by visitors. In 1865 Queen Victoria gave her consent that they should be lent to the South Kensington Museum, and they were transported there, crated on rubber slings to reduce vibrations, in a specially designed van drawn by eight horses (fig. 57).[81] They were displayed, glazed and protected by blinds, in the first-floor gallery where they were to remain until the Second World War. In 1950 the Cartoons were transferred to their present location, on the ground floor of the V&A.

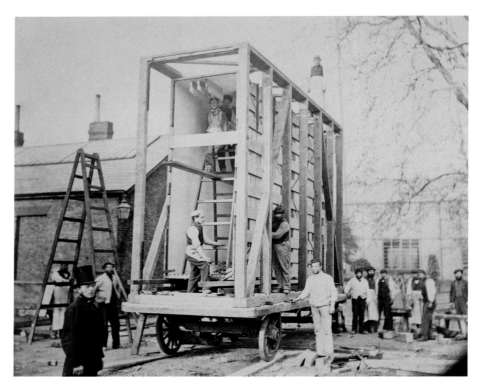

FIG. 57
Charles Thurston Thompson, Royal Engineers making the van used to transport the Raphael Cartoons, 1865, albumen print from a wet-plate collodion negative; V&A: 68.729

Notes

1 Goethe (trans. & ed. Auden & Meyer) (1962), p.325
2 Cited in Christensen (1979), pp.181–206
3 Reynolds (ed. Wark) (1959), pp.78–9
4 Ruskin (ed. Cook & Wedderburn), vol.12 (1904), p.322
5 Ibid., vol.35 (1908), p.247; vol.5 (1904), p.81
6 In September 1938 the Lord Chamberlain's office issued the V&A with a three-year permit for this purpose. From 1953 the V&A handled applications for copying internally. I am grateful to Christopher Marsden for this information.
7 Vasari (trans. Bull) (1971), p.284
8 Baxandall (1972), pp.111–15
9 Burckhardt (1960 edn), p.67
10 Jones and Penny (1983), p.93
11 Zimmermann (1995), p.23, citing Giovio, *De vita Leonis* (1551), p.68
12 For bibliography, see Bihlmeyer and Tuechle (1996); Crocker (2001); Durant (1985); Febvre (2003); Garcia-Villoslada (1976); Giovio (1551); Hollingsworth (1996), pp.14–20; Kemper (1999); Levillain (2000); Moreau, Jourda and Janelle (1997); Nesselrath in Cornini et al. (1993), pp.202–45; Pastor (1910); Pellegrini (2000); Pozzoli (1983); Roscoe (1846); Shearman (1972)
13 Pastor (1910), p.222. Translation mine.
14 Ibid., p.233. Translation mine.
15 For bibliography, see Eisengrein (1564); Frey (1955), pp.58–73, 178–99, 412–37; Frey (1956), pp.46–57, 139–56, 411–19; Pastor, vol.4, parts 5–7 (1923); Pirro (1935), pp.1–16; Roth (2002), pp.529–45; Sherr (1987), pp.452–62
16 Shearman (1972), pp.12–13, n.75
17 Blackburn (1992), p.24
18 Shearman (2003), nos 1515/16 and 1516/31
19 For a summary of the commission and its documentation, see White and Shearman (1958), pp.214–16
20 For the structure and technique of the Cartoons, see Plesters (1990), pp.111–24; Fermor (1996), pp.45–64; and Fermor and Derbyshire (1998), pp.236–50
21 For bibliography, see Baglioni (1733); Chambers (1978), pp.322–6; Elam (1988),

pp.813–26; Ettlinger (1965); Gnoli (1893), pp.128–9; Groner (1906), pp.163–70, 193–202, 227–36; Hirst (1988); Hirst (1997), pp.63–84; Horne (1908); Kemper (2002), pp.109–18; Mancinelli et al. (1990); Mejìa et al. (2003); Monfasani (1983), pp.9–18; Nesselrath in Mejìa et al. (2003), pp.39–75; Nesselrath (2004); Pagliara (1994), pp.15–19; Pagliara in Mejìa et al. (2003), pp.77–86; Passavant (1966), pp.214–16, 220–23; Redig de Campos (pp.299–314); Shearman (1971); Shearman (1986), pp.22–87; Shearman in Mancinelli et al. (1990), pp.19–28; Steinmann (1901); Vasari (ed. Milanesi) (1906); Wilde (1953); Wilde (1958), pp.61–81; Zagnoli (2003), p.305, cat.144
22 Vasari, IV (1976), p.202
23 Archivio Cerimonie Pontificie, vol.377 s.p.
24 Campbell (2002), pp.94, 132
25 Shearman (2003), p.292
26 Shearman (1972), pp.21–44
27 Shearman (2003), p.293
28 Gilbert (1984), pp.533–50
29 Shearman (2003), 1521/38, 1521/39, pp.707–9; Archivio Segreto Vaticano, Camera Apostolica, Div. Cam., 70, f.119v
30 Archivio Segreto Vaticano, Camera Apostolica, Div. Cam., 105, ff.148, 150
31 Shearman (2003), 1530/3, p.849; 1532/4–5, pp.870–72
32 Shearman (2003), 1531/2
33 Shearman (2003), 1528/10
34 Shearman (2003), 1541/4, pp.922, 923
35 Archivio di Stato di Roma, *Camerale I*, 1557, f.202v. It is likely that a border panel from Leo's time was returned with them. This panel was not part of the cycle, but was sewn to the *Conversion* for the occasion, as it presents the same dedication found on *Paul Preaching in Athens* (Vatican Museums, inv. 43879)
36 For bibliography, see Archivio di Stato di Roma, *Camerale I*, nn.1557, 1558; Bertrand (2005); De Strobel (1989); De Strobel (1999), pp.173–80; Forti Grazzini (1994), vol.2, pp.440–41; Müntz (1878 & 1879); Shearman (2003), vol.1; Smit (1993a), pp.19–264; Smit (1993b), pp.49–59

37 Archivio Segreto Vaticano, *Fondo Albani 16*, f.41
38 F. Rangoni, *1749, 24 dicembre. Apertura della Porta Santa* in *Corpus delle Feste a Roma/2. Il Settecento e l'Ottocento*, a cura di Marcello Fagiolo, pp.143–4
39 Campbell (2002), p.201
40 Campbell (2007b), p.111
41 Campbell (1996), p.73
42 Campbell (2007a), p.274
43 Campbell (2007a), p.297
44 Junquera de Vega and Carretero (1986), pp.63–72
45 Brown and Delmarcel (1996), pp.148–57; Campbell (2002), pp.214–18
46 Campbell (2002), p.193
47 Campbell (2002), p.201
48 Campbell (2007b), pp.6–8
49 Campbell (2002), p.380
50 Vasari (trans. du C. de Vere) (1996), vol.2, pp.83–5, 88, 90
51 Shearman (1972), p.139
52 For the early prints after the Cartoons, see Hollstein (c.1954), p.183; Shearman (1972), pp.68, 96–8, 100, 102–3, 106–7, 109, 115, 120, 138–9; Johnson (1982), pp.63–7; Shoemaker and Brown (1981), pp.152–4; Pezzini et al. (1985), pp.129–34; Bellini (1991), pp.181–4; Landau and Parshall (1994), pp.120–46, 150, 266, 270; Clayton (1999), pp.102, 109–10; Franklin (2005), pp.116–18, 128–30
53 Shearman (1972), p.144; Shearman (1992), pp.223, 252–3
54 Giononi-Visani and Gamulin (1993), pp.37, 39, 42–4, 49, 88–9, 100; Cordellier and Py (1992), no.405
55 Sulzberger (1959), pp.177–84. For Tommaso da Vincidor, see Dacos (1980)
56 For later papal cycles of tapestries, see Campbell (2002), pp.225–60
57 For the impact of the Cartoons in the Netherlands, see especially Dacos (1997), pp.1–22
58 Hendrikman (2002), pp.83–9
59 Polychromed limewood, 50 × 50.5 × 14 cm; Suermondt-Ludwig-Museum, SK 281; *Heilige und Menschen*, exhibition catalogue, National Museum of Western Art, Tokyo (1994),

cat. no.26, pp.78–9, 239. I am indebted to Michael Rief for this reference.
60 Polychromed wood, 112 × 94 cm; sold at Christie's, London, *Important European Sculpture and Works of Art*, 1 July 1997, lot 94
61 Gibson (1986), pp.45–50
62 Museum of Fine Arts, Budapest, no.4315; see Dacos (1997), pp.7–8
63 Thomson (1930), p.281
64 Boccardo (2006), p.182
65 For a detailed account of the Mortlake manufactory, to which this section is indebted, see Hefford (2007)
66 Howarth (1994), p.156
67 See Pope-Hennessey (1971), pp.238, 240, 242; Shearman (1972), pp.99, 139, 147; Jaffé (1977), pp.9, 25, 27, 59; Jones and Penny (1983), pp.142, 146; Rosenberg (1995), pp.14, 29, 37–8, 40, 45, 57, 75–6, 80–82, 104–5, 109, 137, 150, 153; Verdi (1995), pp.194, 221–31, 241–55, 267–8
68 Muller (1989), pp.110–11
69 For eighteenth-century prints after the Cartoons, see Miller (1995) and Meyer (1996), pp.22–34, 51–5
70 Sold at Sotheby's, Zurich, 17 November 1976, lot 58 (diam. 4.6 cm). I am grateful to Richard Edgcumbe for this reference.
71 In *The Connoisseur* (1725), cited in Fermor (1996), p.24; for Richardson's comments, see also Shearman (1972), pp.150–52; Rosenberg (1995), pp.80–89; Meyer (1996), pp.46–9
72 Meyer (1996), pp.34–45
73 Meyer (1996), pp.51–67; Dickey (1986), pp.37–42
74 Reynolds (ed. Wark) (1959), p.81; Wilkes cited in Shearman (1972), pp.152–3
75 Reynolds (1996), p.5
76 Cummings (1963), pp.371–2
77 Clayton in Marsden (ed.) (2010), pp.176–7; Montagu (1995), pp.37–55
78 Physick (1975), pp.6–7; Fawcett (1986), pp.191–2
79 *The Athenaeum* (1859), quoted in Fawcett (1986), p.192
80 Committee of Council on Education, *Price List of Reproductions* (1859), p.9
81 Physick (1982), pp.95–6

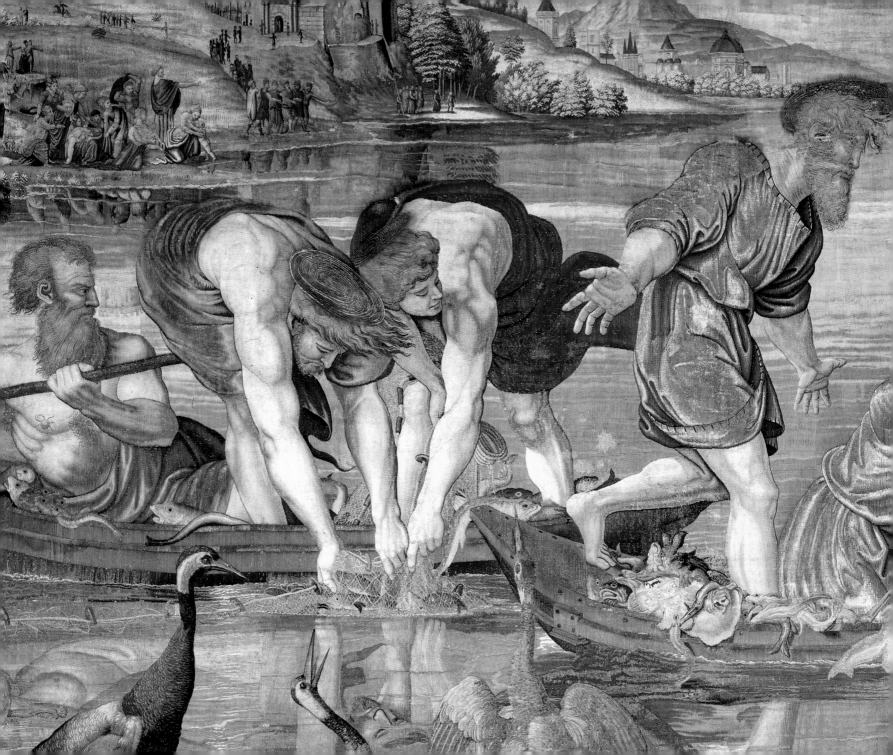

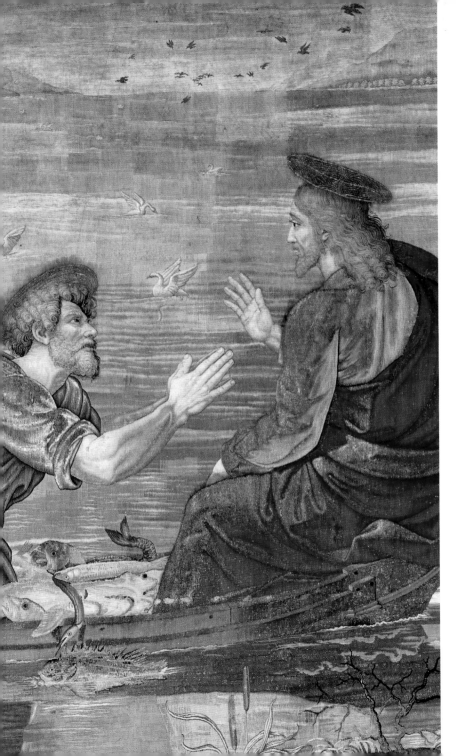

The Story of St Peter

(*The Petrine Cycle*)

Known later as 'The Prince of the
Apostles', Peter was the leader of Christ's
disciples. He reputedly went to Rome,
where he established the first Christian
community, and was crucified in AD 64.
His tomb is believed to be under St Peter's
basilica. From an early date he was
paired with Paul as one of the founders
of the Roman Church, with the mission
of converting the Jews. Their joint feast
is kept on 29 June. The popes were
considered Peter's successors as Christ's
vicar on earth. This series of key episodes
from his life emphasizes his selection
by Christ and his power to heal and to
punish, but omits a concluding scene
of his martyrdom.

1 The Miraculous Draught of Fishes

Cartoon bodycolour over charcoal underdrawing on paper mounted on canvas, 319 × 399 cm; on loan from HM Queen Elizabeth II; RCIN 912944
Tapestry warp: wool (7.2 warps per cm); weft: wool (16–18 wefts per cm), silk (20 wefts per cm), gilt-metal-wrapped thread (22–4 wefts per cm), 493 × 440 cm; Vatican Museums, inv. 43867

LUKE *Chapter 5, verses 1–10*

And it came to pass, that, as the people pressed upon him to hear the word of God, he stood by the Lake of Gennesaret. And saw two ships standing by the lake: but the fishermen were gone out of them, and were washing their nets. And he entered into one of the ships, which was Simon's and prayed him that he would thrust out a little from the land. And he sat down, and taught the people out of the ship. Now when he had left speaking, he said unto Simon, Launch out into the deep, and let down your nets for a draught. And Simon answering said unto him, Master, we have toiled all the night, and have taken nothing: nevertheless at thy word I will let down the net. And when they had this done, they inclosed a great multitude of fishes: and their net brake. And they beckoned unto their partners, which were in the other ship, that they should come and help them. And they came, and filled both the ships, so that they began to sink. When Simon Peter saw it, he fell down at Jesus' knees, saying, Depart from me; for I am a sinful man, O Lord. For he was astonished, and all that were with him, at the draught of the fishes which they had taken: And so was also James, and John, the sons of Zebedee, which were partners with Simon. And Jesus said unto Simon, Fear not: from henceforth thou shalt catch men.

CHRIST CHOSE THE POOR fishermen Simon Peter and Andrew as his first Apostles. They have been fishing unsuccessfully in the Sea of Galilee when Christ appears and tells Peter to let down his nets into deep water. They make a miraculous catch, so that their boats overflow with fish. In another boat James and John struggle to pull up a net with a huge catch, while their father Zebedee tries to keep the vessel steady. Peter recognizes Christ as a holy man and kneels before him in an attitude of prayer, while Andrew steps forward with his hands spread in amazement at the miracle. A consecutive chain of action runs across this balanced composition to culminate in the figure of Christ, who calmly raises his hand in blessing. On the distant shore the faithful gaze and point at the miraculous events. The monuments on the horizon are generally reminiscent of Roman buildings, but do not include any topographically identifiable representations. The landscape background appears to be continuous with that in the next scene, *Christ's Charge to Peter*.

The story refers to Peter's role as 'fisher of men', who converts others to Christianity. It also demonstrates his humility as he kneels before Christ to confess his sinfulness. Since Early Christian times the Church had been personified as a ship, and fish were traditional symbols for Christ and Christian piety. Here, they may also represent souls that have been saved (taken up in Peter's nets), in contrast to the discarded shellfish on shore that are being picked over by the cranes in the foreground. Many of the fish depicted are recognizable deep-water varieties, including eels, lampreys, a small shark, a flounder and a fish native to Israel, the St Peter fish. Cranes are fishing birds, and were sometimes interpreted as symbols of vigilance and of the papal duty of care.

SOURCES AND STUDIES

In his choice of this unusual subject, Raphael may have drawn upon a miniature in an eleventh-century Greek Gospel book then in the library of Leo X (Florence, Biblioteca Laurenziana, MS. Plu. Vi. 23, fol.111v), which also depicts two overlapping boats with Peter kneeling before Christ. The head of Christ is probably based upon a supposedly authentic likeness, derived from an emerald cameo from the Treasury of Constantinople, which was reproduced in a number of bronze medals at the end of the fifteenth century. The oarsman Zebedee is represented in the form of a classical river god, while the muscular figures of James and John resemble Michelangelo's lost cartoon for his unexecuted fresco of the *Battle of Cascina*.

Mindful of the Gospel text, which describes how Jesus preached from the ship, Raphael initially intended to relegate the miracle to the background, with the people who 'pressed upon him to hear the word of God' in the foreground. These included a figure of a woman with an outstretched arm, whose head and upper body form the subject of an autograph drawing by Raphael (pen over black chalk, 100 × 138 mm; Munich, Graphische Sammlung, 8235). This preliminary version of the composition appears in a study variously attributed to Raphael, Giulio Romano and Giovanni Francesco Penni (pen, brush and wash, white heightening over black chalk, 228 × 327 mm; Vienna, Albertina, inv. SR 226r). On the reverse of this sheet is a cursory preliminary sketch

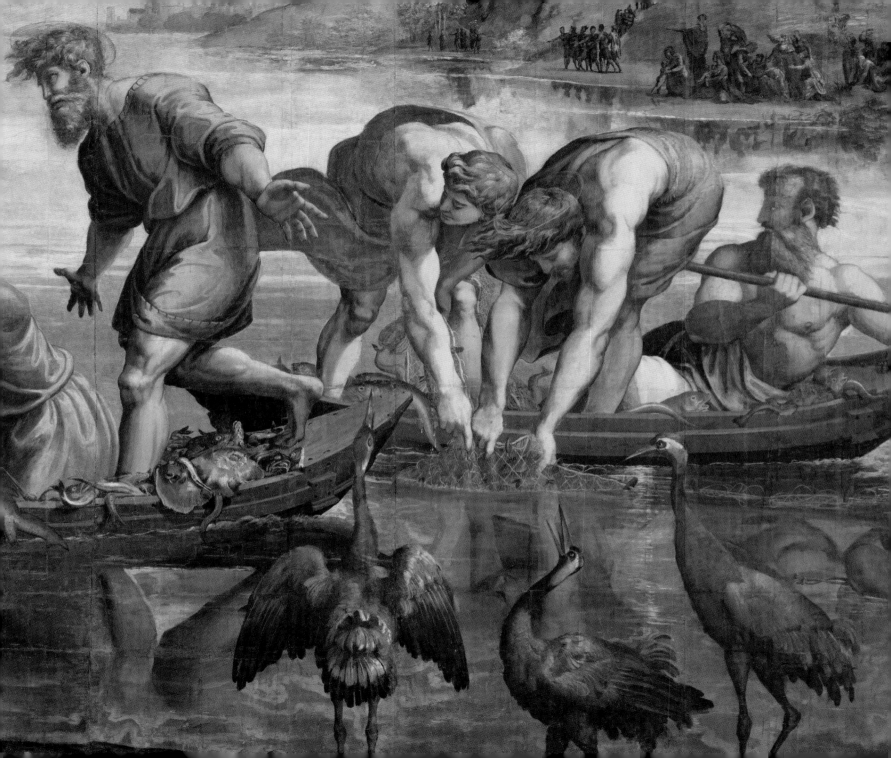

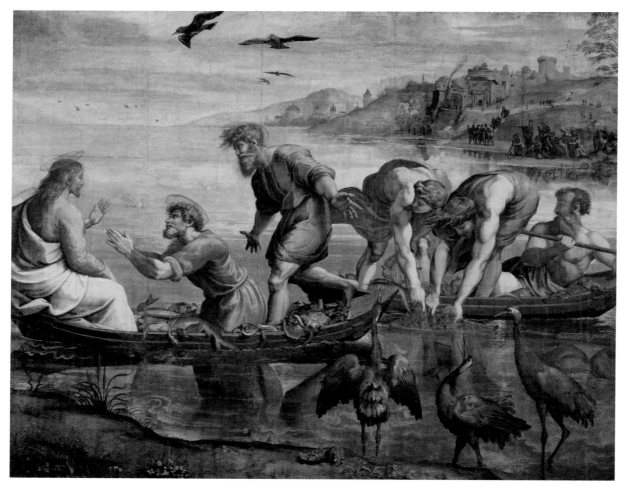

CAT. 1, *Cartoon*

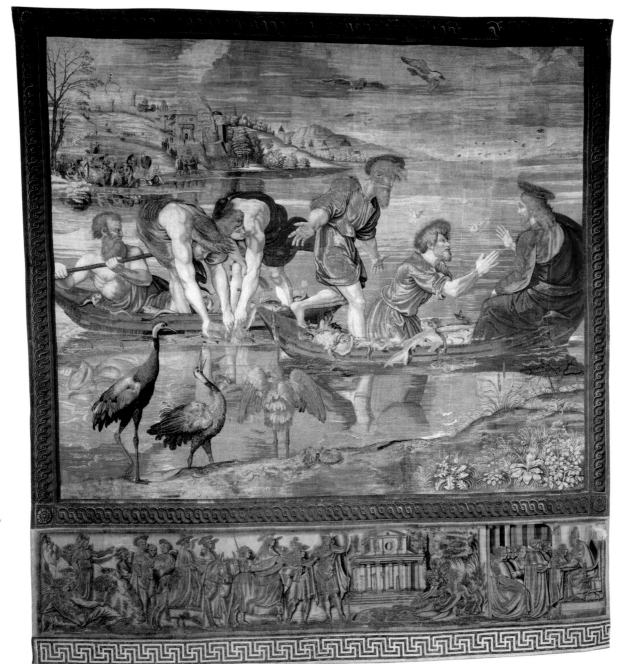

CAT. 1, *Tapestry*

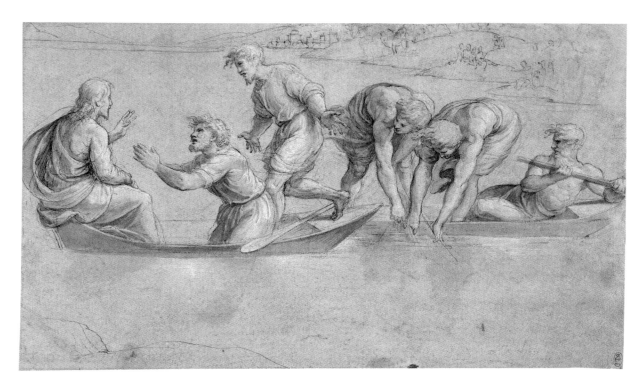

The Cartoon

(pen over black chalk) for the final composition by Raphael or Giulio Romano. A final, more highly finished study by Raphael or Penni represents the principal group of figures much as they appear in the Cartoon (pen, brush and wash and white heightening over black chalk, some red chalk and stylus on pale buff washed paper, 201 × 339 mm; Windsor, Royal Collection, RL 12749, cat. 1.1). This drawing was reproduced in a chiaroscuro woodcut by Ugo da Carpi (Bartsch XII, 37.13, cat. 1.2). A preparatory study of two of the cranes with other fowl is probably by Giovanni da Udine (pen, bistre and watercolour, 320 × 420 mm; current location unknown).

Light is represented as falling from the right. It is generally believed that *The Miraculous Draught of Fishes* was the first of the Cartoons to be completed, and that it was the one to which Raphael made the greatest personal contribution. This is apparent in the high quality of the heads of Peter and Andrew. The Cartoon has the most extensive underdrawing in the series, with complex cross-hatching and shading, which was manipulated and modified, probably by Raphael, to achieve precise effects – perhaps without reference to preparatory studies. A wide range of blues was achieved using azurite in varying concentrations, mixed

with white, and the reflections in the water are represented with great finesse. Giovanni da Udine, who was noted for his skill in depicting animals and fish, probably painted the cranes and the fish in the foreground. Christ's robe was originally a deep pink, but has faded to white, while its reflection retains its original colour. More light-sensitive pigments were evidently used for the robe than for its reflection – perhaps by two different artists. The Cartoon was cut into vertical strips by the weavers and has been rejoined; it has also been pricked for transfer.

CAT. 1.2
Ugo da Carpi after Raphael,
The Miraculous Draught of Fishes,
c.1518, chiaroscuro woodcut
from three blocks, reissued by
Andrea Andreani 1609;
V&A: E.493–1925

The Tapestry

This tapestry was among the seven displayed in the Sistine Chapel on 26 December 1519. Although it is difficult to assess the original colours of the Cartoons and tapestries, due to alterations caused by light exposure, comparison of the two sometimes permits the reconstruction of their original shades. For example, the evident fading of Christ's robe in the Cartoon is confirmed by the tapestry, in which it is red with gold highlights. However, such reasoning seems inapplicable to the colour of his tunic, which is blue in the Cartoon, but a purplish-red on the reverse (see overleaf) of the tapestry, and now appears beige on its more faded front.

In this specific case the weavers remained quite faithful to the colours of the Cartoon, although the shades (especially the blues and reds) acquired more brilliant hues in the tapestry when compared with the more subtle and harmonious tones of the painting. The tapestry displays greater attention to the vegetation in the right-hand corner (corresponding to the left-hand corner of the Cartoon), emphasizing the skill of the Flemish weavers in this genre, while the landscape at the top left seems relegated even more to the background, appearing less evident than it is in the Cartoon.

Technically, the tapestry is formed of three separately woven parts: firstly the upper section of the guilloche frame; secondly the central scene and side borders of the frame, with the original edging still present on both sides; and finally the lower section of the guilloche frame, the frieze and the Greek-key pattern.

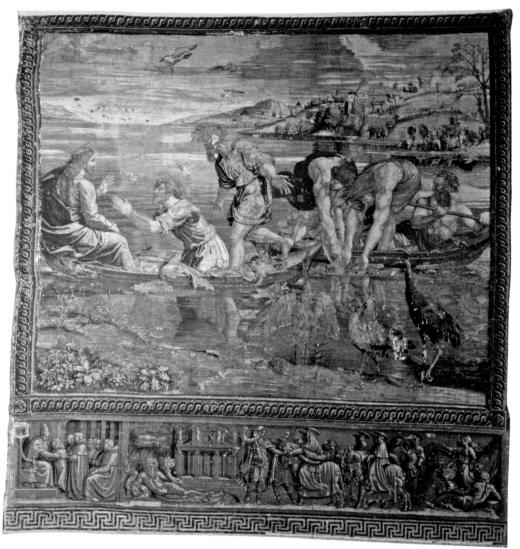

CAT. 1, *Tapestry* (reverse)

The Tapestry Borders

The scene is surrounded by a frame with a continuous guilloche design running from left to right and rosettes in the corners. Beneath is a fictive bronze relief. At the bottom is a continuous Greek-key design.

The fictive relief (opposite) is one of five friezes illustrating the life of Leo X, which accompany all the tapestries of the *Story of St Peter*, plus *The Stoning of Stephen*. It comprises two scenes. The larger one, which is flanked on either side by figures of reclining river gods, has recently been identified as the arrival of Giovanni de' Medici (the future Leo X) and his retinue in Rome, after he received the insignia of cardinal on 9 March 1492 at the Badia in Fiesole. He is welcomed to the city of Rome by an armed figure, possibly Giovanni Orsini. There follows a representation of a church, probably Santa Maria in Domnica. The scene on the right has been identified as Giovanni kneeling before Pope Innocent VIII, who admitted him to the College of Cardinals on 23 March 1492. Santa Maria in Domnica was of special significance to Giovanni, who was its titular priest until he became a cardinal, and ordered its restoration after his election to the papacy.

The Miraculous Draught of Fishes is usually associated with the *Elements* border, no longer extant in the Sistine set, but present in the later set at Mantua. The customary reconstruction of the hanging order of the tapestries in the Sistine Chapel locates these to the right of the altar, beneath the first fresco of the fifteenth-

century cycle of the *Life of Christ*, which was destroyed when Michelangelo painted his *Last Judgement*. Despite cogent iconographic reasons in support of this proposed location, it poses significant technical problems: the breadth of the wall between the old altar and the north wall of the Chapel, including the door that led into the sacristy, is in fact 60 cm narrower than the combined width of the tapestry and such a border. Moreover, fragments of blue edging appear on both the left and the right sides of *The Miraculous Draught of Fishes*, thereby ruling out the existence of a border woven together with the tapestry, as is the case with some of the other tapestries in the series.

The red and gilt-metal guilloche frame was inspired by the decoration of the Sistine Chapel itself. A similar motif features among the earlier works commissioned by Sixtus IV: in the stone band beneath the singing gallery and the volutes above it. Recent restoration work also uncovered a painted version, in a slightly different form, above the trabeation on the back wall. Raphael's thorough knowledge of the ornamental features of the Chapel guided his choice of the decorative elements in the tapestries, which were designed to enrich the lower register and were positioned in line with the singing gallery. The re-use of the guilloche motif seems almost to incorporate the singing gallery, with its living choristers, among the woven scenes. Raphael may have utilized the depth of the space between the marble band and the seat beneath as a guide to the height of the fictive relief, which concludes the tapestries together with the Greek-key pattern, as their dimensions closely coincide.

The tapestry is finished at the lower edge, like the others, by a double Greek-key pattern in green and yellow gold, already used by Raphael some years earlier to decorate the arches framing the four scenes in the *Stanza della Segnatura*.

REFERENCES

White and Shearman (1958), pp.198, 202, 204–5, 211, 307–8, 321; Shearman (1972), pp.21–44, 50–55, 61–5, 79, 84, 86, 94–6, 118, 126, 133, 141, 149, 211; White (1972), pp.5, 8; Mancinelli (1982), no.17; Joannides (1983), nos 355–7; Jones and Penny (1983), pp.136, 141–2; Harprath (1984), no.92b; Bober and Rubinstein (1986), ills 64–7; Plesters (1990), pp.112, 114, 116, 120–23; Fermor (1996), pp.13, 15–16, 56, 60, 61–2, 66, 74, 76, 80, 82–3, 85–6, 88; Meyer (1996), p.4; Delmarcel and Dacos Crifò (1998), no.162; Fermor and Derbyshire (1998), pp.241–2, 244, 249; Clayton (1999), no.25; de Strobel (1999), no.314; Weddigen (1999), pp.273–84; Campbell (2002), pp.190–91, no.23; Shearman (2003), no.1519/66; Hornik and Parsons (2005), pp.48–81; Hefford (2007), no.16

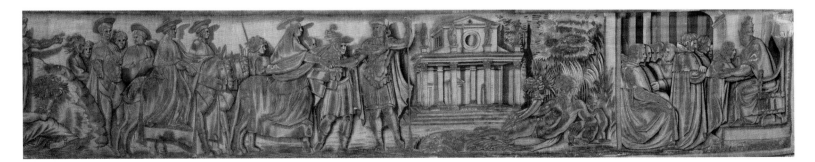

CAT. 1, *Tapestry* (detail)

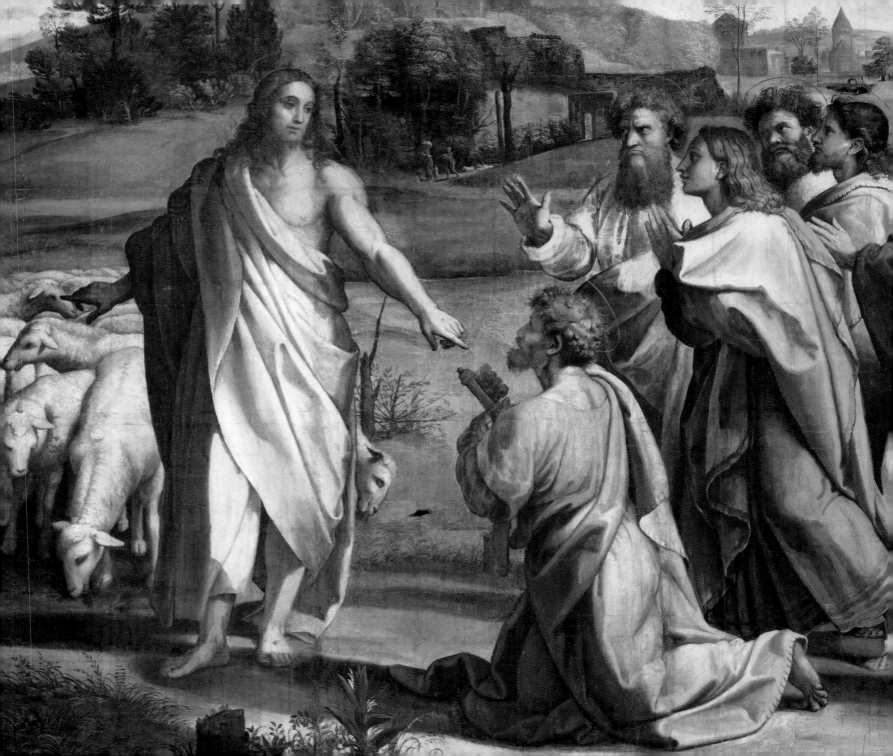

2 Christ's Charge to Peter

Cartoon bodycolour over charcoal underdrawing on paper mounted on canvas, 343 × 532 cm; on loan from HM Queen Elizabeth II; RCIN 912945
Tapestry warp: wool (7.2 warps per cm); weft: wool (16-20 wefts per cm), silk (20-22 wefts per cm), gilt-metal-wrapped thread (22 wefts per cm), 466 × 634 cm; Vatican Museums, inv. 43868

MATTHEW *Chapter 16, verses 18-19*

And I say also unto thee, That thou art Peter, and upon this rock I will build my church; and the gates of hell shall not prevail against it. And I will give unto thee the keys of the kingdom of heaven: and whatsoever thou shalt bind on earth shall be bound in heaven: and whatsoever thou shalt loose on earth shall be loosed in heaven.

JOHN *Chapter 21, verses 15-17*

So when they had dined, Jesus saith to Simon Peter, Simon, son of Jonas, lovest thou me more than these? He saith unto him, Yea, Lord; thou knowest that I love thee. He saith unto him, Feed my lambs. He saith to him again the second time, Simon, son of Jonas, lovest thou me? He saith unto him, Yea, Lord; thou knowest that I love thee. He saith unto him, Feed my sheep. He saith unto him, the third time, Simon, son of Jonas, lovest thou me? Peter was grieved because he said unto him the third time, Lovest thou me? And he said unto him, Lord, thou knowest all things; thou knowest that I love thee. Jesus saith unto him, Feed my sheep.

FROM THE FIFTH CENTURY the two events depicted here were sometimes conflated. At Caesarea Philippi, Christ addressed his disciples and said to Peter: 'I will give unto thee the keys of the kingdom of heaven.' After the Resurrection he appeared to seven of the disciples at the sea of Tiberias and charged Peter: 'Feed my sheep.' These two texts from the Gospels were the most important scriptural justifications of papal authority. They emphasize that Christ selected Peter as the foundation stone of the Church, and demonstrate his pre-eminence among the Apostles. Here, Christ gestures with one hand towards the flock of sheep and with the other to the kneeling figure of Peter, at the head of the solid phalanx of Apostles. The focal point of this dramatic composition is Christ's pointing finger, which invests Peter with leadership of the Church.

The Sistine tapestry of this subject was known for many years as *The Donation of the Keys*. However, in the earliest inventory of 1518/21, it was called *Feed My Sheep* ('*Pasce oves meas*'). Peter has already received the keys and clasps them tightly. This gesture and the number of Apostles may have been intended to link the tapestry to the fifteenth-century fresco by Pietro Perugino of *The Donation of the Keys* in the upper register of the Sistine Chapel.

SOURCES AND STUDIES

The composition incorporates references to a range of antique and modern sources, including the relief of *The Donation of the Keys* from the Ciborium of Sixtus IV and, perhaps, Donatello's marble relief of the *Assumption*, now in the V&A. Christ's gesture resembles that of Michelangelo's *God Creating the Sun and the Moon* on the Sistine Chapel Ceiling. Its extensive and varied landscape background may have been intended to rival those in imported Flemish landscape paintings, which were highly prized in Italy.

Raphael made a preparatory study of studio models in everyday clothes for this composition, with a figure of Christ with his left arm raised. Three fragments of this survive, one with the figure of Christ (red chalk over stylus, 253 × 134 mm; Paris, Louvre, inv. 3854, cat. 2.1) and two others with the heads of the Apostles (mounted together, red chalk over stylus, 81 × 232 mm overall; Washington, National Gallery of Art, Woodner Collection, inv. 1993.51.2). The entire composition is recorded in an offset (red chalk, 258 × 375 mm; Windsor, Royal Collection, RL 12751, cat. 2.2), made by laying a dampened sheet of paper against the original drawing and pressing the two together. This was probably made by Raphael to test the composition in reverse (as it would appear in a tapestry woven after it). Raphael revised the rather rhetorical pose of Christ in favour of a more restrained attitude, which focuses attention on the keys held by Peter and on the sheep in the background. He then made a detailed *modello* of the composition, very like the final Cartoon (pen, brush and wash, white heightening over black chalk on grey washed paper, squared off, 221 × 354 mm; Paris, Louvre, inv. 3863, cat. 2.3). This *modello* may be identical to a drawing of this subject, attributed to Raphael, in the collection of Cardinal Marino Grimani in 1526-8.

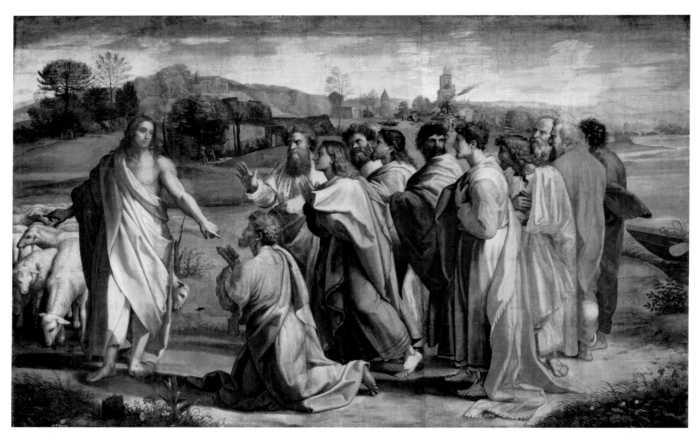

CAT. 2, *Cartoon*

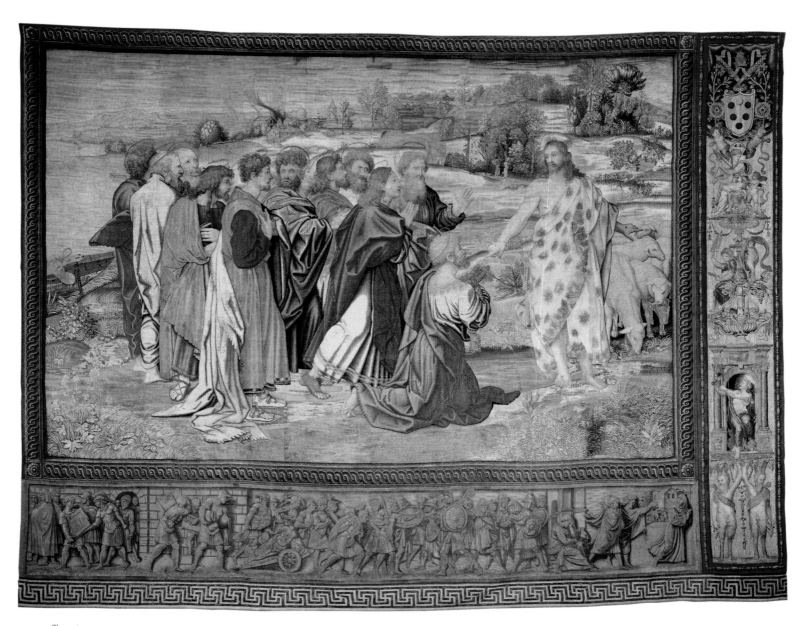

CAT. 2, *Tapestry*

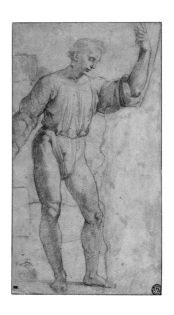

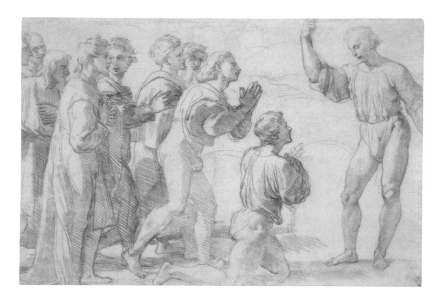

The Cartoon

Light is represented as falling from the right. There is a general consensus that this work was largely painted by Raphael, with a minimum of assistance. There is an unusually free and spontaneous passage of underdrawing at the right of the landscape background. Christ's now-white robe was probably originally a lilac colour, painted with fugitive pigments that have faded. Similarly, the garment of the bearded Apostle behind Peter was probably originally dark green with purple patches of shadow. The Cartoon was cut into vertical strips in Brussels and has been rejoined. Probably for the convenience of the weavers, the main group of figures and two smaller background figures have been carefully cut around, to separate them from the landscape, and later reattached. With the exception of its landscape background, the outlines have been pricked for transfer. The three fragments from a duplicate full-size cartoon, apparently from the sixteenth century (Chantilly, Musée Condé), may have been from a working copy made in Brussels for the weaving of tapestries.

The Tapestry

This tapestry was probably the first to be woven, as it was admired by Antonio de Beatis on 30-31 July 1517 when he and Cardinal Luigi d'Aragona visited the weavers' workshop in Brussels: 'one piece of the story of the *Donation of the Keys*, which is very fine, we saw complete, and from it the cardinal estimated that they would be among the richest in Christendom'. It was also one of the seven tapestries displayed in the Sistine Chapel on 26 December 1519.

Comparison of the tapestry, front and back, and the Cartoon permits some observations

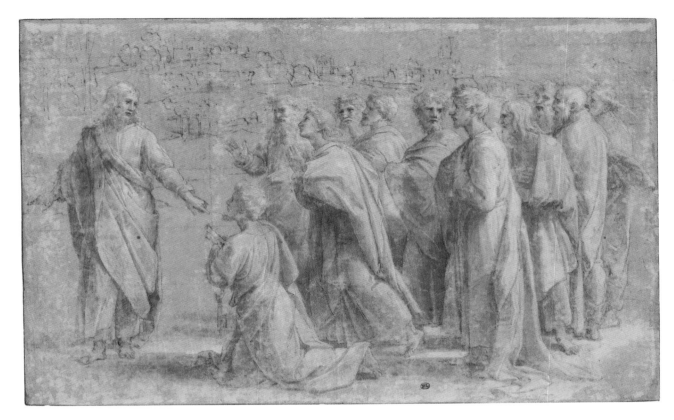

on the changes made by the weavers. In the tapestry Christ's robe is not plain, as it is in the Cartoon, but adorned with stars of gilt-metal-wrapped thread, adding lustre. The pale colour of the robe is no longer uniform, but softened and refined by formerly lilac hues, still evident on the reverse, which have become sky-blue through deterioration of pigments in the dye as a result of light exposure. Additional decoration can also be observed in St Peter's tunic, which appears to be edged with detailed gold embroidery.

Perhaps due to the fading of the colours in the Cartoon, the shades of Peter's robe and John's tunic (John being the third figure to Jesus' right in the Cartoon, and to his left in the tapestry) are markedly different in the tapestry: the yellow of the former corresponds to a bright red in the latter, and the green to a muted blue. However, the very different colours of the other robes cannot be due to fading, but to the preference of the weavers for alternative colour combinations. For example, in the clothing of the Apostle behind John, the green robe over

a white tunic in the Cartoon corresponds to a single shade of blue in the tapestry, also visible on the reverse. Similarly, the yellow robe and white tunic with blue highlights of the Apostle fourth from the right in the Cartoon are both red in the tapestry. This difference is still evident on the reverse of the tapestry, but much less so on the front, where the purplish-red of the robe has changing to beige as a result of prolonged exposure to light.

Another difference is the woven strip of vegetation that separates the heads of the

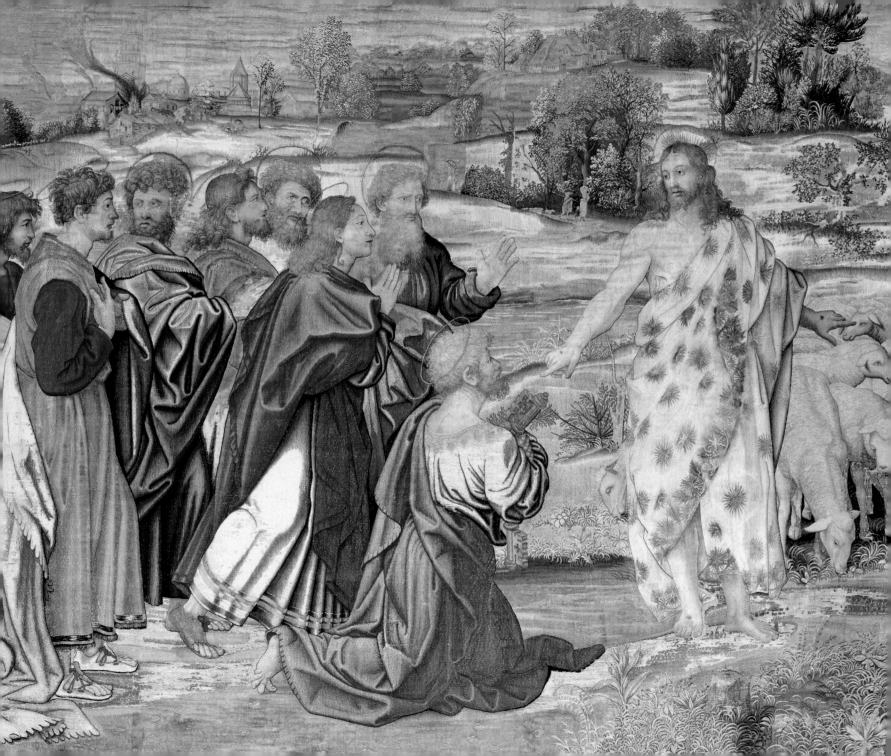

Apostles from the more detailed landscape behind, which appears in the tapestry, but not in the Cartoon. The latter was cut just above the figures' heads, perhaps to permit the insertion of a new strip for weaving or the addition of the strip to a working copy. Unlike the Vatican weaving and that from the lost set acquired by Henry VIII, the two sets completed between the late 1540s and early 1550s (Madrid and Mantua) follow the original Cartoon: the heads are located above the more detailed landscape, as conceived by Raphael.

The Tapestry Borders

The scene is surrounded by a frame with a continuous guilloche design running from left to right and rosettes in the corners. Beneath is a fictive bronze relief. At the bottom is a continuous Greek-key design. The vertical border at the right, in the form of a pilaster with grotesque decoration, is woven together with the central scene.

The fictive relief depicts the expulsion of the Medici family, previously rulers of Florence, from the city in November 1494. Following the invasion of Italy by the French king Charles VIII, a popular uprising forced Cardinal Giovanni de' Medici (the future Leo X) and his brothers Piero and Giuliano to flee in the night. At the left, a mob – represented as warriors in classical armour – are looting the Medici palace on the Via Larga of works of art and other spoils, which they carry away in a cart. In the middle is a group of armed men. At the right a seated personification of Florence laments the departure of the cardinal, who flees disguised as a Franciscan friar.

The vertical border at the right incorporates – set against a brightly shining background of gilt-metal-wrapped thread – the following superimposed motifs (from the top): the Medici arms, the papal insignia of Leo X and two putti; a candelabra-like structure with the three Fates and putti, the whole supported at the bottom by two caryatid figures (see detail). The Fates were responsible for deciding man's destiny, by spinning the thread of life and measuring it out, before cutting it. The caryatids are based on the pair of antique statues of Pan, then in the Della Valle collection, used in 1513 to decorate a temporary triumphal arch in honour of Leo X.

REFERENCES

White and Shearman (1958), pp.204-5, 211, 308-11, 321; Shearman (1972), pp.33-5, 37, 42, 55, 62, 66-8, 79, 84, 89, 96-7, 114, 132, 134, 139-40, 145, 151, 155, 161-3, 211; White (1972), pp.5-8; Joannides (1983), pp.102-3, nos 358-60; Jones and Penny (1983), pp.136-7, 141-2; Bober and Rubinstein (1986), pp.109-10, ill.75; Plesters (1990), pp.112, 115-16, 118, 120, 123; Cordellier and Py (1992), nos 379, 381; Shearman (1992), p.216; Fermor (1996), pp.12-13, 15-16, 20, 24, 26, 56, 58-9, 66, 76, 78-9, 83-5, 89-90; Meyer (1996), pp.5-6; Fermor and Derbyshire (1998), pp.239-40, 243, 246, 249-50; Clayton (1999), no.26; Campbell (2002), no.18, pp.192-3, 204-10; Shearman (2003), nos 1517/14, 1519/66, 1526/4, 1528/8

CAT. 2, *Tapestry* (detail)

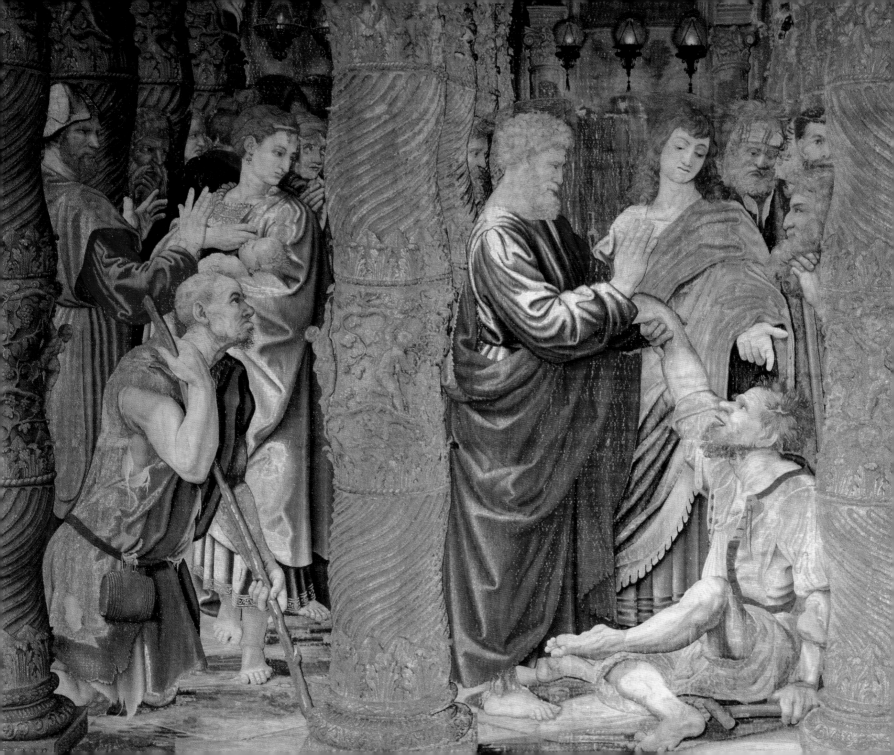

3 The Healing of the Lame Man

Cartoon bodycolour over charcoal underdrawing on paper mounted on canvas, 342 × 536 cm; on loan from HM Queen Elizabeth II; RCIN 912946
Tapestry warp: wool (7 warps per cm); weft: wool (20 wefts per cm), silk (25 wefts per cm), gilt-metal-wrapped thread (18–20 wefts per cm), 501 × 575 cm; Vatican Museums, inv. 43869

ACTS *Chapter 3, verses 1–8*

Now Peter and John went up together into the temple at the hour of prayer, being the ninth hour. And a certain man lame from his mother's womb was carried, whom they laid daily at the gate of the temple which is called Beautiful, to ask alms of them that entered into the temple; Who seeing Peter and John about to go into the temple asked an alms. And Peter, fastening his eyes upon him with John, said, Look on us. And he gave heed unto them, expecting to receive something of them. Then Peter said, Silver and gold have I none; but such as I have give I thee: In the name of Jesus Christ of Nazareth rise up and walk. And he took him by the right hand, and lifted him up: and immediately his feet and ancle bones received strength. And he leaping up stood, and walked, and entered with them into the temple, walking, and leaping, and praising God.

A CROWD IS GATHERED at the 'Beautiful Gate', the *Porta speciosa* between the second and third of the peripheral courts around the Temple of Jerusalem. At the centre stands Peter, healing the lame man, while the youthful John the Evangelist looks on. This act symbolizes Peter's spiritual healing and conversion of the Jews. On either side women come to purify themselves at the Temple after the birth of male children. *The Healing of the Lame Man* was the first of Peter's miracles in the Acts of the Apostles, performed among the Jews. This symmetrical composition of weighty figures and columns provides a massive centrepiece to the *Petrine Cycle*.

SOURCES AND STUDIES

The tripartite division of the scene derives from Early Christian sarcophagi of so-called 'columnar' type, in which the relief sculpture is depicted within an arched colonnade. The ornate, twisted columns are based upon the 12 antique spiral columns that formed the screen of the sanctuary in the old basilica of St Peter's in Rome, which traditionally were believed to have come from Solomon's Temple in Jerusalem. The grouping of the figures resembles the relief of *The Healing of the Lame Man* from the Ciborium of Sixtus IV, and probably Albrecht Dürer's engraving of the same subject, dated 1513, from the Small Passion (Bartsch VII, 40.18).

Although the preparatory studies for this work are lost, copies survive of the left third (pen and brown wash, white heightening, 220 × 125 mm; sold Christie's, 25 June 1968, lot 134, current location unknown) and central third (pen and brown wash, white heightening;

Nuremberg, Germanisches Nationalmuseum, no.12097) of a preparatory *modello*. The latter may have provided the model for the etching of the composition by Parmigianino (Bartsch XII, 78.27 and XVI, 9.7). The composition was also engraved by Battista Franco (Bartsch XVI, 124.15). A further drawing, of indifferent quality, may record a lost early version of the composition (black chalk and sepia wash, white heightening, 267 × 414 mm; Paris, Louvre, inv. 3988). Raphael also reused an autograph study of the head of a woman, made in 1509–10 for a muse in the Vatican fresco of *Parnassus* (black chalk, 264 × 207 mm; Florence, Horne Museum, inv. 5643) for the head of the woman with a child at the right of the Cartoon.

The Cartoon

The construction of the paper mosaic support is less tidy than that of the others, with numerous patches and repairs. Light is represented as falling from the right. Overall, the underdrawing is rather crude and sketchy. However, the columns are carefully drawn, and their sculpted motifs composed directly; their decorative putti are very spontaneously drawn, perhaps by Raphael's pupil Giulio Romano. Raphael seems to have painted the grotesque heads of the two crippled men and the beautiful figure of a woman with a baby at the right. He may also have drawn the head of St Peter, although its quality is marred by losses. The woman's garment was probably originally lilac with some areas of blue, but has faded, as has that of the crippled man before her. The Cartoon was cut into vertical strips by the weavers and has been rejoined; it has also been pricked for transfer.

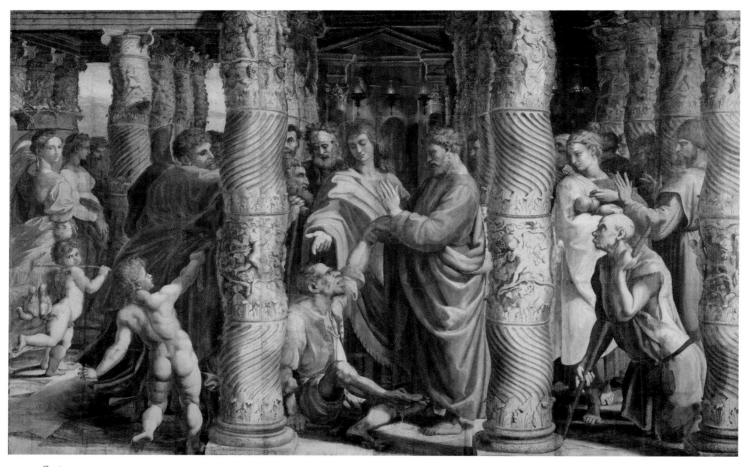

CAT. 3, *Cartoon*

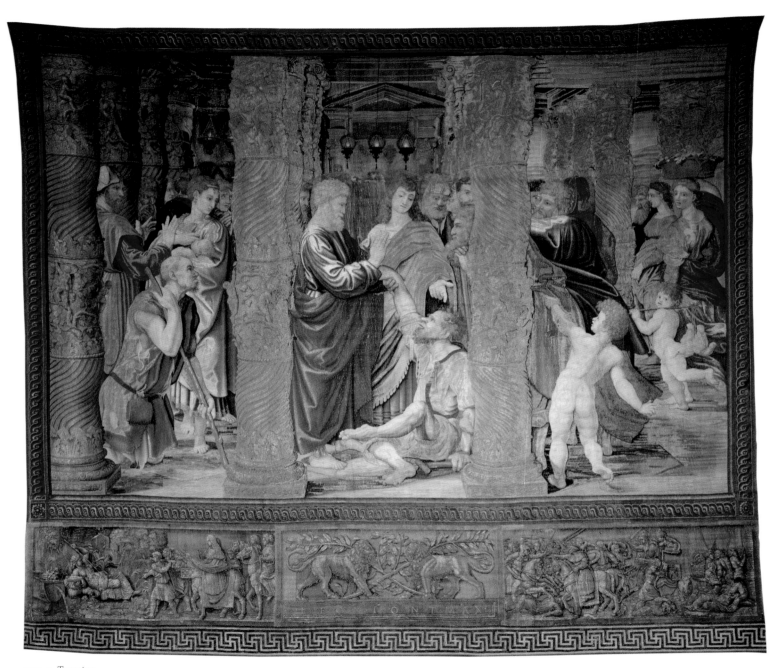

CAT. 3, *Tapestry*

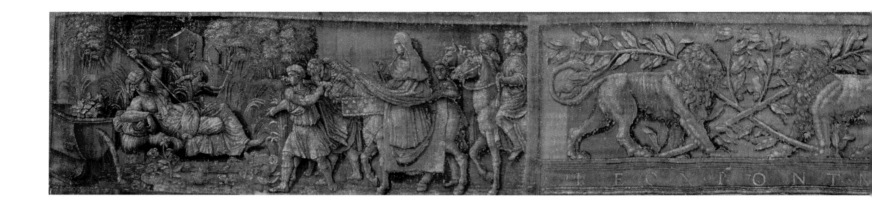

A duplicate full-size version, apparently of sixteenth-century date and traditionally once in the collection of Sir Joshua Reynolds (Dublin, National Gallery of Ireland, NGI 171; fig. 37), may be one of the copies mentioned in a 1573 letter to Cardinal Granvelle.

The Tapestry

This is one of the seven tapestries displayed at the Sistine Chapel on St Stephen's Day 1519.

There are a number of differences between the Cartoon and the tapestry, when examined on the front and on the back, where the damage caused by light exposure is less evident. The columns in the tapestry are much brighter than those in the Cartoon, due to the extensive use of gilt-metal-wrapped thread. There are also some differences in the colours used for the clothes. Peter's yellow cloak has been changed to red in the tapestry, while John's cloak, which appears beige on the front of the tapestry, is a purplish-red on the reverse – a colour similar

to that in the Cartoon. The tunic of the central lame man is sky-blue edged with red in the Cartoon, while in the tapestry it has yellow and green highlights; the tunic of the other paralytic, which appears very faded in the Cartoon, is blue in the tapestry. The colours of the clothes worn by the woman with a child are much stronger on the reverse of the tapestry than on its front, or in the Cartoon. The greenish tunic and the pale cloak with traces of blue in the Cartoon are replaced by a green cloak over a blue tunic in the tapestry. The rest of the tapestry seems to follow the Cartoon in terms of the figures and the architecture.

The Tapestry Borders

The scene is surrounded by a frame with a continuous guilloche design running from left to right and rosettes in the corners. Beneath is a fictive bronze relief. At the bottom is a continuous Greek-key design.

The fictive relief was woven separately from the rest of the tapestry and is made up of three separate parts, joined by seams on either side of the central section (see detail). In the centre appears a pair of confronted lions emblematic of Leo X, with palm branches, standing on a pedestal with the inscription .LEO.X.PONT.MAX. The other two scenes are not in sequence, so that the earlier event is depicted on the right and the later one on the left. Both occurred during the pontificate of Julius II, following his appointment of Cardinal Giovanni de' Medici (the future Leo X) as commander of the papal troops campaigning against the French. The scene on the right represents the capture of the cardinal by the victorious French at the Battle of Ravenna on 11 April 1512. He was later freed by an army of peasants, and the scene on the left depicts his safe arrival at Mantua, which is identified by the nymph Amymone and the Virgilian fountain.

The transposition of the two scenes may have occurred because the fictive relief is a replacement for a destroyed original, or was

damaged and put back in the wrong order after repair, or even because the scenes were removed from another tapestry and reused. It is also possible that the central part had to be rewoven in Brussels because its accompanying text had been accidentally reversed at the first attempt.

Whatever happened, the positioning of the two scenes could not have been different, as the left scene showing the cardinal's escape has the original blue edging on the left and has been cut along a dark-brown strip of shadow on the right. The scene was therefore designed to be located to the left of the viewer. The other scene has edging on its right and was therefore created as the right-hand end section, beginning on the left with a pale-brown strip bearing traces of a pattern. The central zone with the lions does not have lateral blue edging, but both sides have been cut, ending on the side of the *Escape* with a narrow pale-brown strip, while on the other side the tapestry ends with a dark-brown colour. The lack of a blue edging means that the piece was not originally made to these dimensions, but must have been adapted.

The most striking feature of the three parts is the much rustier colour of the background compared to all the other lower borders in the series, which are more of a golden yellow. This could support the hypothesis that the three pieces were all part of a single border adapted in some way. Technically, the weaving of the three parts is practically identical and does not differ from that of the other tapestries in the series, suggesting that it was made in the same workshop and at the same time, or only shortly afterwards.

The difference in colour could also suggest that this piece was remade, perhaps after the Sack of Rome, to replicate a lost original. If so, the weavers may have had trouble reproducing the background colour exactly, as they would not have had the opportunity of comparing it to that of the other borders. This could also apply to the dimensions. Lacking direct comparison with the central part, the lower border may have been made slightly too long and then had to be cut to size, when joining it to the central tapestry.

It has been suggested that the tapestry once had a side border, perhaps that of the *Seasons* (see cat. 11 below). Recent restoration work has shown that it did not have a side border woven together with the tapestry in the same way as the others that survive, as it has fragments of a blue edging on both sides. The border panel of the *Seasons* may have been woven together with another scene, given that it has been cut along the red strip on both sides and is 10 cm shorter than *The Healing of the Lame Man*.

REFERENCES

White and Shearman (1958), pp.198, 206–7, 310–12, 322; Shearman (1972), pp.34–5, 37, 55–7, 63, 67–8, 80, 84–5, 97–9, 112–15, 119, 128, 132, 134–5, 145, 155, 163, 211; White (1972), pp.6, 8–9; Joannides (1983), no.244; Jones and Penny (1983), pp.138, 142; Harprath (1984), no.92c; Plesters (1990), pp.118, 122; Cordellier and Py (1992), no.384; Shearman (1992), p.206; Nesselrath (1993), pp.144–7; Fermor (1996), pp.14–16, 20, 24, 58, 69, 76, 82, 85, 87–8, 92–3; Meyer (1996), pp.6–9; Fermor and Derbyshire (1998), pp.241–3, 246, 249; de Strobel (1999), no.315; Shearman (2003), nos 1519/66, 1573/3, 1575–6

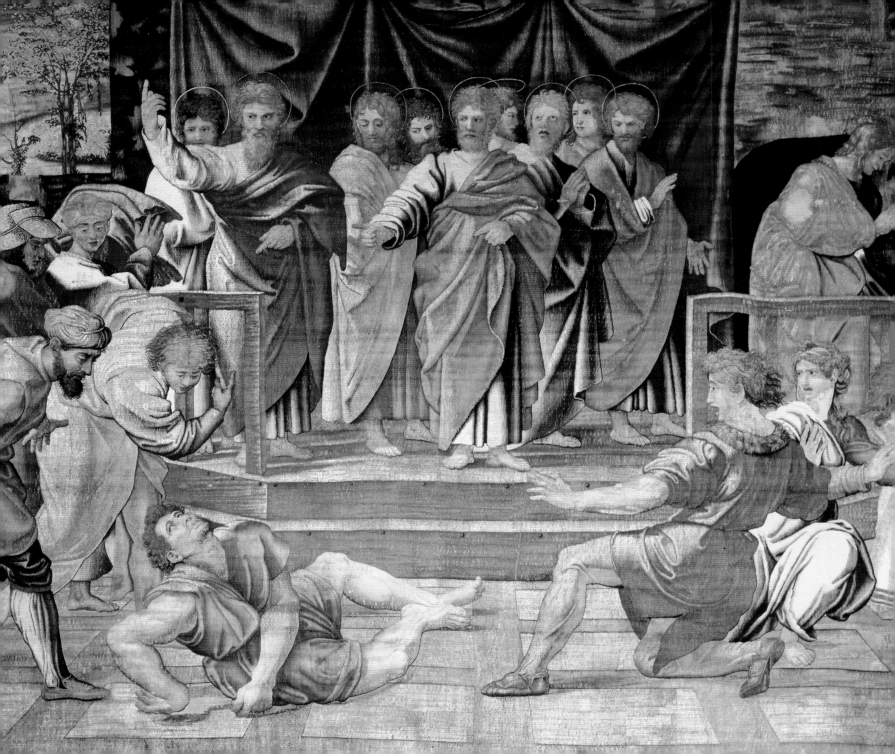

4 The Death of Ananias

Cartoon bodycolour over charcoal underdrawing on paper mounted on canvas, 342 × 532 cm; on loan from HM Queen Elizabeth II; RCIN 912947
Tapestry warp: wool (6.8–7.2 warps per cm); weft: wool (18–24 wefts per cm), silk (16–18 wefts per cm), gilt-metal-wrapped thread (14–17 wefts per cm), 488 × 631 cm; Vatican Museums, inv. 43870

ACTS *Chapter 5, verses 1–5*

But a certain man named Ananias, with Sapphira his wife, sold a possession, and kept back part of the price, his wife also being privy to it, and brought a certain part, and laid it at the apostles' feet. But Peter said, Ananias, why hath Satan filled thine heart to lie to the Holy Ghost, and to keep back part of the price of the land? Whiles it remained, was it not thine own? and after it was sold, was it not in thine own power? why hast thou conceived this thing in thine heart? thou has not lied unto men, but unto God. And Ananias hearing these words fell down, and gave up the ghost: and great fear came on all them that heard these things.

THE APOSTLES PERSUADED wealthy men to sell off land and property so that the proceeds could be distributed to the poor. One of them, Ananias, secretly kept back some of the proceeds from the sale of his property. Peter rebukes him for his greed and deceit, and Ananias falls down, dying, in front of the townspeople, who react in shock. At the left of the Cartoon, Apostles give alms to the poor. At the right, two men carry in goods, while Ananias' wife, Sapphira, in a green gown, counts her coins, oblivious to her husband's fate. She also kept back some of her wealth, and three hours later was herself struck dead. After the death of Ananias, deacons were appointed with responsibility for the common goods of the Church. In this episode Peter punishes the Jews for disobedience. The miracle was also interpreted as the punishment of simony (embezzlement of Church funds). Ironically, Pope Leo himself was accused of improperly diverting money for the commission of the Sistine tapestries. Here, the elevated and impassive central block of Apostles cleaves between the two lesser groups, whose subordination is emphasized by their bent poses and the centrifugal motion of the foreground figures.

SOURCES AND STUDIES

The main feature of the composition, with the principal protagonists standing on a dais, flanked by onlookers, reflects the late antique relief of the *Oratio Augusti* from the Arch of Constantine, while the collapsing figure of Ananias may be based on an antique statue of the *Dying Gaul*. The pose of the woman with upraised hands looking back at the dying Ananias is derived from Michelangelo's *Death of Haman* from the Sistine Ceiling.

No preparatory studies for this composition survive, but its lost preparatory *modello* may have been the source for the engraving after it attributed to Agostino Veneziano (Bartsch XIV, 47.42, cat. 4.1), which may date from 1516.

CAT. 4.1
Agostino Veneziano after Raphael, *The Death of Ananias*, c.1516, engraving, first state; V&A: Dyce 1065

CAT. 4, *Tapestry* (detail)

89

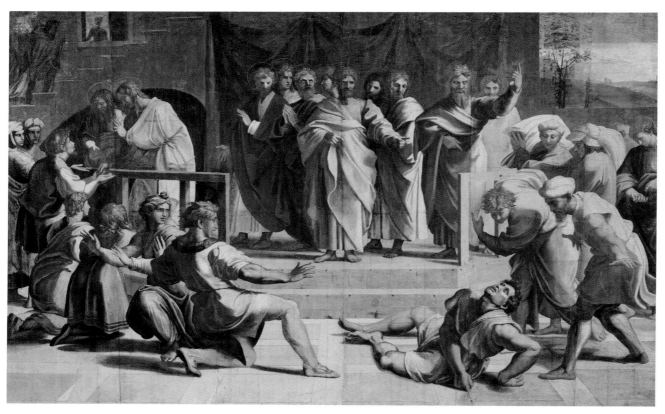

CAT. 4, *Cartoon*

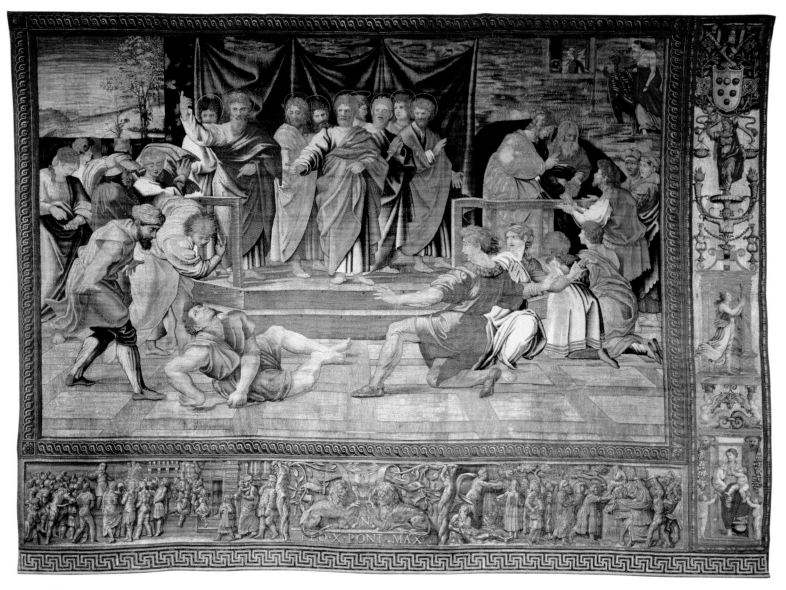

CAT. 4, *Tapestry*

blue and the colour of his cloak, now beige
on the front, suggests – on the basis of other
examples – that it was originally purplish-red.
The clothes of the two figures to the left of
Ananias may have been interpreted differently
from those in the Cartoon. Their uniform beige
colour does not convey the extensive use
of chiaroscuro and colour observed in the
Cartoon. The striking light-blue sleeve of
the crouching woman at the front right has
been changed to red in the tapestry.

The composition of the tapestry extends
slightly further to the left than at the correspon-
ding edge of the Cartoon, including the whole
of the trailing tunic of the bearded man in the
foreground, and the greater part of the figure
of Sapphira. The discrepancy could be due to
the loss of the edge of the Cartoon, or to an
increase required by the desired dimensions
of the weaving. The same can be observed,
to a lesser extent, at the bottom edge.

Agostino's print was copied by Ugo da Carpi
in a fine chiaroscuro woodcut, one version of
which is dated 1518 (Bartsch XII, 46.27, cat. 4.2).

was cut into vertical strips by the weavers and
has been rejoined; it has also been pricked for
transfer.

The Cartoon

Light is represented as falling from the right,
and the foreground perspective engages the
spectator's eye level. While the figure of
Ananias and the alarmed woman are probably
by Raphael, the histrionic recoiling man has
been attributed to Giulio Romano. The cruder
and more schematic figures of the Apostles
seem to be largely by assistants. Their drapery
is broadly painted, and the headdresses of the
two women at the extreme left use the bare
paper support, with only a few strokes of paint.
The pink colours of Ananias' garment and the
robe of the Apostle distributing alms at the left
have probably faded considerably. The Cartoon

The Tapestry

This is one of the three tapestries that were
not delivered in time for display at the Sistine
Chapel on 26 December 1519. As it has not yet
been conserved, and its back is covered by
supports attached during earlier conservation
programmes, comparison can only be made
between its front and the Cartoon.

St Peter has a yellow cloak in the Cartoon,
which has been changed to red adorned with
gold highlights in the tapestry. This difference
applies to all the depictions of the saint in the
cycle. The figure on the right, near St Peter,
appears in a pale tunic and terracotta cloak in
the Cartoon, while in the tapestry his tunic is

The Tapestry Borders

The scene is surrounded by a frame with a
continuous guilloche design running from left
to right and rosettes in the corners. Beneath
is a fictive bronze relief. At the bottom is a
continuous Greek-key design. These, and the
vertical border at the right, in the form of a
pilaster with grotesque decoration, were woven
together with the central scene. The lateral
edgings are original.

The fictive relief is divided into three zones,
with imagery referring to the renewed supremacy
of the Medici with the triumphant return of the
cardinal and his family to Florence in 1512.

In the centre appear a pair of confronted

lions emblematic of Leo X with his device of a yoke, alluding to his motto 'the ring unites, the yoke is easy', standing on a pedestal with the inscription .LEO.X.PONT.MAX., and a pair of herms represented as old laurel trees sprouting tendrils, which may allude to the renewal of the Medici through Leo X. The cardinal reputedly adopted the device of a yoke to signify that his rule would be clement and mild. The yoke is combined with the letter *N*, which probably signifies the word *Nostrum*, as in *Jugum nostrum suave* ('Our agreeable yoke').

With the support of Pope Julius II, the cardinal defeated the Florentine army, and his solemn entry to Florence on 14 September 1512 is illustrated on the right of the fictive relief. He is greeted by a cheering crowd and by a personification of the city, arms outstretched, standing between two lions and a river god, symbolic of the River Arno. The scene on the left is identifiable, by the presence of Michelangelo's *David*, as the Palazzo Vecchio at the Piazza della Signoria in Florence. It probably represents the occupation of the Palazzo, two days after the return of the Medici, by their supporters. The figure addressing the crowd may be Giovan Battista Ridolfi, who was later elected *Gonfaloniere* (governor) of the city.

The vertical border at the right incorporates the following superimposed motifs (from the top): the Medici arms and the papal insignia of Leo X; a set of scales, probably alluding to the Cardinal Virtue of Justice; and the three Theological Virtues, Faith, Hope and Charity (I Corinthians 13:13). Faith holds a chalice and stands on a candelabrum; Hope stands before a *tempietto* supported by a pair of sphinxes; and Charity nurses four children in a *tempietto* draped with swags (see detail).

REFERENCES

White and Shearman (1958), pp.203, 205-6, 210-11, 312-14, 322; Shearman (1972), pp.34-7, 43, 57, 63, 85, 88-9, 99-101, 114, 120-21, 129, 131-2, 134, 136, 141, 143, 147, 155, 211; White (1972), pp.5-6, 8-9; Jones and Penny (1983), p.138; Bober and Rubinstein (1986), no.151; Lewine (1990), p.274; Shearman (1992), pp.204-5, 216-17, 238-9; Fermor (1996), pp.14-16, 24, 50, 52-4, 56, 58, 60, 62, 66, 68-9, 76-8, 81, 85-7, 92; Meyer (1996), pp.9-11; Fermor and Derbyshire (1998), pp.236, 244, 249; Shearman (2003), no.1519/66

CAT. 4, *Tapestry* (detail)

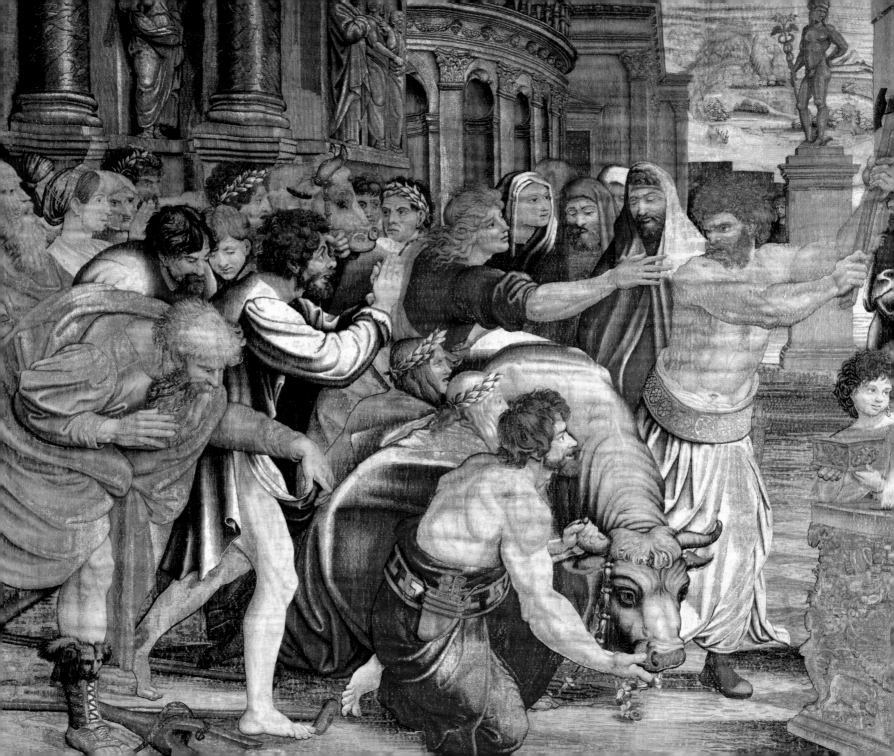

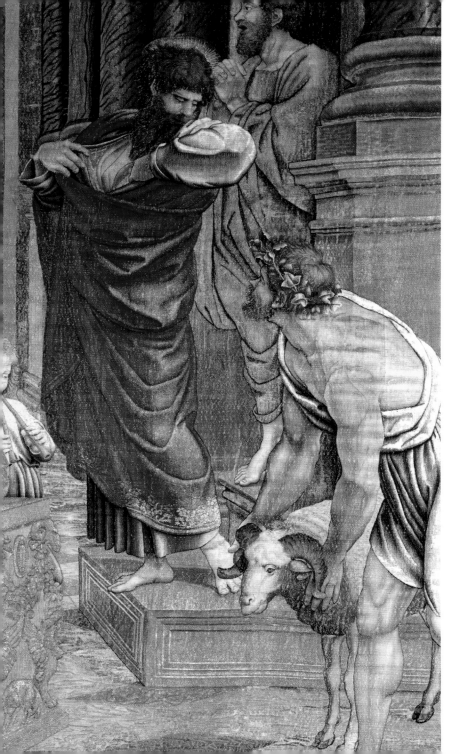

The Story of St Paul
(*The Pauline Cycle*)

Known later as 'The Prince of Preachers', Paul was a Roman citizen and an Apostle, but not one of the original 12. He reputedly went to Rome, and was martyred on the same day as St Peter; his tomb is believed to be at the major basilica of San Paolo fuori le Mura. From an early date he was paired with Peter as one of the founders of the Roman Church, with the mission of converting the Gentiles. Their joint feast is kept on 29 June. Paul was present at the martyrdom of St Stephen, the first martyr, whose feast day is 26 December. This cycle emphasizes Paul's conversion, his authority to punish or heal, and especially the power of his preaching, but omits a concluding scene of his martyrdom.

5 The Stoning of Stephen

Cartoon lost; probably in the collection of Ferdinand de' Medici in Florence in 1627
Tapestry warp: wool (7.4 warps per cm); weft: wool (18–22 wefts per cm), silk (18–22 wefts per cm), gilt-metal-wrapped thread (20–22 wefts per cm), 450 × 370 cm; Vatican Museums, inv. 43871

ACTS *Chapter 7, verses 54–60*

When they heard these things, they were cut to the heart, and they gnashed on him with their teeth. But he, being full of the Holy Ghost, looked up steadfastly into heaven, and saw the glory of God, and Jesus standing on the right hand of God, and said, Behold, I see the heavens opened, and the Son of man standing on the right hand of God. Then they cried out with a loud voice, and stopped their ears, and ran upon him with one accord, and cast him out of the city, and stoned him: and the witnesses laid down their clothes at a young man's feet, whose name was Saul. And they stoned Stephen, calling upon God, and saying, Lord Jesus, receive my spirit. And he kneeled down, and cried with a loud voice, Lord, lay not this sin to their charge. And when he had said this, he fell asleep.

STEPHEN WAS ONE OF the seven men ordained by the Apostles as the first deacons responsible for the distribution of goods to the needy. He performed miracles and was falsely accused of blasphemy. Stephen rebuked his accusers and received an apparition of Jesus and God the Father, visible at the top right of the tapestry. He was taken out and stoned to death. The young man named Saul, the future St Paul, who consented to Stephen's death and guarded his executioners' garments, appears as a seated figure at the far right of the tapestry. The snow-clad hills in the background may allude to the path to martyrdom, which the sixth-century poet Arator likened to a snowy mountain slope. As the first martyr, Stephen occupies a special place in the calendar of saints. This subject relates to *The Death of Ananias*, which shows the distribution of goods, and introduces Saul, who as St Paul is the principal subject of this cycle. While the weighty group of muscular executioners bears down on the crouching saint, his soaring pose and upturned glance suggest the spirit's flight.

SOURCES AND STUDIES

Raphael would have been familiar with the traditional iconography of this subject, as represented in the late thirteenth-century fresco in the *Sancta sanctorum* of Nicholas III at the Lateran, and the later frescoes of Fra Angelico in the Chapel of Nicholas V in the Vatican and of Filippo Lippi at Prato Cathedral. Raphael's own earlier sketch of the subject, made around 1507–8 (pen, 267 × 420 mm; Vienna, Albertina, Bd. V, 211), incorporates a number of figures that are reused here, including a seated figure of Saul.

The Tapestry

This is one of the seven tapestries that arrived in Rome before 26 December 1519. As its Cartoon is lost, it is only possible to compare the colours on the front and back of the tapestry itself. The only significant observations concern two figures: the robe of the figure on the far left is beige on the front and purplish-red on the reverse, and the tunic worn by Christ, at top right, has undergone a similar colour change.

The Tapestry Borders

The scene is surrounded by a frame with a continuous guilloche design running from right to left and lions' heads, symbolic of Leo X, in the corners. Beneath is a fictive bronze relief, which was woven together with the main scene. At the bottom is a continuous Greek-key design, which was woven separately. Only the left edging is original.

The episode depicted in the fictive relief occurred directly after that represented in the relief below *The Miraculous Draught of Fishes* (see cat. 1 above). Shortly after Giovanni de' Medici was made a cardinal, he was appointed *legate a latere* of the Florentine dominion on 11 May 1492. This scene represents his ceremonial entry into Florence, where he is greeted by a female personification of the city and by citizens. At each side of the composition appears a river god, probably representing the rivers Arno and Mugnone. The mounted Roman soldier in the cardinal's entourage was inspired by a figure from the *Passage of the Danube* on Trajan's Column.

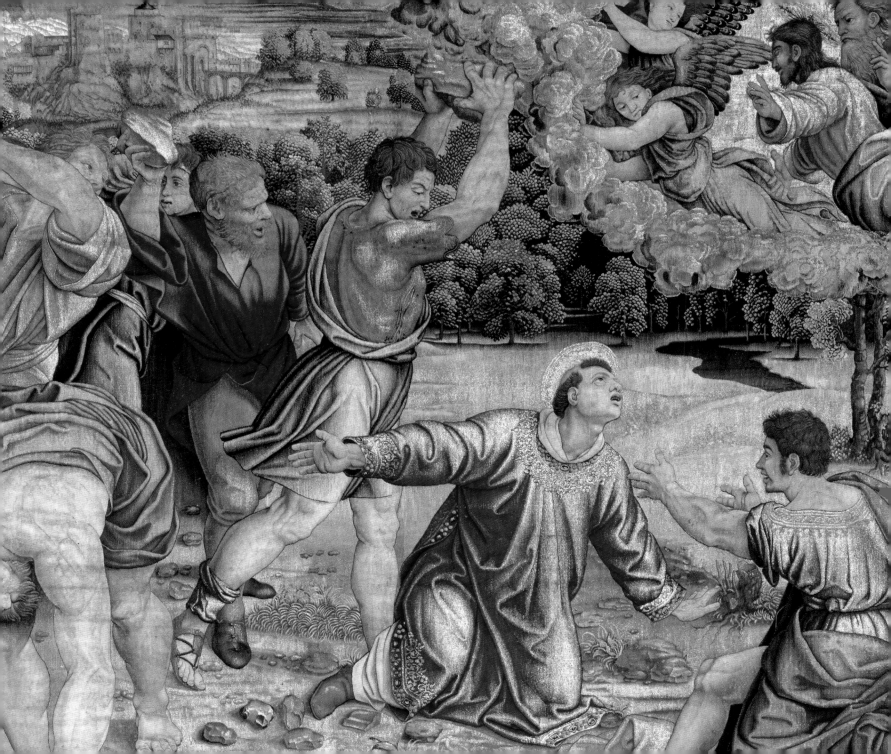

There may be an implied link between the main scene and that represented in the fictive relief: St Stephen, the first deacon, was given the mission of spreading the word of God, and Giovanni de' Medici, in accepting his first mission, vowed to serve the Church against all adversities.

REFERENCES

White and Shearman (1958), pp.198–9, 200, 202–4, 206, 314–16, 321; Shearman (1972), pp.31–2, 34–6, 57–8, 84, 86, 101, 110, 121, 211–12; Jones and Penny (1983), p.141; Harprath (1984), no.92a; Howarth (1994), pp.155–8; Fermor (1996), pp.14–16; Shearman (2003), no.1519/66

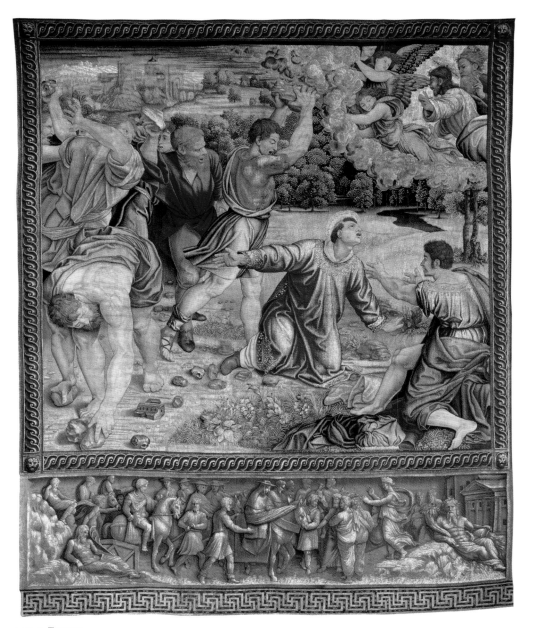

CAT. 5, *Tapestry*

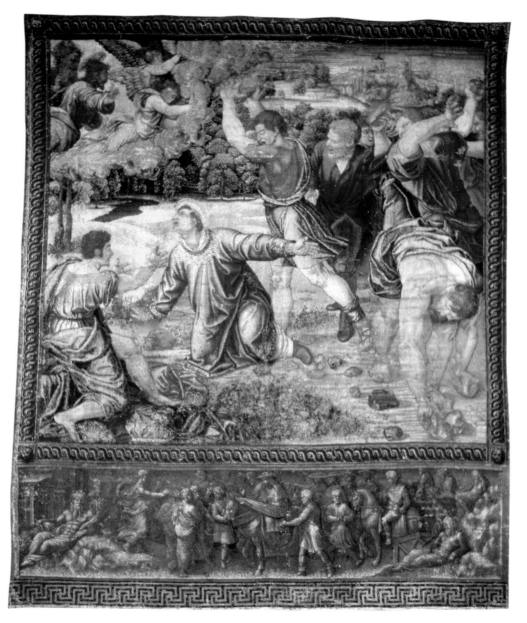

CAT. 5, *Tapestry* (reverse)

6 The Conversion of Saul

Cartoon lost; recorded in the collection of Cardinal Domenico Grimani in Venice in 1521 and that of Cardinal Marino Grimani in 1526; probably in the collection of Ferdinand de' Medici in Florence in 1627
Tapestry warp: wool (6.8–7.2 warps per cm); weft: wool (18–20 wefts per cm), silk (20–22 wefts per cm), gilt-metal-wrapped thread (22 wefts per cm), 464 × 533 cm; Vatican Museums, inv. 43872

ACTS *Chapter 9, verses 1–7*

And Saul, yet breathing out threatenings and slaughter against the disciples of the Lord, went unto the high priest. And desired of him letters to Damascus to the synagogues, that if he found any of this way, whether they were men or women, he might bring them bound unto Jerusalem. And as he journeyed, he came near Damascus: and suddenly there shined round about him a light from heaven: and he fell to the earth, and heard a voice saying unto him, Saul, Saul, why persecutest thou me? And he said, Who art thou, Lord? And the Lord said, I am Jesus whom thou persecutest: it is hard for thee to kick against the pricks. And he trembling and astonished said, Lord, what wilt thou have me to do? And the Lord said unto him, Arise, and go into the city, and it shall be told thee what thou must do. And the men which journeyed with him stood speechless, hearing a voice, but seeing no man.

WHEN THE ROMAN CITIZEN Saul was travelling to Damascus to arrest Christians he received an apparition of Christ and was struck blind. Although unsupported by the biblical text, it was traditional to represent him falling from a horse, surrounded by startled horsemen. Saul wears the armour of a Roman legionary: a helmet with prominent cheek-pieces and neck protection, and a cuirass or *lorica segmentata* of jointed hoops of iron. His sword, of sixteenth-century pattern, is prominently depicted; as the weapon with which he was ultimately martyred, it became his attribute. The totality of Saul's overthrow is emphasized by his supine opposition to the overwhelming momentum of the oncoming group. Once converted, he recovered his sight and became the missionary St Paul.

SOURCES AND STUDIES

For the figure of Saul facing the apparition, juxtaposed with the running soldier, Raphael seems to have recalled the miniature of the same subject in the Urbino Bible (Biblioteca Apostolica Vaticana, Urb. Lat. 2, fol. 250), made in Florence for Federico da Montefeltro in 1476–8. The surging equestrian group at the right of the tapestry derives from Leonardo's lost fresco of the *Battle of Anghiari*, painted in 1505, while the groom struggling with the runaway horse at the left quotes from the antique statues of the *Dioscuri* on the Quirinale in Rome.

A preparatory study survives of the running soldier and the two gesticulating horsemen hurrying to Saul's aid (red chalk over stylus, 313 × 241 mm; formerly Chatsworth, no.905; private collection). Another version of this study is usually considered to be a close copy

(red chalk, 247 × 242 mm; Haarlem, Teylers Museum, A.78v).

The Tapestry

This is one of the tapestries exhibited in the Sistine Chapel on 26 December 1519.

As its Cartoon is lost, the original colouring can only be assessed by studying the back of the tapestry, which has not suffered as the front has from light exposure. The general deterioration of the colours into an overall beige, when viewed from the front, corresponds to a prevalence of orange-red tones on the back. The figure of Christ in his purplish-red tunic, surrounded by clouds and sunrays, was highlighted by the use of wool, silk and gilt-metal-wrapped threads ranging from white to bright orange, but this can no longer be appreciated. A touch of colour was also given to the figure with a spear in the foreground, who was portrayed wearing a bright orange-red tunic.

This tapestry and *Paul Preaching at Athens* (see cat. 10 below) were stolen during the Sack of Rome in 1527 and were only returned to the papal collections after many vicissitudes. Isabella d'Este redeemed them from the sackers, but the ship taking them to Mantua was seized by Turkish pirates, from whom they passed to the King of Tunisia. They were acquired by the sea captain Contarino Cacciadiavoli, who took them and two older pieces from the papal collections to Constantinople, where they were purchased for 3,000 scudos by Zuanantonio Venier, at whose house in Venice they were seen by Marcantonio Michiel in 1528. Subsequently they were taken to France. In 1554 the two tapestries were given to Julius III by

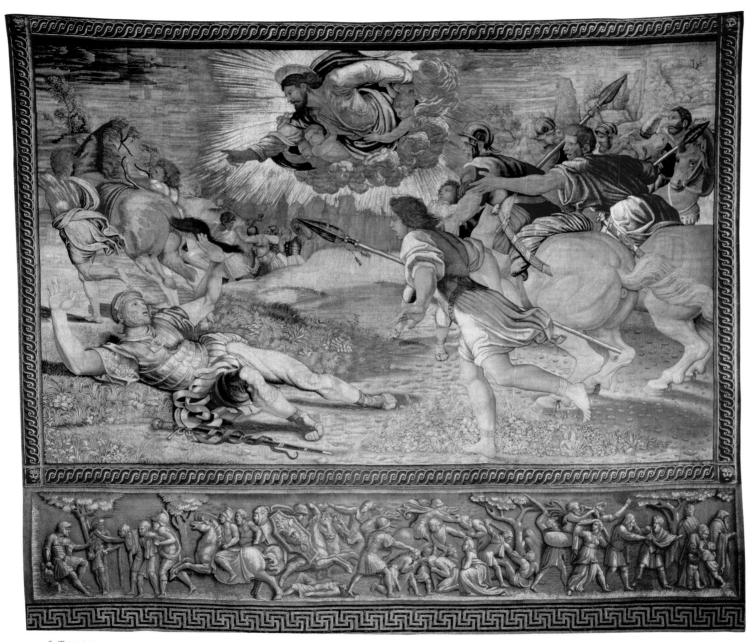

CAT. 6, *Tapestry*

the Constable of France, Anne de Montmorency, as recorded in the Inventory of the *Floreria* (the papal storeroom): 'two gold cloths from the chapel, made in the time of Leo X, which were stolen during the Sack of Rome; the Constable of France found them in Constantinople, much damaged, and had them repaired and returned to His Holiness on 29 September 1554'.

The Tapestry Borders

The scene is surrounded by a frame with a continuous guilloche design running from right to left and lions' heads, symbolic of Leo X, in the corners. Beneath is a fictive bronze relief, which was woven together with the main scene. At the bottom is a continuous Greek-key design, which was woven separately. Given the presence of the original edging on both sides, *The Conversion* could not have been woven with any side borders, but may have been accompanied by borders woven separately.

The subject matter of the fictive relief connects *The Stoning of Stephen* with *The Conversion of Saul*, directly above. It illustrates events following Stephen's martyrdom: 'And at that time there was a great persecution against the church which was at Jerusalem; and they were all scattered abroad throughout the regions of Judaea and Samaria except the apostles . . . As for Saul, he made havoc of the church, entering into every house, and haling men and women committed them to prison' (Acts 8:1–3). Armed horsemen and foot soldiers in antique armour occupy most of the scene, attacking men, women and children. At the left a prisoner is led before Saul, who is depicted wearing the same costume as in the *Conversion* above. The frieze makes reference to ancient Roman reliefs, especially the bearded horseman with flying hair looking back, and the soldier attacking the woman as she attempts to protect her children, derived from the column of Marcus Aurelius.

REFERENCES

Archivio di Stato, *Camerale I*, n.1557, f.102v; White and Shearman (1958), pp.198, 202, 204, 206, 211, 316–17, 321; Shearman (1972), pp.31, 34–5, 62–3, 101–2, 121, 128, 132, 139–41, 144–5, 211; Joannides (1983), nos 337v, 362; Jones and Penny (1983), p.141; Bober and Rubinstein (1986), no.125; Shearman (1992), pp.223, 252; Jaffé (1994), no.314; Howarth (1994), pp.155–8; Fermor (1996), pp.14, 16–18; Campbell (2002), no.23, pp.192–3, 204–10; Shearman (2003), nos 1519/66, 1521/44, 1526/4, 1528/8, 1528/10, 1541/4

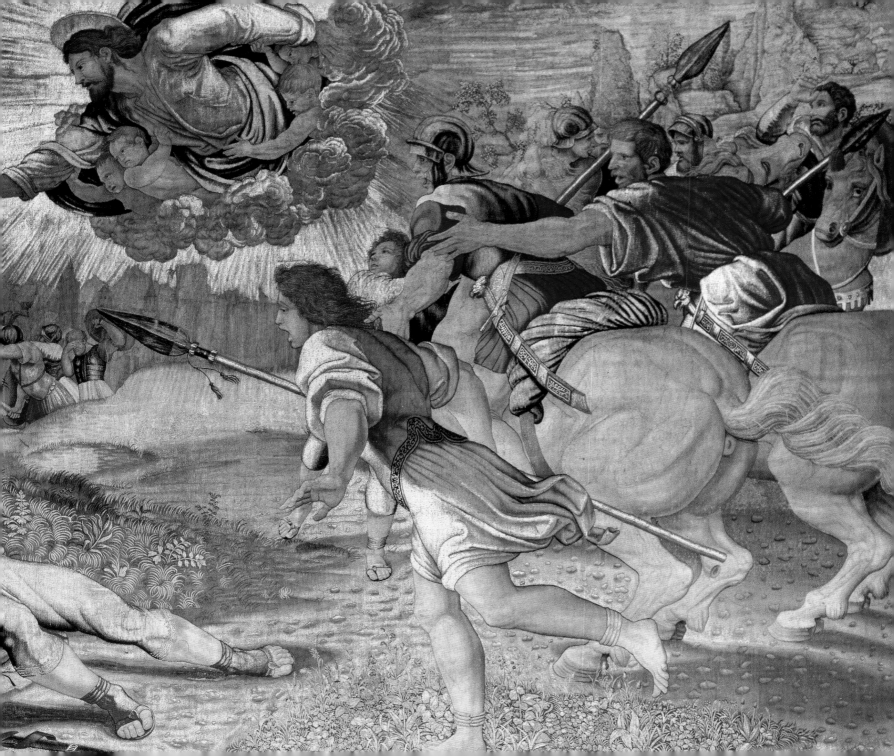

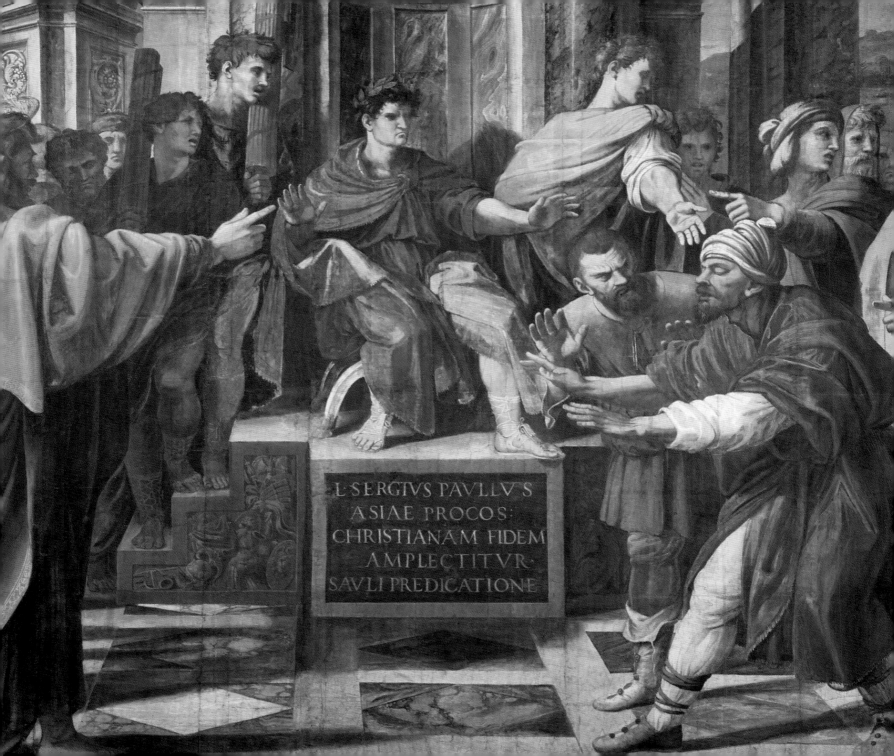

L·SERGIVS·PAVLLVS
ASIAE·PROCOS:
CHRISTIANAM·FIDEM
AMPLECTITVR·
SAVLI·PREDICATIONE

7 The Conversion of the Proconsul

Cartoon bodycolour over charcoal underdrawing on paper mounted on canvas, 342 x 446 cm; on loan from HM Queen Elizabeth II; RCIN 912948
Tapestry warp: wool (7.2–7.6 warps per cm); weft: wool (18–22 wefts per cm), silk (20–23 wefts per cm), gilt-metal-wrapped thread (18–20 wefts per cm), 220 × 579 cm (original part), 501 × 579 cm (with addition); Vatican Museums, inv. 43873

ACTS *Chapter 13, verses 6–12*

And when they had gone through the isle unto Paphos, they found a certain sorcerer, a false prophet, a Jew, whose name was Bar-jesus: which was with the deputy of the country, Sergius Paulus, a prudent man; who called for Barnabas and Saul, and desired to hear the word of God. But Elymas the sorcerer (for so is his name by interpretation) withstood them, seeking to turn away the deputy from the faith. Then Saul (who also is called Paul), filled with the Holy Ghost, set his eyes on him, and said, O full of all subtlety and all mischief, thou child of the devil, thou enemy of all righteousness, wilt thou not cease to pervert the right ways of the Lord? And now, behold, the hand of the Lord is upon thee, and thou shalt be blind, not seeing the sun for a season. And immediately there fell on him a mist and a darkness; and he went about seeking some to lead him by the hand. Then the deputy, when he saw what was done, believed, being astonished at the doctrine of the Lord.

THE SORCERER ELYMAS sought to prevent Barnabas and Paul from converting the Roman proconsul Sergius Paulus to Christianity, and was struck blind by Paul. The proconsul was converted, as the text on the plinth below his throne explains: 'Lucius Sergius Paulus, Proconsul of Asia, embraces the Christian faith through the preaching of Paul.' This was the first of Paul's miracles in the Acts of the Apostles, performed among the Gentiles. In the centre, the proconsul, wearing a toga and a laurel wreath, occupies the seat of justice in a splendidly marbled apse or tribune, the focal point reserved for magistrates in a Roman basilica. To his left, each of the pair of lictors (attendant officers) craning their heads to witness the miracle holds a *fasces*, the bundle of rods tied together with an axe that symbolize his authority to administer corporal or capital punishment. At the right of the Cartoon, Elymas wears the baggy leggings and soft cap of a barbarian. This symmetrical composition occupies a central location within the cycle. Paul's emphatic gesture is relayed by the outstretched hands of the proconsul and his aide to the afflicted Elymas, whose groping arms suggest a feeble riposte.

SOURCES AND STUDIES

This composition belongs to a tradition of judgement scenes and representations of saints confounding pagans before rulers, including Sebastiano del Piombo's *Judgement of Solomon*, now at Kingston Lacey in Dorset, and Ghirlandaio's fresco of the *Trial by Fire before the Sultan*, in the Sassetti Chapel at S. Trinita in Florence. Sir Joshua Reynolds already recognized in 1784 that the block-like figure of St Paul

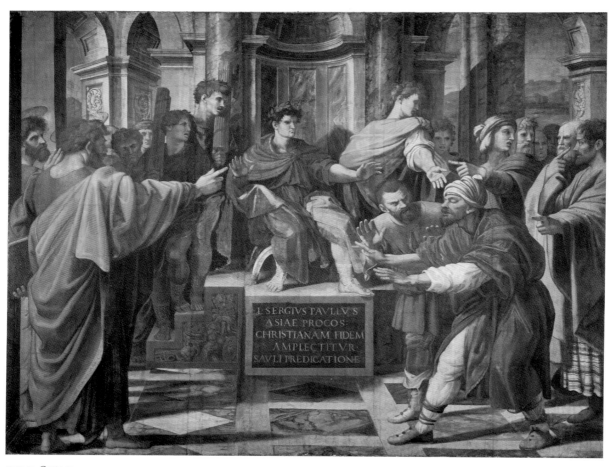

The inscription on the base reads:

L SERGIVS PAVLLVS
ASIAE PROCOS:
CHRISTIANAM FIDEM
AMPLECTITVR
SAVLI PREDICATIONE

CAT. 7, *Cartoon*

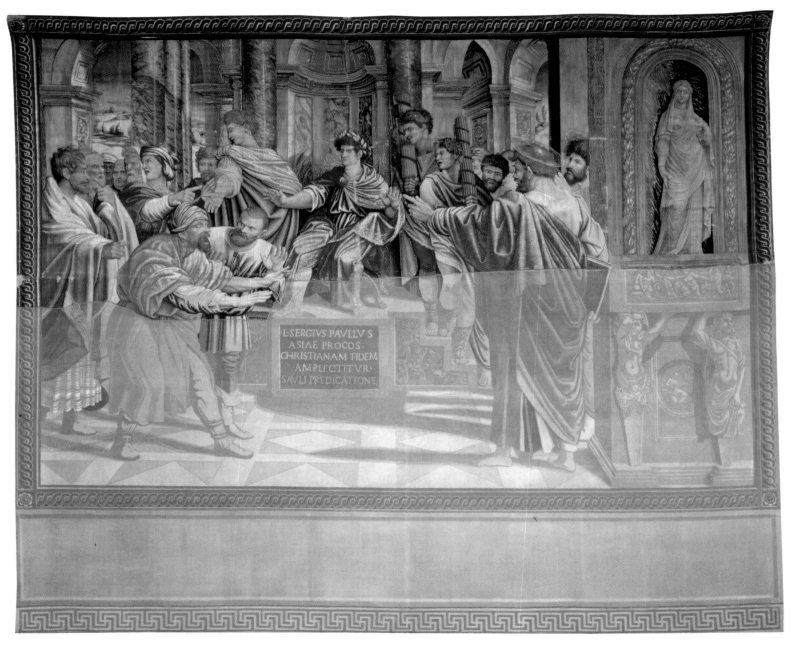

The text within the tapestry image reads:

L·SERGIVS PAVLLV S
ASIAE PROCOS·
CHRISTIANAM FIDEM
AMPLECTITVR
SAVLI PREDICATIONE

CAT. 7.1
Raphael, *The Conversion of the Proconsul*, c.1515, silverpoint, with white heightening over pen, brush and wash on pale buff washed paper, 269 × 354 mm; Windsor, Royal Collection, RL 12750

derives from a fresco in the Brancacci Chapel in Florence, by Filippino Lippi, but formerly attributed to Masaccio.

Raphael made a detailed *modello* of the composition with numerous detailed constructional lines, very like the final Cartoon (silverpoint, with white heightening over pen, brush and wash on pale buff washed paper, 269 × 354 mm; Windsor, Royal Collection, RL 12750, cat. 7.1). This drawing was reproduced as an engraving by Agostino Veneziano, which is dated 1516 (Bartsch XIV, p.48.43, cat. 7.2). Studies also survive for the draped female statue and one of the herms below it, which are depicted in the tapestry, but not in the Cartoon (silverpoint on pink ground, 146 × 98 mm; Oxford, Ashmolean Museum, 569B).

The Cartoon

Light is represented as falling from the left, and the foreground perspective engages the spectator's eye level. Beneath the proconsul, the Latin inscription identifying the subject reads in the correct order, rather than reversed in preparation for the weaving. Only the heads of Paul and Barnabas seem to have been painted by Raphael, although the head of Elymas is also of significant quality. His sleeve has lost its pale-pink shading and retains only a passage of brown glaze, while his leggings were originally mauve. Originally the pale robe of the man at the extreme right was probably bright green. The Cartoon was cut into vertical strips by the weavers and has been rejoined; it has also been pricked for transfer. A duplicate full-size version, apparently made in the sixteenth century and reputedly owned by Sir Joshua Reynolds (Dublin, National Gallery, NGI 172; fig. 39, p.47), may be one of the copies mentioned in 1573 in a letter to Cardinal Granvelle.

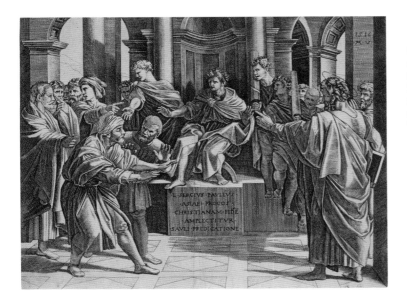

CAT. 7.2
Agostino Veneziano
after Raphael,
*The Conversion of
the Proconsul*, 1516,
engraving, first state;
V&A: Dyce 1066

for display in the new Vatican Picture Gallery. The replacement half was painted on canvas and was based on the corresponding tapestry from the later Mantua series.

The Tapestry Borders

These are severely damaged, and the bottom half is entirely lost. The scene is surrounded by a frame with a continuous guilloche design running from right to left and rosettes in the corners. The tapestry has been cut on both sides and therefore does not have the original edging. This raises the question of whether it was woven together with a side border. In 1521 it was described as 'the ninth cloth, in which Saint Paul is preaching to the Blind Man, illuminated by an Idol and Hercules supporting the sky in the border'. However, the *Hercules* border panel is in fact woven together with *Paul Preaching at Athens* (see cat. 10 below).

The Tapestry

This is one of the tapestries exhibited in the Sistine Chapel on 26 December 1519. Of the entire set, it is the one that suffered most during the Sack of Rome in 1527. It is cut vertically into two parts, which have been reattached, and the lower section is entirely missing.

In comparison with the Cartoon, the composition of the tapestry was extended by a further quarter, beyond the figures of Paul and Barnabas, to incorporate a female statue in a niche, above a frieze supported by herms. This may be because a decision was made, subsequent to the execution of the Cartoon, to enlarge the composition. The addition is in the style of Raphael.

The tapestry disappeared after the Sack of Rome, but in 1544 part of it was recovered by an unnamed bishop, as is recounted in the *Camerale I*: 'one quarter of one of the Chapel cloths made for Pope Leo X, looted at the time of the Sack, cut up by the soldiers and returned'. It may have found its way to Naples, to judge from a letter from Bonaventura Samuelli to Clement VII dated 9 September 1532: 'in . . . Naples there are many people, both Christian and Jews, in secret possession of some beautiful gold and silk cloths acquired after the Sack of Rome . . . it seems to me that they are the ones from the Chapel in the Holy Palace, made for Leo'. In 1592 the *Camerale I* records that another quarter of the tapestry was located: 'two pieces of a gold cloth from the chapel, cut during the Sack of Rome, now joined and sewn together'. Thereafter the tapestry was always referred to as 'half a piece'. It remained in this condition until 1931, when it was restored and given a new lower section,

REFERENCES

Archivio di Stato, *Camerale I*, n.1557, ff.30v; Archivio di Stato, *Camerale I*, n.1557, allegato D, f.1r; White and Shearman (1958), pp.207, 317–19, 322; Reynolds (ed. Wark) (1959), p.216; Shearman (1972), pp.31, 34–7, 58–9, 63, 68–9, 80, 102–3, 110, 113–14, 117, 121–2, 131–2, 137, 139, 141, 145, 147, 149, 155, 211–12; White (1972), pp.6, 9; Joannides (1983), nos 346r, 363; Jones and Penny (1983), p.141; *Raffaello in Vaticano* (1984), no.137; Bober and Rubinstein (1986), ill.165; Plesters (1990), pp.112, 113, 116; Fermor (1996), pp.14–15, 20, 50, 56, 58, 60, 69, 76, 78, 80, 82, 87, 89–90; Meyer (1996), pp.11–12; Fermor and Derbyshire (1998), pp.246, 250; Clayton (1999), no.27; Shearman (2003), nos 1516/32, 1519/66, 1532/5, 1573/3, 1573/5–6

8 The Sacrifice at Lystra

Cartoon bodycolour over charcoal underdrawing on paper mounted on canvas, 347 × 532 cm; on loan from HM Queen Elizabeth II; RCIN 912949
Tapestry warp: wool (7–7.6 warps per cm); weft: wool (20–24 wefts per cm), silk (22 wefts per cm), gilt-metal-wrapped thread (20 wefts per cm), 482 × 581 cm; Vatican Museums, inv. 43874

ACTS *Chapter 14, verses 8–18*

And there sat a certain man at Lystra, impotent in his feet, being a cripple from his mother's womb, who never had walked: the same heard Paul speak: who stedfastly beholding him, and perceiving that he had faith to be healed, said with a loud voice, Stand upright on thy feet. And he leaped and walked. And when the people saw what Paul had done, they lifted up their voices, saying in the speech of Lycaonia, The gods are come down to us in the likeness of men. And they called Barnabas, Jupiter; and Paul, Mercurius, because he was the chief speaker. Then the priest of Jupiter, which was before their city, brought oxen and garlands unto the gates, and would have done sacrifice with the people. Which when the apostles, Barnabas and Paul, heard of, they rent their clothes, and ran in among the people, crying out, and saying, Sirs, why do ye these things? We also are men of like passions with you, and preach unto you that ye should turn from these vanities unto the living God, which made heaven, and earth, and the sea, and all things that are therein: who in times past suffered all nations to walk in their own ways. Nevertheless he left not himself without witness, in that he did good, and gave us rain from heaven, and fruitful seasons, filling our hearts with food and gladness. And with these sayings scarce restrained they the people, that they had not done sacrifice unto them.

PAUL AND BARNABAS CURED a lame man in the city of Lystra (now Hatunsaray in Turkey). Because of this miracle, the Lystrians mistook them for the gods Jupiter and Mercury and sought to offer them sacrifice. Their idolatry is emphasized by the statue of Mercury in the background and by the ornate altar in the foreground. Paul rends his garments in fury, while Barnabas pleads with the crowd to stop the sacrifice. The healed man is the figure in profile, dressed in blue, directly beneath the head of the second sacrificial ox. With hands raised in prayer, he strides past his discarded crutches while a bearded man stoops to examine his miraculously restored leg. A young man in the crowd seems to respond to the entreaties of the saints, and leans towards the butcher as if to prevent him from slaughtering the ox. The implacability of the saints is emphasized by their juxtaposition with the columns, while the sharp leading edge of the altar introduces the plunging perspective that insulates them from the surging motion of the Lystrians.

SOURCES AND STUDIES

The imagery of this scene derives from a number of antique sculptures depicting sacrificial scenes, including a relief on the Arch of the Argentarri in Benevento, a sarcophagus now in the Uffizi, and the celebrated relief of *Marcus Aurelius sacrificing before the Temple of Jupiter*, presented in 1515 by Leo X to the Palazzo dei Conservatori on the Capitol. The ornate triangular altar in the foreground is a conflation of an antique candelabrum base and a cinerary urn. The man presenting a ram derives from a similar figure in Michelangelo's *Sacrifice of Noah* on the Sistine Chapel Ceiling. While

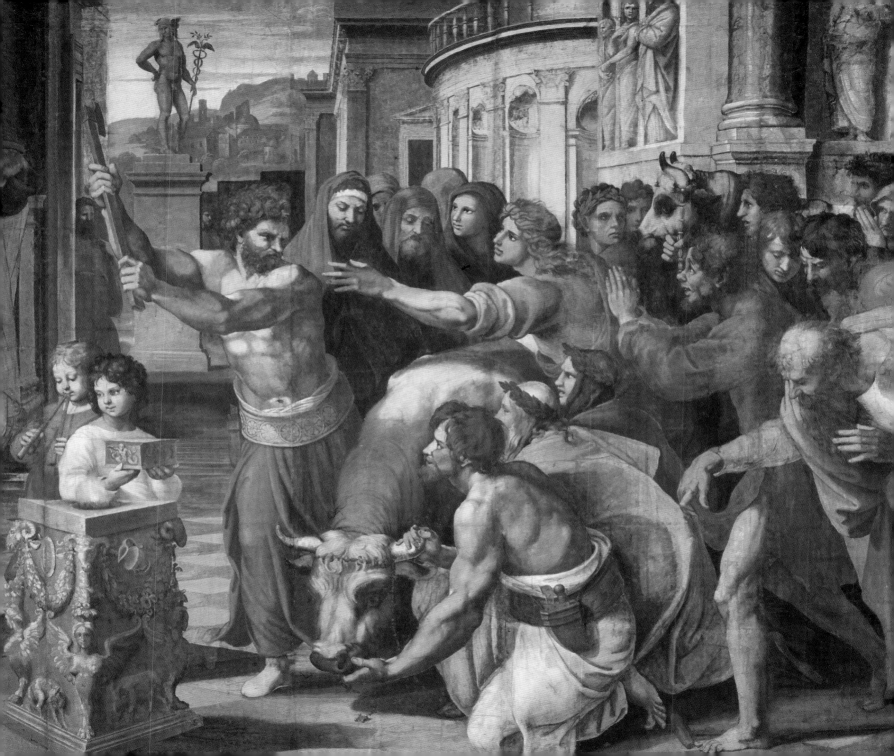

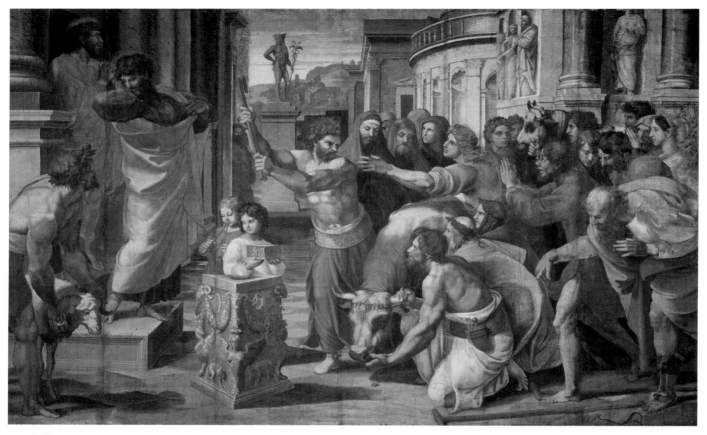

CAT. 8, *Cartoon*

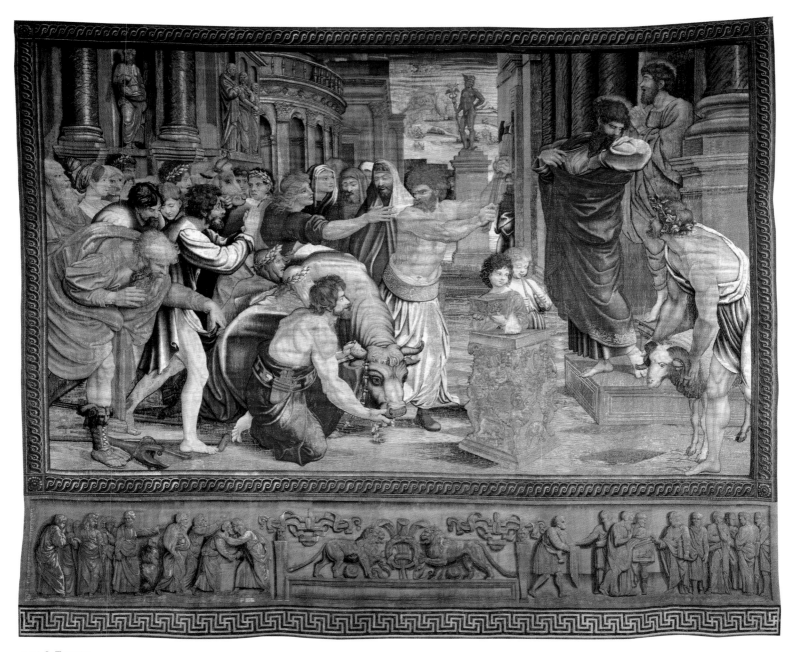

CAT. 8, *Tapestry*

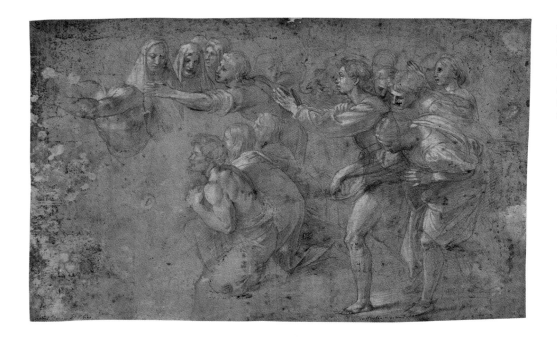

CAT. 8.1
Raphael, fragment of a study
for *The Sacrifice at Lystra*, *c.*1515,
silverpoint and white heightening
on blue-grey ground, 248 × 392
mm; Département des Arts
Graphiques, Musée du Louvre,
Paris, inv. RF 38813

the attitude of St Paul is based on traditional personifications of *Anger*, the extensive architectural background resembles that of a stucco relief of *Discord*, attributed to Francesco di Giorgio, at the V&A.

Raphael made a fine preparatory study of St Paul rending his garments (silverpoint and white heightening on blue-grey ground, 228 × 103 mm; formerly Chatsworth, no.730; Los Angeles, J. Paul Getty Museum, 84.GG.919), which corresponds closely to the figure in the Cartoon. A further, rather damaged study, of comparable quality and similar technique, depicts studio models in everyday clothes

posed as the principal figures in the right half of the Cartoon, without the sacrificial ox or the background townscape (silverpoint and white heightening on blue-grey ground, 248 × 392 mm; Paris, Louvre, inv. RF 38813, cat. 8.1). Both studies may originally have formed part of a continuous composition on the same sheet, which had been divided by the seventeenth century (the former bears the collector's mark of Peter Lely). The latter study was probably the source of a copy of the right half of the composition (pen and brown ink, white heightening, 236 × 293 mm; Florence, Uffizi, Santarelli Collection, no.128).

The Cartoon

Light is represented as falling from the left. The saints, the crippled man and the other main protagonists seem to have been painted by Raphael, and the underdrawing of the head of St Barnabas is vigorous. However, with the exception of the two heads peering down, the background figures are of markedly uneven quality, as is the landscape. In the preparatory study, the left arm of the principal kneeling figure is bent sharply upwards. This was transferred to the underdrawing of the Cartoon, but subsequently revised in favour of the straightened arm now visible. Albeit water-damaged, the multicoloured garment of the crippled man includes especially complex passages, combining pigments and highlights with glazes and

areas of bare paper. The Cartoon was cut into vertical strips by the weavers and has been rejoined; it has also been pricked for transfer.

The Tapestry

This is one of the tapestries exhibited at the Sistine Chapel on 26 December 1519. The Inventory of the *Floreria* in the Archivio Segreto indicates that it was in the papal tapestry store from 1536, with six other tapestries.

Comparison between the Cartoon and the tapestry reveals minor changes in composition, made during the weaving phase. At the bottom right of the Cartoon appear two discarded crutches, one on each side of the left foot of the lame man. In the tapestry, the foremost crutch has been relocated behind his feet, and its place taken by a wooden stump with a cord, probably to make it easier to identify the man who has been miraculously healed. In the tapestry, the scene is slightly reduced in width across its entire lower section. The sandalled foot of the stooping bearded man almost touches the guilloche frame, and a corresponding reduction is visible between the altar and the lower edge of the composition. Similarly, in the Cartoon only a glimpse is visible of the face of the bearded figure at the right edge of the composition, and the head of the first statue at the right is heavily cropped.

The colours on the reverse of the tapestry are closer to those intended by Raphael in the Cartoon, as exposure of the tapestries to light has damaged some shades in particular. For example, it has completely changed the tonal relationship between the figure of Paul and that of Barnabas behind him. The relationship

between two reds of different intensity, still apparent in the Cartoon and on the back of the tapestry, is completely distorted when looking at its front. Paul's red robe contrasts strongly with the faded beige of Barnabas' robe. The same situation can also be observed in the two children behind the altar.

The Tapestry Borders

The scene is surrounded by a frame with a continuous guilloche design running from right to left and rosettes in the corners. Beneath is a fictive bronze relief. The tapestry has the original edging on both vertical sides, indicating that it could not have been woven together with a side border. At the bottom is a continuous Greek-key design, which was woven separately.

The fictive relief is divided into three zones. In the centre appears the Medicean device of three feathers combined with a diamond ring, flanked by a pair of lions emblematic of Leo X and two yokes entwined with scrolls, alluding to his motto 'the ring unites, the yoke is easy', and a pair of herms or terminus figures. The scene on the left represents the confirmation by the Church in Jerusalem of the mission to the Gentiles (Acts 15:22 and Galatians 2:9) and that on the right the disputation at Jerusalem over the circumcision of the Gentiles (Acts 15:4–21). The Christian Jews of Jerusalem had believed it necessary for Gentiles to be circumcised before becoming Christians. After Peter spoke in favour of non-circumcision, and Paul and Barnabas told of the miracles that God had done through them, the Assembly decided that circumcision was unnecessary.

REFERENCES

Archivio Segreto, Div. Cam., 105, f.148; White and Shearman (1958), pp.207, 318–20, 322; Shearman (1972), pp.34–5, 37, 40, 59, 63, 68, 87–8, 103–5, 122–4, 126, 132, 136, 147, 155, 212; White (1972), pp.6, 8–9; Joannides (1983), no.364; Jones and Penny (1983), p.141; Bober and Rubinstein (1986), ills 57, 89, 191, 197; Lewine (1990), pp.271–83; Plesters (1990), pp.115–16, 118; Cordellier and Py (1992), no.407; Shearman (1992), pp.238–40, 253; Jaffé (1994), no.313; Fermor (1996), pp.14, 16, 58, 62, 68, 74, 82, 88, 92; Meyer (1996), pp.12–13; Fermor and Derbyshire (1998), pp.242–3, 246; Shearman (2003), no.1519/66

9 Paul in Prison

Cartoon lost

Tapestry warp: wool (7.2-7.4 warps per cm); weft: wool (20-22 wefts per cm), silk (21-3 wefts per cm), gilt-metal-wrapped thread (20-22 wefts per cm), 479 × 128 cm; Vatican Museums, inv. 43875

ACTS *Chapter 16, verses 23-6*

And when they had laid many stripes upon them, they cast them into prison, charging the jailor to keep them safely: who, having received such a charge, thrust them into the inner prison, and made their feet fast in the stocks. And at midnight Paul and Silas prayed, and sang praises unto God: and the prisoners heard them. And suddenly there was a great earthquake, so that the foundations of the prison were shaken: and immediately all the doors were opened, and every one's bands were loosed.

REFERENCES

White and Shearman (1958), pp.202, 206-7; Shearman (1972), pp.34-5, 37, 59, 69, 87, 105, 124, 133, 212; Joannides (1983), no.361; Jones and Penny (1983), p.141; Bober and Rubinstein (1986), no.119; Shearman (2003), no.1519/66

THE PRINCIPAL SUBJECT IS relegated to the background, and the foreground is dominated by a Herculean personification of the earthquake, which seemingly fractures the earth and even the edge of the tapestry frame with a blow of its powerful arms.

SOURCES AND STUDIES

A preparatory study depicts the personification of the earthquake at the bottom of the scene (silverpoint and white heightening on grey ground, trimmed to a circle, diameter 114 mm; New York, Pierpont Morgan Library, 1977.45). The figure derives from an antique relief of the *Judgement of Paris* in the Villa Medici in Rome.

The Tapestry

This is one of the tapestries that had not yet arrived on 26 December 1519. Its unusual dimensions suggest that it was designed for a specific location, which is still the subject of debate. The most obvious location in the Sistine Chapel would seem to be the space between the singing gallery and the door leading to the choristers' entrance, which has dimensions almost identical to the tapestry. However, the customary reconstruction locates this tapestry on the left wall, as the last in the cycle inside the area reserved for the clergy, separated from the rest of the chapel by the marble *transenna*, formerly positioned closer to the altar. This hypothesis is not totally convincing.

CAT.9, *Tapestry*

The Tapestry Borders

The cartoon has been lost and this tapestry was not reproduced in the later sets, probably because its dimensions were site-specific. In terms of the colours, there are no substantial differences between the front and back of the tapestry.

The scene is surrounded by a frame with a continuous guilloche design running from right to left and rosettes in the corners. Beneath is a fictive bronze relief. At the bottom is a continuous Greek-key design. The border was woven separately from the central scene and from the key pattern. Each of the three parts has its original edging.

The fictive relief may represent Paul's vision in which he was summoned to Philippi in Macedonia (Acts 16:9), where he and Silas were imprisoned.

CAT. 9, *Tapestry* (detail)

CAT. 9, *Tapestry* (detail)

10 Paul Preaching at Athens

Cartoon bodycolour over charcoal underdrawing on paper mounted on canvas, 343 × 442 cm; on loan from HM Queen Elizabeth II; RCIN 912950
Tapestry warp: wool (7.2 warps per cm); weft: wool (20–22 wefts per cm), silk (22–6 wefts per cm), gilt-metal-wrapped thread (24 wefts per cm), 498/504 × 535 cm; Vatican Museums, inv. 43876

ACTS *Chapter 17, verses 16–34*

Now while Paul waited for them at Athens, his spirit was stirred in him, when he saw the city wholly given to idolatry. Therefore disputed he in the synagogue with the Jews, and with the devout persons, and in the market daily with them that met with him. Then certain philosophers of the Epicureans, and of the Stoicks, encountered him. And some said, What will this babbler say? other some, He seemeth to be a setter forth of strange gods: because he preached unto them Jesus, and the resurrection. And they took him, and brought him unto Areopagus, saying, May we know what this new doctrine, whereof thou speakest, is? For thou bringest certain strange things to our ears: we would know therefore what these things mean. (For all the Athenians and strangers which were there spent their time in nothing else, but either to tell, or to hear some new thing.) Then Paul stood in the midst of Mars' hill, and said, Ye men of Athens, I perceive that in all things ye are too superstitious. For as I passed by, and beheld your devotions, I found an altar with this inscription, TO THE UNKNOWN GOD. Whom therefore ye ignorantly worship, him declare I unto you. God that made the world and all things therein, seeing that he is Lord of heaven and earth, dwelleth not in temples made with hands; neither is worshipped with men's hands, as though he needed any thing, seeing he giveth to all life, and breath, and all things; and hath made of one blood all nations of men for to dwell on all the face of the earth, and hath determined the times before appointed, and the bounds of their habitation; that they should seek the Lord, if haply they might feel after him, and find him, though he be not far from every one of us: For in him we live, and move, and have our being; as certain also of your own poets have said, For we are also his offspring. Forasmuch then as we are the offspring of God, we ought not to think that the Godhead is like unto gold, or silver, or stone, graven by art and man's device. And the times of this ignorance God winked at; but now commandeth all men every where to repent: Because he hath appointed a day, in which he will judge the world in righteousness by that man whom he hath ordained; whereof he hath given assurance unto all men, in that he hath raised him from the dead. And when they heard of the resurrection of the dead, some mocked: and others said, We will hear thee again of this matter. So Paul departed from among them. Howbeit certain men clave unto him, and believed: among the which was Dionysius the Areopagite, and a woman named Damaris, and others with them.

PAUL IS DEPICTED IN the Agora before the assembled court of the Araeopagus, the judicial council of Athens. He is preaching on the Immortality of the Soul, a subject with special significance for Leo X, who defined official Catholic doctrine on it in a Bull of 1513. Behind him three followers pay rapt attention. Seated figures gesture excitedly at the Apostle, and turn from one to the other. A group of standing figures register a range of attitudes, ranging from deep thought to surprise and scepticism. In the middle distance is an armed statue of Mars with its back to the Apostle, before a circular Doric temple. The expansive gesture of the vertical figure of Paul, emphasized by the sharp diagonal steps of his supporting dais, dominates the semicircle of his audience. At the lower right-hand corner of the Cartoon, the converts Dionysius and Damaris seem cropped by the edge of the frame and to occupy the area of pictorial space nearest the observer.

SOURCES AND STUDIES

The scene belongs to a tradition of representations of saints preaching, such as Fra Angelico's *Sermon of St Stephen*, in the Chapel of Nicholas V in the Vatican, supplemented by Albrecht Dürer's woodcut of *Christ before Pilate* of *c.*1508–9, from the Small Passion (Bartsch VII, 120.31). Sir Joshua Reynolds already recognized in 1784 that the figure of St Paul derives from a fresco in the Brancacci Chapel in Florence, by Filippino Lippi, but formerly attributed to Masaccio. Another source for the composition was a rejected design for Raphael's own fresco of *The Mass of Bolsena*, painted around 1511–12 in the Vatican *Stanze*, recorded in an old copy in Oxford.

CAT. 10, *Tapestry* (detail)

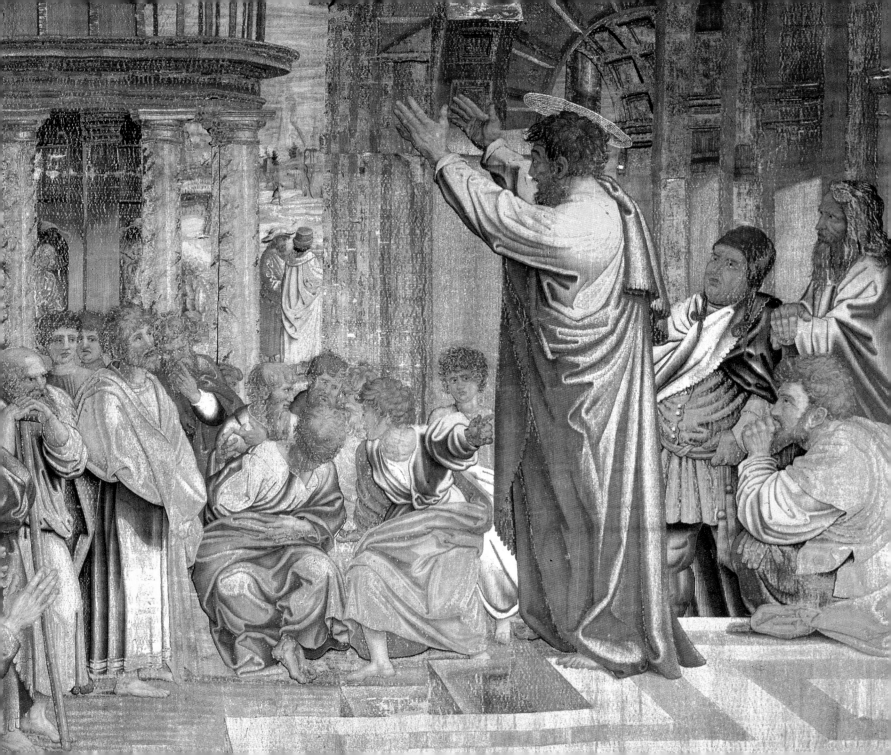

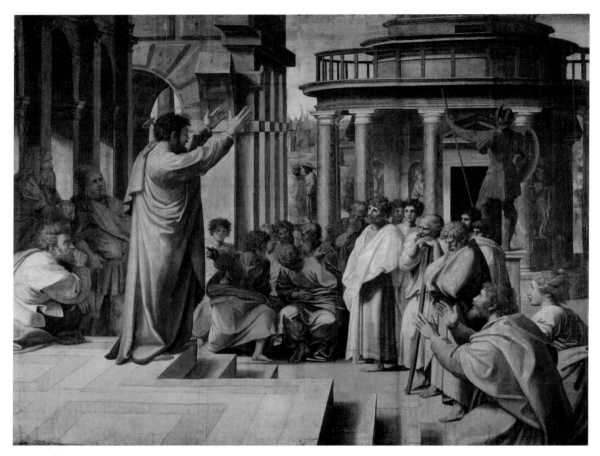

CAT. 10, *Cartoon*

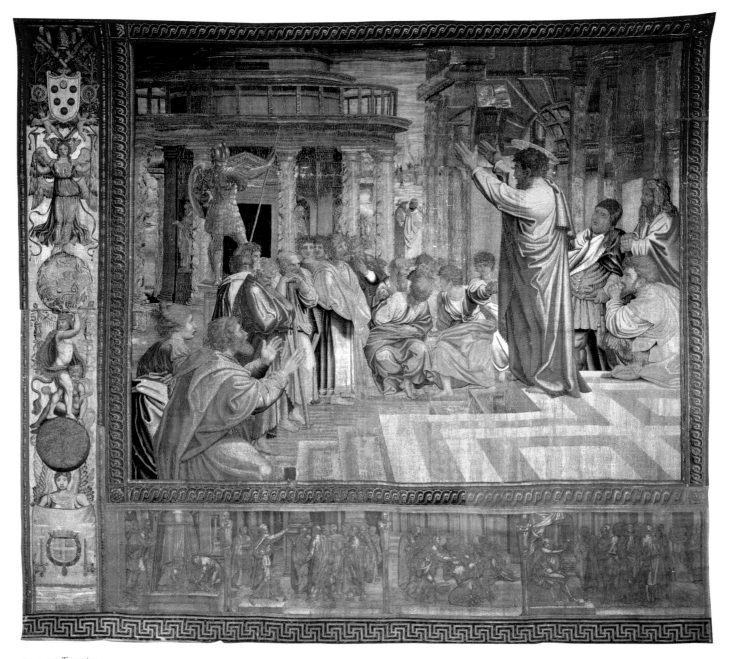

CAT. 10, *Tapestry*

Raphael made a preparatory study of St Paul and five of the other principal figures, without the background architecture, with the foreground dais only roughly sketched in (red chalk over stylus, 278 × 419 mm; Florence, Uffizi, inv. 540E). This depicted the figure of Dionysius at full length on a higher level, more directly associated with St Paul. Dionysius and Damaris were subsequently relegated to a more subordinate location, at three-quarter length. The final Cartoon corresponds closely to the damaged and rather crude *modello* attributed to Giovanni Francesco Penni (pen, brush and wash, white heightening over black chalk, squared in black chalk, with scaling at right edge, 270 × 400 mm; Paris, Louvre, inv. 3884r, cat. 10.1), which includes two figures on the balcony of the round temple, later omitted. This *modello* may be identical with a drawing of this subject, attributed to Raphael, in the post-mortem inventory of Antonio Tronsarelli in Rome in 1601.

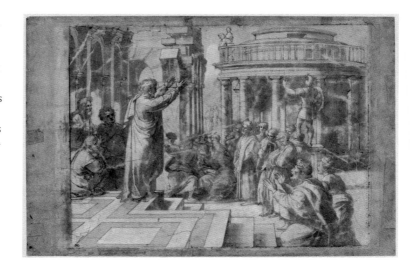

CAT. 10.1
Attributed to Giovanni Francesco Penni, *Paul Preaching at Athens*, pen, brush and wash, white heightening over black chalk, squared in black chalk, with scaling at right edge, 270 × 400 mm; Paris, Louvre, inv. 3884r

The Cartoon

Light is represented as falling from the left, and the foreground perspective engages the spectator's eye level (at about the knee height of the protagonists). While the majority of the figures seem to have been painted by Raphael, those of Dionysius and Damaris at the bottom right have been attributed to Giulio Romano. Her shoulder has been inscribed on the reverse of the Cartoon with it subject: '*S. Paul predict*'. The Cartoon was cut into vertical strips by the weavers and has been rejoined; it has also been pricked for transfer.

The Tapestry

This tapestry was not among those displayed in the Sistine Chapel on St Stephen's Day in 1519.

Comparison of the tapestry with its corresponding Cartoon does not reveal any significant differences in the main scene. The only clothing that now appears very different is that of the cap-wearing figure behind the Apostle and the figure in the distance wearing a large hat. In the first case, reference to the back of the tapestry shows that this variance is a result of fading. In the latter case, the bright red used in the tapestry corresponds to a bluish-white with pink highlights in the Cartoon. This clearly reflects a conscious decision by the weavers.

After the Sack of Rome in 1527 this tapestry suffered the same fate as *The Conversion of Saul* (see cat. 6 above). Its return as a gift from Anne de Montmorency in 1554 is documented by the inscription and the coat of arms at the bottom of the border panel, as well as by the inventory of 28 October 1555 and a number of letters. The inscription, which has now almost disappeared as a result of repeated restoration work, recorded the event as follows: '*Urbe capta partem aulaeorum a praedonib. distractorum conquisitam Annae Mommorancius Gallicae Militiae praef. resarciendam atq. Julio III P.M. restituendam curavit*' – 'Anne de Montmorency, Constable of France, saw to the restitution to Pope Julius III of part, diligently sought out, of the tapestries that had been sold off by robbers when the city was sacked' (the date is illegible even in the earliest photographs). This indicates that the lower strip of the side border and much of the frieze represents restoration carried out before its return to Rome in 1554.

The Tapestry Borders

These were severely damaged after the tapestry was stolen in 1527. The scene is surrounded by a frame with a continuous guilloche design running from right to left and rosettes in the corners (its bottom right part is a replacement). Beneath is a fictive bronze relief. At the bottom is a continuous Greek-key design. The vertical border at the left takes the form of a pilaster with grotesque decoration. The original parts of the tapestry still have their original edging. This suggests that if the piece had a border panel on the right as well, it must have been woven separately and then sewn on.

The substantial restoration undergone by the frieze and the side border before the tapestry was returned in 1554 is immediately apparent, as the later weaving has a very different warp count and different colours from the original. The difference is also obvious in the guilloche frame, perhaps because the later weaver did not have the original to hand, or was asked to make the reworked part clearly identifiable, possibly to highlight the severity of the damage and the generosity of Anne de Montmorency. As the fictive relief has been entirely rewoven, it is impossible to tell whether it reflects the original or follows an entirely new design.

The relief depicts scenes from the life of Paul immediately after his departure from Athens (Acts 18:1-17), telling the story of the saint's arrival in Corinth, in Achaia, where he is welcomed into the house of a tentmaker, finding pleasure in his work because that was his family profession. This is followed by scenes of the Conversion of the Corinthians, and Paul being cursed and derided by the Jews at the court of Governor Gallio.

Only the top half of the vertical border is original. This incorporates the following super-imposed motifs (from the top): the Medici arms, the papal insignia of Leo X supported by a pair of putti, a winged personification of Fame standing on a celestial globe. The bottom half is the result of mid-sixteenth-century restoration work. This includes the supporting figure of Hercules (his lion skin symbolic of Leo X), with Atlas, standing on a terrestrial globe. Beneath this appears a winged figure holding a cloth emblazoned with the coat of arms of Anne de Montmorency (see detail).

The inventory of 1518-21 indicates that the story of Hercules was originally depicted, although it associates this subject with the border of a different tapestry, *The Conversion of the Proconsul*. Comparison with the corresponding left border of the weaving of *The Sacrifice at Lystra*, made around 1550 and now in Madrid, indicates that the figure of Hercules corresponds to the original design, while the winged figure at the bottom is apparently the invention of the mid-sixteenth-century restorers.

CAT. 10, *Tapestry* (detail)

REFERENCES

Archivio di Stato, *Camerale I*, n.1557, ff.30r, 30v, 102v; White and Shearman (1958), pp.207-8, 211, 320-22; Reynolds (ed. Wark) (1959), p.216; Shearman (1972), pp.31, 34-5, 37, 43-4, 59-61, 69-73, 89, 105-7, 112, 124-6, 133, 140-41, 147, 149, 151, 154, 212; White (1972), p.8; Joannides (1983), nos 365-6r; Jones and Penny (1983), p.141; Plesters (1990), p.119; Cordellier and Py (1992), no.413; Shearman (1992), pp.206-7; Fermor (1996), pp.14, 16, 56, 58, 69-70, 73, 82, 85, 88, 92; Meyer (1996), pp.14-16; Fermor and Derbyshire (1998), pp.244, 250; Campbell (2002), p.195; Shearman (2003), nos 1519/66, 1520/81, 1550/7, 1553/3, 1541/2-3, 1601/1

11 Detached border with the Four Seasons

Cartoon lost
Tapestry warp: wool (6.8–7 warps per cm); weft:
wool (18 wefts per cm), silk (22 wefts per cm),
gilt-metal-wrapped thread (22 wefts per cm),
492 × 78 cm; Vatican Museums, inv. 43867.2.2

REFERENCES

Archivio di Stato, *Camerale I*, n.1557, f.30v; White and
Shearman (1958), pp.210–12; Shearman (1972), p.89;
Mancinelli (1982), no.18; Harprath (1984), no.92c

THIS BORDER HAS THE FORM of a pilaster
with grotesque decoration, incorporating
the following superimposed motifs (from
the top): the Medici arms and the papal insignia
of Leo X supported by two putti; the Four
Seasons: a pair of lovers on a basket of flowers
(Spring), Ceres and two putti on a platter of
fruit (Summer), seven putti harvesting grapes
on a wine fountain (Autumn), a figure cloaked
against cold and wet weather crouching
beneath two bare trees and an irate Juno with
personifications of the winds (Winter). At the
bottom is a continuous Greek-key design. The
time symbolism probably relates to the Medici
motto '*Le temps revient*' (The time returns). The
high quality of the design suggests that it may
be by Raphael.

As in the case of the border panel of the
Hours (see cat. 12 below), no documentation
indicates its location in the Sistine Chapel. The
border has been cut along the red strip on both
sides, suggesting that it was woven together
with one of the two tapestries missing their
original edging. One of these is *The Stoning of
Stephen*, but there is a 40-cm height difference
between it and this border, so it is unlikely they
were juxtaposed. The other possibility is *The
Conversion of the Pronconsul*, which, in the
inventory of 1518–21, is mentioned with a
border depicting 'Hercules supporting the sky'.

The *Hours* and the *Seasons* may have been
woven separately and only sewn to one of the
main scenes later on.

CAT. 11, *Tapestry border*

CAT. 11, *Tapestry border* (details)

12 Detached border with the Hours

Cartoon lost
Tapestry warp: wool (6.8 warps per cm);
weft: wool (12-18 wefts per cm), silk (24 wefts per cm),
gilt-metal-wrapped thread (20-21 wefts per cm),
498 × 81 cm; Vatican Museums, inv. 43878

REFERENCES
Archivio di Stato, *Camerale I*, n.1557, f.30v; White and
Shearman (1958), pp.210-12; Shearman (1972), p.89;
Mancinelli (1982), no.19; Harprath (1984), no.92d

THIS BORDER HAS THE FORM of a pilaster with grotesque decoration, incorporating the following superimposed motifs (from the top): the Medici arms and the papal insignia of Leo X supported by two putti; an hourglass on a column (Time) flanked by Apollo (Day) and Diana (Night); a serpent biting its tail (Eternity); a pedestal flanked by two seated personifications of Day (with pale skin, holding a flower) and Night (with dark skin, holding a bat); a 24-hour clock (Time) on a candelabrum flanked by standing male and female nude figures bearing cornucopia, standing on a cartouche decorated with battling sea monsters, the whole supported by a caryatid herm on an ornamental base with foliate lions' feet. At the bottom is a continuous Greek-key design. The time symbolism probably relates to the Medici motto '*Le temps revient*' (The time returns). It has been suggested that the caryatid may have been designed by Perino del Vaga.

Comparison between the front and back of the tapestry does not reveal any substantial colour changes.

The lack of documented information on its true location makes it difficult to reconstruct the position of the panel within the set. If the border was woven together with another tapestry, it must have been joined at the right, as it still has the original edging on its left side. As *The Stoning of Stephen* is only missing its original edging on the right, it could not have been woven with this border. *The Conversion of the Pronconsul* has been cut along the red strip on both sides, but the inventory of 1518-21 mentions its border as showing 'Hercules supporting the sky', which sounds very similar to that accompanying *Paul Preaching at Athens* (see cat. 10 above).

CAT. 12, *Tapestry border*

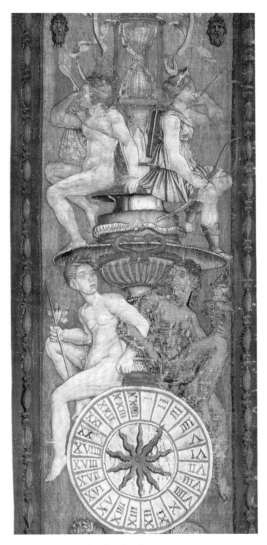

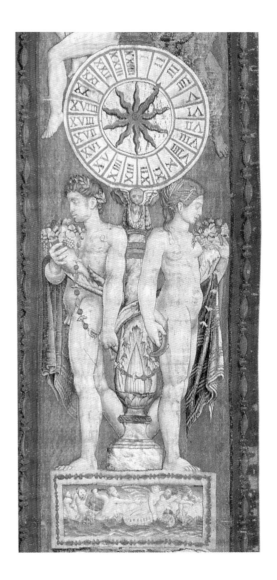

CAT. 12, *Tapestry border* (details)

Bibliography

MANUSCRIPTS

Archivio di Stato di Roma, *Camerale I*, n.1557 (Inventari di *Floreria* anni 1518/21, 1544, 1592)

Archivio Segreto Vaticano, *Camera Apostolica, Div. Cam.*, 75, 105

PUBLICATIONS

Giovanni Baglioni, *Le vite de'pittori, scultori, architetti ed intagliatori* (Naples, 1733)

Carmen C. Bambach, *Drawing and Painting in the Italian Renaissance Workshop* (Cambridge, 1999)

Adam Bartsch, *Le Peintre Graveur*, 21 vols (Vienna, 1803-21)

Adam Bartsch, *The Illustrated Bartsch*, ed. Walter L. Strauss (Pennsylvania and New York, 1971-)

Michael Baxandall, *Painting and Experience in Fifteenth-Century Italy* (Oxford, 1972)

G. Becatti, 'Raffaello e l'antico', in *Raffaello. L'opera, le fonti, la fortuna*, vol.II (Novara, 1968)

Paolo Bellini, *L'Opera Incisa di Adamo e Diana Scultori* (Vicenza, 1991)

P.F. Bertrand, *Les tapisseries des Barberini et la décoration d'intérieur dans la Rome Baroque* (Turnhout, 2005)

Karl Bihlmeyer and Hermann Tuechle, *Storia della Chiesa*, vol.3 (Brescia, 1996)

Bonnie J. Blackburn, 'Music and Festivities at the Court of Leo X: A Venetian View', in *Early Music History*, vol.11 (1992), pp.1-37

Phyllis Pray Bober and Ruth Rubinstein, *Renaissance Artists & Antique Sculpture. A Handbook of Sources* (London and New York, 1986)

Piero Boccardo, 'Prima qualita "di seconda mano": Vicende dei Mesi di Mortlake e di altri arazzi e cartoni fra l'Inghilterra e Genova', in *Genova e l'Europa atlantica:*

Opere, artisti, committenti, collezionisti – Inghilterra, Fiandre, Portogallo, ed. Piero Boccardo and Clario Di Fabio (Milan, 2006), pp.182-5

Clifford M. Brown and Guy Delmarcel, *Tapestries for the Courts of Federico II, Ercole, and Ferrnate Gonzaga 1522-63* (Seattle and London, 1996)

Jacob Burckhardt, *The Civilization of the Renaissance in Italy* (edn New York, 1960)

Thomas P. Campbell, 'School of Raphael Tapestries in the collection of Henry VIII', *The Burlington Magazine*, vol.138, no.1115 (1996), pp.69-78

Thomas P. Campbell, *Tapestry in the Renaissance: Art and Magnificence*, exhibition catalogue, Metropolitan Museum of Art, New York (New Haven and London, 2002)

Thomas P. Campbell, *Henry VIII and the Art of Majesty: Tapestries at the Tudor Court* (New Haven and London, 2007a)

Thomas P. Campbell (ed.), *Tapestry in the Baroque: Threads of Splendour*, exhibition catalogue, Metropolitan Museum of Art, New York (New Haven and London, 2007b)

David S. Chambers: 'Papal Conclaves and Prophetic Mystery in the Sistine Chapel', *Journal of the Warburg and Courtauld Institutes*, vol.XLI (1978), pp.322-6

Hugo Chapman, Tom Henry and Carol Plazzotta, *Raphael: From Urbino to Rome*, exhibition catalogue, National Gallery, London (London, 2004)

Carl C. Christensen, *Art and the Reformation in Germany* (Athens, OH, 1979)

Martin Clayton, *Raphael and his Circle. Drawings from Windsor Castle*, exhibition catalogue, The Royal Collection, London (London and New York, 1999)

Martin Clayton, in Marsden (ed.) (2010), pp.176-7

Committee of Council on Education, Department of Science and Art, *Price List of reproductions*

of works of art by means of photography, electrotyping, casting &c. selected from the South Kensington Museum, and from various other public and private collections: produced for the use of schools of art and public instruction generally (London, 1859)

Dominique Cordellier and Bernadette Py, *Inventaire Général des Dessins Italiens. Raphaël, son Atelier, ses Copistes*, Musée du Louvre, Paris, Département des Arts Graphiques (Paris, 1992)

G. Cornini et al., *Raffaello nell'appartamento di Giulio II e Leone X* (Milan, 1993)

H.W. Crocker III, *Triumph* (Roseville, CA, 2001)

Frederick Cummings, 'B.R. Haydon and His School', *Journal of the Warburg and Courtauld Institutes*, vol.XXVI, no.3/4 (1963), pp.367-80

Nicole Dacos, 'Tommaso Vincidor. Un élève de Raphaël aux Pays-Bas', in *Relations Artistiques entre les Pays-Bas et L'Italie à La Renaissance. Études dédiées à Suzanne Sulzberger* (Rome and Brussels, 1980), pp.61-99

Nicole Dacos, 'Cartons et dessins raphaelésques à Bruxelles: l'action de Rome aux Pays-Bas', *Bollettino d'Arte*, Supplemento al no.100; Atti del Convegno Internazionale, *Fiamminghi a Roma 1508-1608*, Nicol Dacos (ed.), conference paper, 1995 (1997), pp.1-22

Nicole Dacos Crifò and Bert W. Meijer, *Fiamminghi a Roma 1508-1608*, exhibition catalogue, Palais des Beaux-Arts, Brussels (Ghent, 1995)

Guy Delmarcel, *Flemish Tapestry* (New York, 2000)

Guy Delmarcel and Nicole Dacos Crifò, in Dacos Crifò and Meijer (1995), no.162

Anna Maria De Strobel, 'Le arazzerie romane dal XVII al XIX secolo', in *Quaderni di Storia dell'Arte*, Istituto Nazionale di Studi Romani, vol.XXII (Città di Castello, 1989)

Anna Maria De Strobel, 'La constitution de la collection du Vatican, tapisseries romaines et françaises', in *La tapisserie au XVIIe siècle et les collections européennes*, Actes du colloque international de Chambord (1996), 'Cahiers du Patrimoine', 57 (Paris, 1999), pp.173–80

Anna Maria De Strobel, in *Hochrenaissance im Vatikan* (1999), nos 314, 315

Stephanie Dickey, 'The Passions and Raphael's Cartoons in Eighteenth-Century British Art', *Marsyas: Studies in the History of Art*, vol.XXII (1986), pp.33–46

William Durant, *The Reformation: A History of European Civilization from Wycliffe to Calvin: 1300–1564* (New York, 1985)

Luitpold Dussler, *Raphael. A critical catalogue of his pictures, wall-paintings and tapestries* (London and New York, 1971)

Wilhelm Eisengrein, *Chronologicarum rerum amplissimae clarissimaeque urbis Spirae libri XVI* (n.p., 1564)

Caroline Elam, 'Art and Diplomacy in Renaissance Florence', *Journal of the Royal Society for the Encouragement of the Arts*, vol.136 (1988), pp.813–26

Leopold D. Ettlinger, *The Sistine Chapel before Michelangelo* (Oxford, 1965)

Trevor Fawcett, 'Graphic versus photographic in the nineteenth-century reproduction', *Art History*, vol.9, no.2 (1986), pp.185–212

Lucien Febvre, *Martin Lutero* (Milan, 2003)

Sharon Fermor, *The Raphael Tapestry Cartoons: Narrative, Decoration, Design* (London, 1996)

Sharon Fermor and Alan Derbyshire, 'The Raphael Tapestry Cartoons Re-Examined', *The Burlington Magazine*, vol.140, no.1141 (1998), pp.236–50

David Franklin, *The Art of Parmigianino*, exhibition catalogue, National Gallery of Canada, Ottawa (New Haven and London, 2003)

Herman-Walther Frey, 'Regesten zur päpstlichen Kapelle unter Leo X. und zu seiner Privatkapelle', in *Die Musikforschung* 8 (1955), pp.58–73, 178–99, 412–37; ibid. 9 (1956), pp.46–57, 139–56, 411–19

Ricardo Garcia-Villoslada, *Martín Lutero, El fraile hambriento de Dios*, 2nd edn (Madrid, 1976)

J.A. Gere and Nicholas Turner, *Drawings by Raphael*, exhibition catalogue, British Museum, London (London, 1983)

Walter S. Gibson, 'Lucas van Leyden's late paintings: The Italian connection', *Nederlands Kunsthistorisch Jaarboek*, vol.37 (1986), pp.41–52

C.E. Gilbert, 'Are the Ten Tapestries a Complete Cycle or a Fragment?', in *Studi su Raffaello*, Atti del Congresso Internazionale di Studi, Urbino and Florence, 6–14 April 1984 (Urbino, 1984), pp.533–50

Maria Giononi-Visani and Grgo Gamulin, *Giorgio Giulio Clovio. Miniaturist of the Renaissance* (London, 1993)

Paolo Giovio, *De vita Leonis Decimi Pont. Max. libri quatuor: His ordine temporum accesserunt Hadriani Sexti Pont. Max. et Pompeii Columnae Cardinalis vitae* (Florence, 1551)

Domenico Gnoli, 'Contratto per gli affreschi nelle pareti laterali della Cappella Sistina', *Archivio storico dell'arte*, VI (1893), pp.128–9

Johann Wolfgang Goethe (trans. and ed. W.H. Auden and Elizabeth Meyer), *Italian Journey 1786–1788* (Harmondsworth, 1962)

Nello Forti Grazzini, *Gli arazzi, Il Patrimonio Artistico del Quirinale*, 2 vols (Rome and Milan, 1994)

Anton Groner, 'Zur Entstehungsgeschichte der Sixtinischen Wandfresken', *Zeitschrift für Christliche Kunst*, XIX (1906), pp.163–70, 193–202, 227–36

Richard Harprath, in *Raffaello in Vaticano* (1984), no.92a–d

Wendy Hefford, 'The Mortlake Manufactory, 1619–49', in Campbell (2007b), pp.171–201

Lars Hendrikman, 'Verknipte interpretatie. Rafaels invloed op het oeuvre van Bernard van Orley heroverwogen', in Henk Th. Van Veen et al. (eds), *Polyptiek. Een velluik van Groninger bijdragen aan de kunstgeschiedenis* (Zwolle, 2002), pp.83–9

Michael Hirst, *Michelangelo. Draftsman* (Milan, 1988)

Michael Hirst, 'Michelangelo and his First Biographers', *Proceedings of the British Academy*, XCIV (1997), pp.63–84

Hochrenaissance im Vatikan (1503–1534). Kunst und Kultur im Rom der Päpste I, exhibition catalogue, Kunst- und Ausstellungshalle der Bundesrepublik Deutschland, Bonn (Bonn, 1999)

Mary Hollingsworth, *Patronage in Sixteenth-Century Italy* (London, 1996)

F.W.H. Hollstein, *Dutch and Flemish Etchings, Engravings and Woodcuts, ca.1450–1700*, vol. XI, *Leyster-Matteus* (Amsterdam, n.d., c.1954)

Herbert P. Horne, *Botticelli, Painter of Florence* (Princeton, 1908; reprinted 1980)

Heidi J. Hornik and Mikeal C. Parsons, *Illuminating Luke. The Public Ministry of Christ in Italian Renaissance and Baroque Painting* (New York and London, 2005)

David Howarth, 'William Turnbull and Art Collecting in Jacobean England', *British Library Journal*, vol.20, no.2 (1994), pp.140–62

Michael Jaffé, *Rubens and Italy* (Oxford, 1977)

Michael Jaffé, *The Devonshire Collection of Italian Drawings. Roman and Neapolitan Schools* (London, 1994)

Paul Joannides, *The Drawings of Raphael with a complete catalogue* (Los Angeles and Oxford, 1983)

Jan Johnson, 'Ugo da Carpi's chiaroscuro woodcuts', *Print Collector*, vols III and IV, nos 57–8 (1982), pp.2–88

Roger Jones and Nicholas Penny, *Raphael* (New Haven and London, 1983)

Paulina Junquera de Vega and Concha Herrero Carretero, *Catalogo de Tapices del Patrimonio Nacional*, vol.I, *Siglo XVI* (Madrid, 1986)

Max-Eugen Kemper, 'Leo X. – Giovanni de'Medici', in *Hochrenaissance im Vatikan* (1999), pp.30–47

Max-Eugen Kemper, 'Die Sixtinische Kapelle als Ort der Papstwahl', in Eberhard Pause (ed.), *Er lasse sein Angesicht über uns leuchten* (Freiburg, Basel and Vienna, 2002), pp.109–18

David Landau and Peter Parshall, *The Renaissance Print 1470–1550* (New Haven and London, 1994)

Philippe Levillain, 'Leo X', in *The Papacy, An Encyclopedia*, vol.2 (New York, 2000)

Carol F. Lewine, 'Aries, Taurus and Gemini in Raphael's Sacrifice at Lystra', *The Art Bulletin*, vol.72, no.2 (1990), pp.271–83

Fabrizio Mancinelli, in Pietrangeli et al. (1982), nos 17–19

Fabrizio Mancinelli, Anna Maria De Strobel, Giovanni Morello and Arnold Nesselrath, *Michelangelo e la Sistina – La Tecnica, il Restauro, il Mito* (Rome, 1990)

Jonathan Marsden (ed.), *Victoria & Albert. Art & Love*, exhibition catalogue, The Queen's Gallery, London (London, 2010)

Jorge Maria Cardinal Mejìa, Arnold Nesselrath, Pier Nicola Pagliara and Maurizio De Luca, *The Fifteenth-Century Frescoes in the Sistine Chapel, Recent Restorations of the Vatican Museums*, IV (Vatican City, 2003)

Arline Meyer, *Apostles in England: Sir James Thornhill & the Legacy of Raphael's Tapestry Cartoons*, exhibition catalogue, Miriam and Ira D. Wallach Art Gallery, Columbia University (New York, 1996)

Elizabeth Miller, *From Marcantonio Raimondi to the Postcard. Prints of the Raphael Cartoons*, exhibition handlist, Victoria and Albert Museum (London, 1995)

John Monfasani, 'A Description of the Sistine Chapel under Pope Sixtus IV', *Artibus et Historiae*, VII (1983), pp.9-18

Jennifer Montagu, 'The "Ruland/Raphael Collection"', in Helene E. Roberts (ed.), *Art History through the Camera's Lens* (Gordon and Breach, 1995), pp.37-57

E. de Moreau, Pierre Jourda and Pierre Janelle, *Storia della Chiesa*, vol.16 (Milan, 1997)

Jeffrey M. Muller, *Rubens: The Artist as Collector* (Princeton, 1989)

Eugène Müntz, *Les Arts à la Cour des Papes pendant le XVe et le XVIe siècle: Recueil de documents inédits tirés des archives et des bibliothèques romaines*, I (Paris, 1878); II (Paris, 1879)

Arnold Nesselrath, *Das Fosssombroner Skizzenbuch* (London, 1993)

Arnold Nesselrath, 'La Stanza d'Eliodoro', in Cornini, Caravaggi et al. (1993), pp.202-45

Arnold Nesselrath, 'The Painters of Lorenzo the Magnificent in the Chapel of Pope Sixtus IV in Rome', in Mejìa, Nesselrath et al. (2003), pp.39-75

Arnold Nesselrath, *Vaticano - La Cappella Sistina - Il Quattrocento* (Parma, 2004)

Bartolomeo Nogara, 'Un arazzo mutilato di Raffaello', in *L'Illustrazione Vaticana*, 2 (1931), pp.22-7

Pier Nicola Pagliara, 'Nuovi documenti sulla costruzione della Cappella Sistina', in *Michelangelo - La Cappella Sistina - Documentazione e Interpretazioni*, vol.III, Atti del Convegno Internazionale di Studi, Roma, Marzo 1990 (Novara, 1994), pp.15-19

Pier Nicola Pagliara: 'The Sistine Chapel: Its Medieval Precedents and Reconstruction', in Mejìa, Nesselrath et al. (2003), pp.77-86

Gunther Passavant, review of Ettlinger (1965), *Kunstchronik*, XIX (1966), pp.214-16, 220-31

Ludwig von Pastor, *Historia de los Papas*, tome 4, vol.8 (Barcelona, 1910)

Ludwig von Pastor, *Geschichte der Päpste seit dem Ausgang des Mittelalters*, vol.4, *Geschichte der Päpste im Zeitalter der Renaissance und der Glaubensspaltung von der Wahl Leos X. bis zum Tode Klemens VII. (1513-1534)*, parts 5-7, revised edn (Freiburg im Breisgau, 1923)

M. Pellegrini, *Leone X*, in *Enciclopedia dei Papi*, vol.III (Rome, 2000), pp.43-7

Nicholas Penny, 'Raphael', *Grove Art Online*, www.oxfordartonline.com, consulted 19 March 2010

Grazia Bernini Pezzini et al., *Raphael Invenit: Stampa da Raffaello nelle collezioni dell' Instituto Nazionale per la Grafica* (Rome, 1985)

John Physick, *Photography and the South Kensington Museum*, Victoria and Albert Museum (London, 1975)

John Physick, *The Victoria and Albert Museum. The history of its building*, Victoria and Albert Museum (London, 1982)

C. Pietrangeli, *I Musei Vaticani. Cinque secoli di storia* (Rome, 1985), p.124, no.61

Carlo Pietrangeli et al., *The Vatican Collections. The Papacy and Art*, exhibition catalogue, Metropolitan Museum of Art, New York (New York, 1982)

André Pirro, 'Leo X and Music', *The Musical Quarterly*, vol.XXI, no.1 (1935), pp.1-16

Joyce Plesters, 'Raphael's Cartoons for the Vatican Tapestries: A Brief Report on the Materials, Technique and Condition', in Shearman and Hall (1990), pp.111-24

John Pope-Hennessy, *The Raphael Cartoons*, Victoria and Albert Museum (London, 1950)

John Pope-Hennessy, *Raphael* (New York, 1970)

Claudio Pozzoli, *Vita di Martin Lutero* (Milan, 1983)

Raffaello in Vaticano, exhibition catalogue, Braccio di Carlo Magno, Vatican City, Rome (Milan, 1984)

Deoclecio Redig de Campos: 'I "tituli" degli affreschi del Quattrocento nella Cappella Sistina', *Atti della Pontificia Accademia Romana di Archeologia - Rendiconti*, XLII, 1969-70, pp.299-314

Sue Welsh Reed and Richard Wallace, *Italian Etchers of the Renaissance & Baroque*, exhibition catalogue, Museum of Fine Arts, Boston (Boston, 1989)

Graham Reynolds, *The Early Paintings and Drawings of John Constable*, 2 vols (New Haven and London, 1996)

Joshua Reynolds, Robert R. Walk (ed.), *The Discourses on Art* (San Marino, 1959)

William Roscoe, *The Life and Pontificate of Leo the Tenth*, 2 vols (London, 1846)

Martin Rosenberg, *Raphael and France. The Artist as Paradigm and Symbol* (University Park, PA, 1995)

Adalbert Roth, 'Französische Musiker und Komponisten am päpstlichen Hof unter Leo X.', in Götz-Rüdiger Tewes and Michael Rohlmann (eds), *Der Medici-Papst Leo X. und Frankreich: Politik, Kultur und Familiengeschäfte in der europäischen Renaissance*, Spätmittelalter und Reformation, Neue Reihe, 19 (Tübingen, 2002), pp.529-45

John Ruskin, E.T. Cook and Alexander Wedderburn (eds), *Works*, 39 vols (London, 1903-12)

John Shearman, 'The Vatican Stanze: Functions and Decoration', *Proceedings of the British Academy*, LVII (London, 1971)

John Shearman, *Raphael's Cartoons in the Collection of Her Majesty the Queen and the Tapestries for the Sistine Chapel* (London, 1972)

John Shearman, 'La costruzione della Cappella e la prima decorazione al tempo di Sisto IV', in *La Cappella Sistina - I primi restauri: La scoperta del colore* (Novara, 1986), pp.22-87

John Shearman, 'La Storia della Cappella Sistina', in Mancinelli, De Strobel et al. (1990), pp.19-28

John Shearman, *Only Connect . . . Art and the Spectator in the Italian Renaissance. The A.W. Mellon Lectures in the Fine Arts* (Princeton, 1992)

John Shearman, *Raphael in Early Modern Sources (1483-1602)*, 2 vols (New Haven and London, 2003)

John Shearman and Marcia B. Hall (ed.), *The Princeton Raphael Symposium* (Princeton, 1990)

Richard Sherr, 'Performance Practice in the Papal Chapel during the 16th Century', in *Early Music*, 15 (1987), pp.452–62

Innis H. Shoemaker and Elizabeth Brown, *The Engravings of Marcantonio Raimondi*, exhibition catalogue, Spencer Museum of Art, University of Kansas (Lawrence, KS, 1981)

Hillie Smit, 'Image Building through Woven Images. The Tapestry Collection of the Papal Court, 1447–1471', in *The Power of Imagery – Essays on Rome, Italy and Imagination*, ed. Peter van Kessel (Rome, 1993a), pp.19–264

Hillie Smit, 'The Tapestry Collection of Pope Julius II (1503–1513): notes by Marcantonio Michiel in 1519', in *Bulletin du CIETA*, 71 (1993b), pp.49–59

Ernst Steinmann, *Die Sixtinische Kapelle*, vol.1 (Munich, 1901)

Suzanne Sulzberger, 'Dürer a-t-il vu à Bruxelles les Cartons de Raphaël?', *Gazette des Beaux-Arts*, vol.LIV (1959), pp.177–84

William George Thomson, *A History of Tapestry from the Earliest Times until the Present Day*, 2nd edn (London, 1930)

Giorgio Vasari, Gaetano Milanesi (ed.), *Le Opere*, 9 vols (Florence, 1906)

Giorgio Vasari, George Bull (trans.), *The Lives of the Artists* (Harmondsworth, 1971)

Giorgio Vasari, R. Bettarini (ed.), commentary by P. Barocchi, *Le Vite de' più eccellenti pittori, scultori, e architettori*, editions of 1550 and 1568, vol.IV (Florence, 1976)

Giorgio Vasari, Gaston du C. de Vere (trans.), intro. and notes by David Ekserdjian, *The Lives of the Painters, Sculptors and Architects*, 2 vols (London, 1996)

Richard Verdi, *Nicolas Poussin 1594–1665*, exhibition catalogue, Royal Academy of Arts, London (London, 1995)

Tristan Weddigen, 'Tapisseriekunst unter Leo X. Raffaels *Apostelgeschichte* für die Sixtinische Kapelle', in *Hochrenaissance im Vatikan* (1999), pp.268–84

John White, *The Raphael Cartoons*, Victoria and Albert Museum (London, 1972)

John White and John Shearman, 'Raphael's Tapestries and their Cartoons', *The Art Bulletin*, vol.40, no.3 (1958), pp.193–221, 299–323

Johannes Wilde, *Michelangelo and his Studio* (London, 1953)

Johannes Wilde, 'The Decoration of the Sistine Chapel', *Proceedings of the British Academy*, XLIV (1958), pp.61–81

Roberto Zagnoli, 'Cylinders for the Stove used in a Papal Conclave', in Allen Duston and Roberto Zagnoli (eds), *Saint Peter and the Vatican – The Legacy of the Popes* (Alexandria, VA, 2003), p.305, cat.144

T.C. Price Zimmermann, *Paolo Giovio. The Historian and the Crisis of Sixteenth-Century Italy* (Princeton, 1995)

Photographic credits

Acknowledgements

This publication, which accompanies the exhibition *Raphael: Cartoons and Tapestries for the Sistine Chapel*, held at the V&A between 8 September and 17 October 2010, has been made possible through the assistance and support of numerous colleagues and friends. In the first instance, its authors gratefully acknowledge their debt to the late John Shearman, whose magisterial book, *Raphael's Cartoons in the Collection of Her Majesty the Queen and the Tapestries for the Sistine Chapel* (1972), remains the fundamental study of these wonderful works of art. Many other scholars have made important contributions to this subject over the last four decades, and we are appreciative of the insights of Thomas P. Campbell, Martin Clayton, Dominique Cordellier, Guy Delmarcel, Alan Derbyshire, Sharon Fermor, Creighton Gilbert, Richard Harprath, Wendy Hefford, Paul Joannides, Roger Jones, Nicholas Penny, Bernadette Py and John White.

At the V&A, Mark Evans and Clare Browne would especially like to thank Rebecca Wallace and David Packer for their work on the administration of the exhibition, Line Lund for its design, and Tom Windross for his editorial work on this book. They also acknowledge the assistance of colleagues, including Jo Banham, Liz Barrett, Bryony Bartlett-Rawlings, Victor Batalha, Julius Bryant, Matthew Clarke, Albertina Cogram, Katie Coombs, Annie Davies, Clare Davis, Ana Debenedetti, Doug Dodds, Mark Eastment, Cathy Flanagan, Catherine Flood, Bárbara Freitas, Mandy Greenfield, Jane Lawson, Philip Lewis, Linda Lloyd Jones, Caroline Lowe, Christopher Marsden, Elizabeth Miller, Lesley Miller, Peta Motture, Lindsay Pentelow, Ella Ravilious, David Redhead, Jennifer Sliwka, Catherine Stuart, Matt Thomas, Nadia Thorp, Lucy Trench, Rebecca Ward, Rowan Watson, Christopher Wilk and Paul Williamson.

At the Vatican Museums, Arnold Nesselrath and Anna Maria De Strobel would like to thank Mons. Paolo Nicolini, Andrea Carignani, Isabella Cordero di Montezemolo and Annavaleria Caffo for the administration of the exhibition, Mario Nocente and the staff of the Laboratorio Restauro Arazzi dei Musei Vaticani and the Laboratorio Restauro Arazzi delle Suore Francescane Missionarie di Maria, Rosanna di Pinto, Filippo Petrignani, Alessandro Bracchetti and Fr Mark Haydu. They also acknowledge the valuable contributions of Fulvio Bernardini, Loredana Boero, Andrea Breno, Roberto Bufalini, Viola Ceppetelli, Mariachiara Cesa, Mauro Chibbaro, Pierino Cicala, Giacomo Cordisco, Fabrizio Cosimo, Fabio Cristofani, Dino di Marcello, Fabio Francati, Roberto Gasperoni, Giancarlo Gobbi, Luigi Grispigni, Valerio Iovine, Karin Jansen, Anna Liguori, Danilo Lucidi, Rosangela Mancusi, Antonio Maura, Sister Angela Messina, Cesare Moretti, Laura Pace Morino, Fabio Morresi, Chiara Pavan, Emanuela Pignataro, Orietta Robino, Marco Roccagalli, Roberto Romano, Carlo Alberto Rossi, Alessandro Sabatucci, Ulderico Santamaria, Sara Savodello, Pietro Simari, Sister Maria Smolen, Daniela Valci and Lucina Vattuone.

The organisers are also grateful for the assistance and advice of Valerie Corvino, Amalia Dalascio, Antony Griffiths, Neil McGregor, Theresa-Mary Morton, Sarah Murray, Judy Rudoe, Desmond Shawe-Taylor and Reinhild Weiss.